UNDERSTANDING
EXPOSURE

FOURTH EDITION

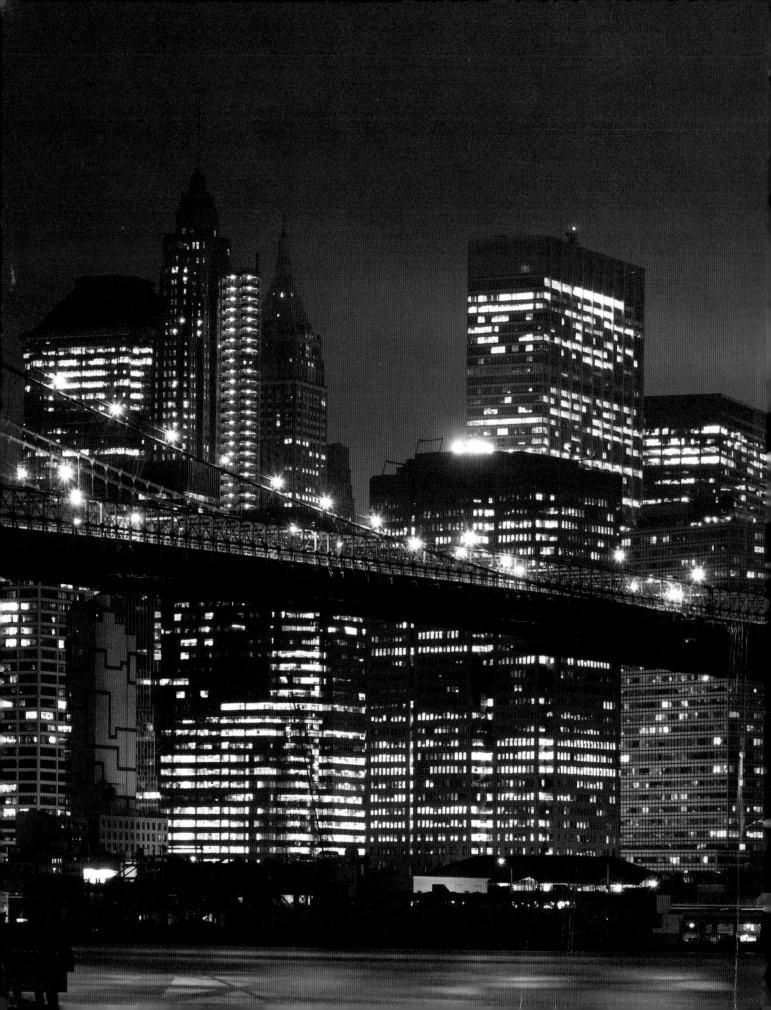

UNDERSTANDING EXPOSURE

How to Shoot
Great Photographs
with Any Camera

BRYAN PETERSON

FOURTH EDITION

AMPHOTO BOOKS
Berkeley

Every photograph is a lie, but within
that lie a mountain of truth is revealed!
And the climb towards the top of that
mountain of truth is greatly accelerated
when one's steps are rooted in the
simple understanding of exposure.

—BRYAN PETERSON

Published in the United States by Amphoto Books,
an imprint of the Crown Publishing Group, a division
of Penguin Random House LLC, New York.
www.crownpublishing.com
www.amphotobooks.com

AMPHOTO BOOKS and the Amphoto Books logo are
registered trademarks of Penguin Random House LLC.

Previous editions of this work were published by
Amphoto Books, Berkeley, in 1990, 2004, 2010.

Library of Congress Cataloging-in-Publication Data
Peterson, Bryan, 1952- author.
 Understanding exposure : how to shoot great photographs
with any camera / Bryan Peterson. — 4th edition.
 pages cm
 Includes bibliographical references and index.
 1. Photography—Exposure. I. Title.
 TR591.P48 2016
 771—dc23
 2015025905

Trade Paperback ISBN: 978-1-60774-850-2
eBook ISBN: 978-1-60774-851-9

Printed in China

Design by Chloe Rawlins

10 9 8 7 6 5 4 3 2 1

Fourth Edition

CONTENTS

INTRODUCTION

The year was 1975, but it seems like yesterday that I first introduced the "photographic triangle" to a group of about forty students. It was on a Saturday, and I was running an all-day workshop on understanding exposure on the campus of Portland Community College as part of a program of continuing adult education. I had never presented to a group this "large," and little did I know then that groups of forty students one day would swell toward one thousand attendees. My journey has in many respects been truly humbling.

When I first picked up a camera in the summer of 1970 (a suggestion made by my older brother Bill, who was a keen amateur photographer), my intention was to use the camera as a way to record landscapes and cityscapes. I was an "artist" and wanted to capture those scenes for later sketching with my inks and charcoals. Little did I know then that the reference photos I took with my brother's camera would send me on a photographic journey that has lasted more than forty-five years. I have had far more adventures, chance encounters, and good fortune than should be legally allowed for a single lifetime. Of course, all of my adventures have not been without some setbacks, unbelievable obstacles, and momentous challenges, but somehow I'm still here churning out another edition of *Understanding Exposure*.

During those first five years, 1970 to 1975, I made it a point to write down *every* exposure for the reference photographs I took. When I would review each image, I knew which aperture I used and which shutter speed I used and was soon able to determine why one aperture in conjunction with a particular lens would produce a massive depth of field or a very narrow depth of field. I also knew which shutter speeds were capable of creating motion-filled water, windblown flowers and leaves, and razor-sharp action-stopping subjects. I was soon figuring out that in every picture-taking situation, I was presented with no fewer than six possible exposure options and those six exposure situations could easily be changed to a different set of six options merely by changing from one film to the other; an ISO of 50 produces a different set of six possible correct exposure options than does an ISO of 200 or an ISO of 640, and so on.

I soon found myself making a drawing of a triangle in one of my notepads, showing the three ingredients of every correct exposure: aperture, shutter speed, and the ISO. Of course at the heart of the triangle was the light meter, whose "job" is 100 percent dependent on the photographer's ability tell it which aperture or shutter speed he or she is using and how many "eyeballs" (ISO) he or she wishes to use for a particular scene. I mention all this for one very important reason: I emphatically believe today, just as I did back then, that if you will invest the time needed to understand the

vision of the photographic triangle and the many "creatively correct" exposures it offers, your mind will be truly free to create almost *any image* it can conceive in camera!

I am all too familiar with the phrase "the third time's a charm," and I honestly thought that when I finished the third edition of *Understanding Exposure*, it would be the *last* edition I'd write for one simple reason: I felt I had exhausted the subject of understanding exposure. Obviously I was wrong!

I am incredibly humbled by the response to the earlier editions, with combined sales of more than one million copies in seven different languages. With numbers like that one might ask, "Why mess with a winning formula?"

To be clear, I am not messing with the winning formula, but since the third edition of *Understanding Exposure* was released in 2009, even more changes have taken place in the photo industry. The one

change I readily welcome is the ease of using an electronic flash. One I don't appreciate as much is the extremely high dynamic range that many cameras are quickly approaching. In a single shot, a few of today's cameras' sensors are capable of capturing upward of 9 stops of light to dark exposure, and at this rate a sensor soon will be recording the human eye's ability to see a 16-stop range! This is a huge change from the days of film, when one might expect about a 5-stop range of light to dark. Why is this a problem? In some cases it will mean the end of the many beautiful sidelit landscapes of great contrast in which the strong highlights are in marked opposition to the deep and dense shadows. There will no more of this stark contrast because of the sensors' ability to create images that cover a much wider exposure and tonal range.

On the flip side of all this new technology, I am hearing from more and more amateurs who have

not only realized the limitations of their camera phones and are buying DSLRs but are also interested in "getting it right" in camera rather than relying on after-market software to clean up their exposure mistakes. In effect, it seems the trend today is akin to the days of film, when most, if not all, amateur photographers took pride in "owning" their creativity. They relied solely on their knowledge of the multitude of creative exposures that lie within the photographic triangle and a full understanding of the power of light, *including* the use of electronic flash. I have seen more evidence of "owning one's creativity" in the last twelve months than I have seen in the previous five years, and needless to say, I am thrilled. I am not, nor have I ever been, nor will I ever be a fan of automated exposures. And yes, beyond the choice to shoot in any automated camera-setting mode, my disdain for automation includes the use of highly manipulative photo software, with HDR (high dynamic range) being just one example.

I am pleased to say what some call my formula (what I call the photographic triangle) for award-winning exposures has not changed one iota since I first introduced it to a group of forty students way back in 1975. Despite the digital age we are in and will be living in for what I am guessing will be years and years to come, the formula for award-winning exposures is no different today from what it was in 1975 and even as far back as the 1930s.

A correct exposure was, is, and always will be a combination of *your* choosing the right-size hole in your lens (the aperture), and the right amount of time that light is allowed to remain on the digital sensor (shutter speed), and how both of these factors are influenced by your choice of ISO.

Back in the day, the pinhole camera proved to be a terrific method of recording an exposure (it was much like a hole in a lightproof shoe box that held a piece of light-sensitive film), and as far as I am concerned, the digital camera of today is nothing more than a lightproof shoe box with a piece of light-sensitive "film" inside. Granted, these cameras don't look like lightproof shoe boxes, but they perform in much the same way, albeit they record a single image a bit faster.

Now that the digital age of photography has grown up since the first introduction of the Kodak/Nikon DCS with its whopping 1.3-megapixel charge-coupled device (CCD), it's also fair to say that many shooters who are just starting out in photography are *more* confused than ever before, and for this I hold the camera manufacturers responsible.

Because of their attempts to make so much of the picture-taking process automated, the simple manual cameras of yesterday have been replaced by cameras reminiscent of the cockpit of a Boeing 747-400. I don't know about you, but I find the cockpit of a 747-400 amazingly intimidating! The once simple shutter speed dial on the camera body and the once simple aperture dial normally found on the lens have taken a backseat to dials that are crammed with "features" such as Landscape mode, Flower mode, Portrait mode, Aperture Priority mode, Action Sequence mode, Sports mode, Group Portrait mode, Shutter Priority mode, and Program mode, and there is even a bee on the Flower mode! Combine all that supposed automation with auto white balance, auto ISO, and auto flash and you've got a recipe for frustration. Attesting to this frustration are the many shooters who have discovered that automation works only sometimes and only with some subjects. As my email in-box shows on a daily basis, there is nothing worse or more embarrassing to a beginning photographer who has taken a really nice image than being asked how he or she did it and not having a clue.

Just last month, I received an email from a young man who had been selected to show his work in his office's cafeteria. He wrote me to say that he had no clue about exposure and was sure that once his prints were on display, many of his coworkers would begin to press him for information about his photographs that he did not have, such as aperture and shutter speed and even lens choice. I do not want to suggest that this is vitally important information that one needs to know to

take great photographs, but I believe it is vitally important information if one wishes to make great photographs consistently.

Understanding exposure is not hard at all, as more than 900,000 photographers all around the world have already discovered. The only requirement is that you throw away your camera's instruction manual *after* you reference it to learn one thing: how to set the controls to manual. Here is a clue: On every DSLR, you will find the symbol M, and when the dial is set to M, you are sitting in the copilot's seat, about to go on a maiden voyage. Sure, setting your camera to M might seem scary at first, but you should have no worries since I, the captain, am sitting right next to you. And once you begin to experience the freedom of truly flying on your own, you will be asking yourself, "What ever possessed me to think I couldn't do a manual exposure?" Honestly, it's that easy; I promise!

With manual exposure, the world of truly creative exposures will open up to you. You will discover the utter joy of owning your exposures from beginning to end, and taking part in their creation. The joy of that one image can last lifetimes as generations yet to come continue to enjoy the work you create!

Also, in this fourth edition of *Understanding Exposure*, all the photographs have been replaced. Not only does this give it a freshened up appearance, but I also have added two additional and invaluable subjects that have much to do with award-winning exposures: an expanded section on the ease and joy of shooting with electronic flash and shooting star trails, and a section on the use of flashlights as another tool for extremely creative in-camera exposure options!

Flash photography was touched on only briefly in the third edition of *Understanding Exposure,* and

many of you let me know that you wanted to see a more thorough discussion in this edition. As the saying goes, "Ask and you shall receive!"

Yes, I know the use of portable electronic flash is deserving of its own book, and that is why I wrote just such a book about three years ago. However, since that time even more amateurs have begun working with flash, most with utter confusion about how, when, and where to use it; this is all the more reason to include a simple and easy-to-understand section on using an electronic flash off camera.

I will add that the ease of using flash is, in my view, the only highlight the camera manufacturers have come up with that really deserves mentioning.

Simply put, automated TTL flash delivers on its promise of "foolproof flash exposure" far more often than not, and the information I am providing in this fourth edition of *Understanding Exposure* is more than enough to get you started down the road of creative flash exposure. If you want even more on the subject of flash, you can purchase my book *Understanding Flash*.

In closing, keep in mind that you are not alone in the confusion or frustration you will at times experience. If you ever need someone to talk to, I encourage you to get online with other like-minded shooters. One way to do that is to participate daily in a public forum in which just about anything photographic is discussed. A great place to do that is my site, www.youkeepshooting.com. Whether you have questions you would like to ask me, wish to contribute an answer, or simply want to upload photos for some honest feedback from your peers, it's a great resource for understanding exposure.

DEFINING
EXPOSURE

WHAT IS MEANT BY EXPOSURE?

Just as it was one hundred years ago and just as it was in 1970 when I made my first exposure, today every camera—whether digital or film—is nothing more than a lightproof box with a lens at one end and a digital card or light-sensitive film at the other. The same light enters the lens (the aperture), and after a certain amount of time (determined by shutter speed) an image will be recorded (on digital media or film). This recorded image has been called—since day 1—an exposure, and it still is.

Sometimes the word *exposure* refers to a finished image: "Wow, that's a nice exposure." At other times it refers to the digital card or film: "I've only got a few exposures left." But more often than not, the word *exposure* refers to the amount, and act, of light falling on photosensitive material (either a digital card or film). And in this context, it comes up most often as part of a question I've heard more often than any other: "Hey, Bryan, what should my exposure be?" (In other words, how much light should hit the digital media/film and

for how long?) My answer is always the same: "Your exposure should be correct."

Although my answer appears to be flippant, it really is *the* answer. A correct exposure is what every photographer, amateur and professional alike, hopes to accomplish with his or her camera.

Until about 1975, before many autoexposure cameras arrived on the scene, every photographer had to choose both an aperture and a shutter speed that, when correct, would record a correct exposure. The choices in aperture and shutter speed were directly influenced by the film's ISO (speed or sensitivity to light). Most photographers' exposures would be based on the available natural light, and when the available light wasn't enough, they'd resort to using flash or a tripod.

Today, most cameras are equipped with so much automation that they promise to do it all for you, allowing photographers to concentrate solely on what they wish to shoot. "Just keep this dial here set to P and fire away! The camera will do

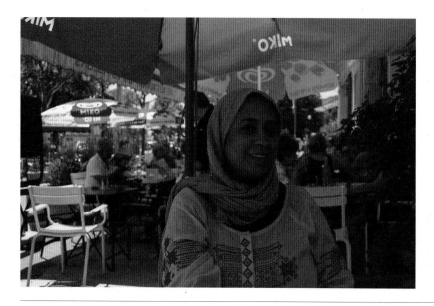
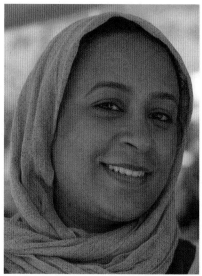

Both images: Nikon D800E, Nikkor 24–120mm, ISO 200, (left) 50mm, *f*/11 for 1/100 sec., (right) 120mm, *f*/5.6 for 1/400 sec.

everything else," says the enthusiastic salesperson at the camera shop. Oh, if only that were true! Most—if not all—of you who bought this book have a do-it-all-for-you camera, yet you still find yourself befuddled, confused, and frustrated by exposure. Why is that? It's because your do-it-all-for-you camera is not living up to that promise and/or you have finally reached the point at which you want to record correct photographic exposures consistently.

"There must be something wrong with this camera! One minute it makes a good picture, and the next it takes a bad picture." I am sure we can all relate to your frustration at trying to record a "perfect exposure," but let's start with a quick analysis of what you have just expressed. Your camera is a machine first and foremost, and despite all of its sophistication, it needs you to intervene if your end goal is to record a perfect exposure each and every time—and the only way you can expect a perfect exposure each and every time is to understand the "mechanics" of your camera.

So how come the close-up portrait of Rasha on the opposite page turned out to be a good exposure but the wider shot that shows her sitting outside in a café turned out too dark? Heck, one was taken right after the other!

The reason is simple, and it has everything to do with the camera's built-in light meter.

As you will learn, the light meter is a very sophisticated tool and quite sensitive to light; that's why it is called a light meter and not a dark meter. We'll of course go much deeper into the full understanding of exposure, but suffice it to say that the camera's light meter was presented with nothing but even light in the full-frame portrait of Rasha and thus responded with a correct exposure. But when I widened my angle of view, the light meter was now being presented with both a lot of bright and shadow, and when given a choice, even today's most sophisticated cameras will get fooled and render an exposure that is sometimes too dark or even too bright.

The first thing you are about to learn is the need to get familiar with manual exposure settings. Not only will these manual settings offer you a chance at foolproof exposure, you will begin to take credit for the most "creative" exposure that every scene or subject offers!

SETTING AND USING YOUR CAMERA ON MANUAL EXPOSURE

I know of no other way to make correct exposures consistently than to learn how to shoot a fully manual exposure. Once you've learned how to shoot in manual exposure mode (it's really terribly easy), you'll better understand the outcome of your exposures when you choose to shoot in semi- or full autoexposure mode.

With your camera and lens in front of you, set the camera dial to M for manual. (If you're unsure how to set your camera to manual exposure mode, read the instructions.) Get someone to use as your subject and go to a shady part of your yard or a neighborhood park; if it's an overcast day, anywhere in the yard or park will

do. Regardless of your camera and regardless of the lens you're using, set the lens opening to the number 5.6 (f/5.6). Place your subject up against the house or some six- to eight-foot shrubbery. Now look through the viewfinder and focus on your subject. Adjust your shutter speed until the camera's light meter indicates a "correct" exposure in the viewfinder and take the photograph. You've just made a manual correct exposure!

Operating in manual exposure mode can be empowering, so make a note of this memorable day!

THE PHOTOGRAPHIC TRIANGLE

The last thing I want you to do is forever leave your camera's aperture at f/5.6 and simply adjust the shutter speed for the light falling on your subject until the viewfinder indicates a correct exposure. Before you forge ahead with your newfound ease in setting a manual exposure, you need to learn some basic concepts about exposure.

A correct exposure is a simple combination of three important factors: aperture, shutter speed, and ISO. Since the beginning of photography, these three factors have always been at the heart of every exposure, whether that exposure was correct or not, and they still are today—even with digital cameras. I refer to them as *the photographic triangle*.

Locate the button, wheel, or dial on your camera or lens that controls the aperture. If you're using an older camera and lens, the aperture control is a ring that you turn on the lens itself. Whether you push buttons, turn a wheel, or rotate a ring on the lens, you'll see a series of numbers coming up in the viewfinder or on the lens itself. Among all the numbers you'll see, take note of 4, 5.6, 8, 11, 16, and maybe even 22. (If you're shooting with a fixed-zoom-lens digital camera, you may find that your apertures don't go past 8 or maybe 11.) Each one of these numbers corresponds to a specific opening in your lens, and those openings are called f-stops. In photographic terms, the 4 is called f/4, the 5.6 is f/5.6, and so on. The primary function of these lens openings is to control the volume of light that reaches the digital media or film during an exposure. The *smaller* the f-stop number, the *larger* the lens opening; the *larger* the f-stop number, the *smaller* the lens opening.

For the technical-minded out there, an f-stop is a fraction that indicates the diameter of the aperture. The f stands for the focal length of the lens, the slash (/) means "divided by," and the number represents the stop in use. For example, if you were shooting with a 50mm lens set at an aperture of f/1.4, the diameter of the actual lens opening would be 35.7mm. Here, 50 (lens focal length) divided by 1.4 (stop) equals 35.7 (diameter of lens opening). Whew! It makes my head spin just thinking about all that. Thank goodness this has very little, if anything, to do with achieving a correct exposure.

Interestingly enough, each time you descend from one aperture opening to the next, or *stop down*, such as from f/4 to f/5.6, the volume of light entering the lens is cut in half. Likewise, if you change from an aperture opening of f/11 to f/8, the volume of light entering the lens doubles. Each halving or doubling of light is referred to as a full stop. This is important to note since most cameras today offer not only full stops but also the ability to set the aperture to one-third stops: **f/4**, f/4.5, f/5, **f/5.6**, f/6.3, f/7.1, **f/8**, f/9, f/10, **f/11**, and so on. (The boldfaced numbers represent the original, basic stops, and the others are the newer one-third options that are also available as a custom setting that is found in your camera's menu.)

Now let's turn to shutter speed. Depending on the make and model, your camera may offer shutter speeds from a blazingly fast 1/8000 sec. all the way down to 30 seconds. The shutter speed controls the amount of time that the volume of light coming through the lens (determined by the aperture) is allowed to stay on the digital media or film in the camera. The same halving and doubling principle that applies to aperture applies to shutter speed.

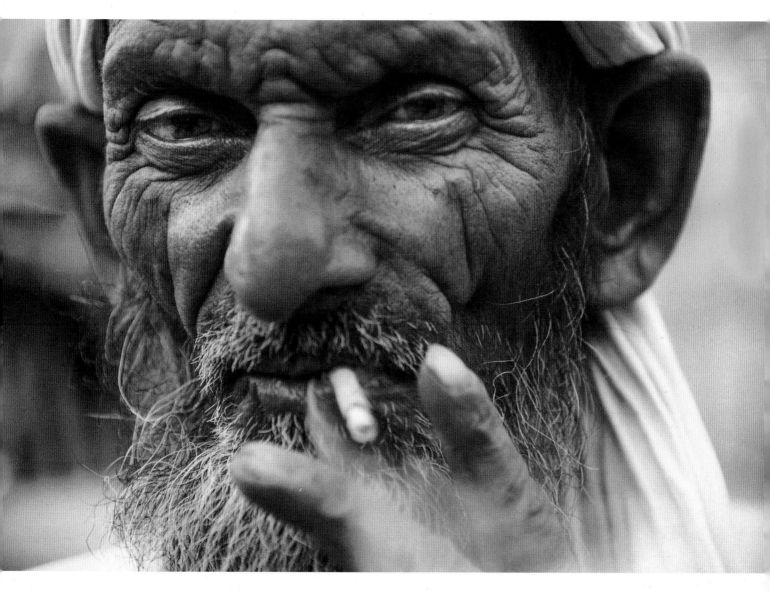

There are many beautiful places throughout the world, but Chandni Chowk market in Old Delhi, India, is on my top-ten list. My impression of beauty goes far beyond the landscapes of Burma or the imposing rocky shorelines of southern New Zealand. I find people far more stunning than most landscapes, as was the case when I came upon this *tuk-tuk* driver. This was a rare instance in which I walked up to this man, handholding my camera and lens and filling the frame as you see here, and fired off three shots. Only then did I open my mouth and introduce myself—a case of shoot first, ask questions later!

You will note that this image has a very limited area of sharpness. The only thing that could be considered sharp and in focus is his right eye. This was deliberate and 100 percent under my control, due to my choice to use the largest lens opening on my 24-120mm lens, which when combined with focusing close, produced the very narrow area of sharpness, or depth of field.

Nikon D800E, Nikkor 24–120mm at 120mm, *f*/4 for 1/320 sec., ISO 200

Let me explain. Set the shutter speed control on your camera to 500. This number denotes a fraction—500 represents 1/500 sec. Now change from 500 to 250; again, this represents 1/250 sec. From 1/250 sec. you go to 1/125, 1/60, 1/30, 1/15, and so on. Whether you change from 1/30 sec. to 1/60 sec. (decreasing the time the light stays on the digital media/film) or from 1/60 sec. to 1/30 sec. (increasing the time the light stays on the digital media/film), you've shifted a full stop. This is important to note since most cameras today also offer the ability to set the shutter speed to one-third stops: **1/500 sec.**, 1/400 sec., 1/320 sec., **1/250 sec.**, 1/200 sec., **1/160 sec.**, 1/125 sec., 1/100 sec., 1/80 sec., **1/60 sec.**, and so on. (Again, the boldfaced numbers represent the original basic stops, and the others are the newer one-third options that sometimes are available.) Cameras that offer one-third stops reflect the camera industry's attempts to make it easier for you to achieve "perfect" exposures. But as you'll learn later on, it's rare that one wants a perfect exposure.

The final leg of the triangle is ISO. Whether you shoot with a digital or a film camera, your choice of ISO has a direct impact on the combination of apertures and shutter speeds you can use. It's so important that it warrants its own discussion and exercise.

A trip to the "Pink City" of Jaipur should not be passed up. Once inside the main walls, you will find an abundance of colorful shops and very friendly shopkeepers.

Note the light in this scene. It is even throughout and thus is an easy exposure for today's most basic digital cameras. So why did I insist on shooting this easy exposure in manual exposure mode? Because it's a habit to do so, and it is very easy to do.

When shooting in manual mode I have full control over what is called the depth of field, and as you will soon learn,

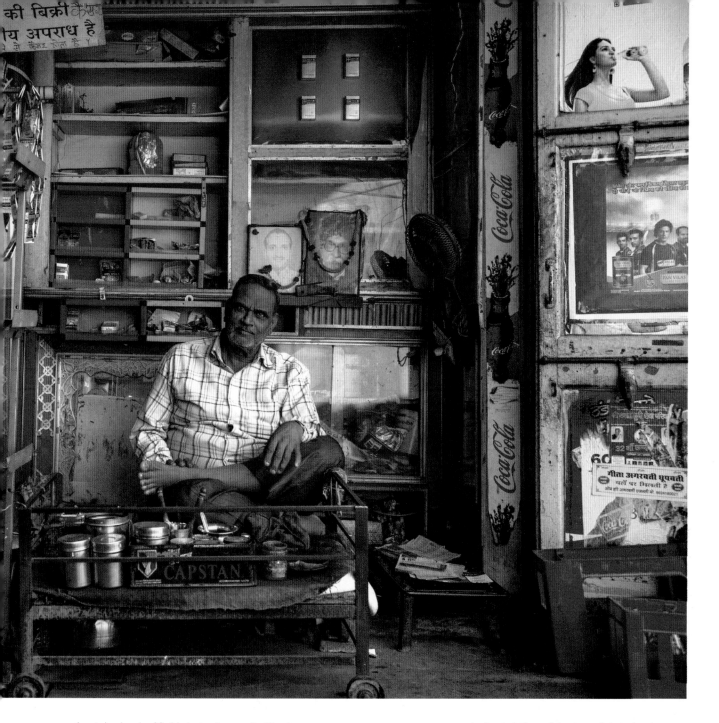

the right depth of field choice (controlled by the aperture, lens choice, and camera-to-subject distance) is often vital to a picture's success.

Ironically, there are no real depth-of-field concerns in this image, and in their absence, I was free to call upon the "who cares?" apertures of *f*/8, *f*/9, *f*/10, and *f*/11. More about these "who cares?" apertures on page 54, but after selecting the aperture of *f*/8 for this picture, I raised the camera to my eye, aimed, focused (yes, manually focused too!), and then adjusted the shutter speed until a correct exposure was indicated. One of the joys of digital is the immediacy of the image, which allows us to get instant feedback and to share the results with our willing subjects. Once he saw his picture, the shopkeeper was quick to offer me his email address, and I was just as quick to email him a copy!

Nikon D800E, Nikkor 24–120mm at 32mm, *f*/8 for 1/200 sec., ISO 100

EXERCISE: UNDERSTANDING ISO

To better understand the effect of ISO on exposure, think of the ISO as a worker bee. If my camera is set for ISO 100, I have in effect 100 worker bees, and if your camera is set for ISO 200, you have 200 worker bees. The job of these worker bees is to gather the light that comes through the lens and make an image. If both of us set our lenses at the same aperture of f/5.6—meaning that the same volume of light will be coming through our lenses—who will record the image the fastest, you or me? You will, since you have twice as many worker bees at ISO 200 as I do at ISO 100.

How does this relate to shutter speed? Let's assume the scene in question is a lone flower on an overcast day. Remember that your camera is set to ISO 200 and mine to ISO 100, both with an aperture of f/5.6. Therefore, when you adjust your shutter speed for a correct exposure, 1/250 sec. is indicated as "correct," but when I adjust my shutter speed for a correct exposure, 1/125 sec.—a longer exposure—is indicated. This is because your 200 worker bees need only half as much time as my 100 worker bees to make the image.

Since this is an important part of understanding exposure, I want you to put the book down for a moment and get out your camera, as well as a pen and paper. Set the ISO to 200. (Do this even if you're still using film and have a roll in your camera that's not ISO 200; don't forget to set the ISO back to the correct number when we're done here.) Now set your aperture opening to f/8, and with the camera pointed at something that's well illuminated, adjust the shutter speed until a correct exposure is indicated in the viewfinder by the camera's light meter. (If you want, you can leave the camera in Aperture Priority mode for this exercise, too.) Then change your ISO again, this time to 400, leaving the aperture at f/8, and once

again point the camera at the same subject. Whether you're in manual mode or Aperture Priority mode (indicated by the letter A or by Av, depending on your camera), you'll see that your light meter is indicating a different shutter speed for a correct exposure. Once again, write down this shutter speed. Finally, change the ISO to 800 and repeat the steps above.

What have you noticed? When you changed from ISO 200 to ISO 400, your shutter speed changed from 1/125 sec. to 1/250 sec. or perhaps from something like 1/160 sec. to 1/320 sec. These shutter speeds are examples, of course, and without knowing what your subject was, it's difficult to determine your actual shutter speeds, but one thing is certain: each shutter speed is close to, if not exactly half as much as, the one before it.

When you increase the number of worker bees (the ISO) from 200 to 400, you cut the time necessary to get the job done in half. (If only the real world worked like that!) This is what your shutter speed was telling you: going from 1/125 sec. to 1/250 sec. is setting half as long an exposure time. When you set the ISO to 400, you went from 1/125 sec.—passing by 1/250 sec.—and ended up at 1/500 sec. Just as each halving of the shutter speed is called 1 stop, each change from ISO 200 to ISO 400 to ISO 800 is considered a 1-stop increase (an increase of worker bees).

You can do this exercise just as easily by leaving the shutter speed constant, for instance, at 1/125 sec., and adjusting the aperture until a correct exposure is indicated in the viewfinder; or, if you choose to stay in autoexposure mode, select Shutter Priority, set a shutter speed of 1/125 sec., and the camera will set the correct aperture for you.

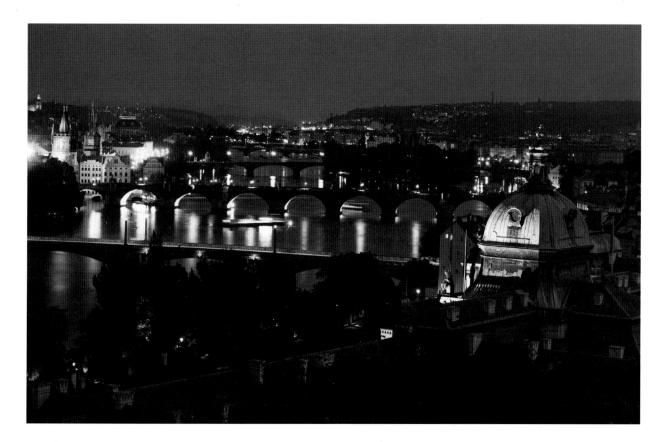

Prague is a European city that will always maintain a certain allure and mystery, a city that remained unscathed by the physical destruction of World War II. At almost every turn a photographic opportunity presents itself.

I had been to Prague five times before I finally made certain to shoot its many bridges at dusk from Letenské sady (Letná Park).

With my ISO set to 200 and my aperture set to $f/11$, I raised the camera up toward the dusky blue sky and adjusted my shutter speed until 4 seconds indicated a correct exposure. I then recomposed and, with the camera's self-timer engaged, fired the shutter release.

I could have shot this scene at other correct exposures—$f/16$ for 8 seconds or $f/22$ for 16 seconds—but intentionally chose not to. First, the motion of the river and boat, car, and train traffic was minimal at best. And this minimal movement did *not* look any different at 8 or 16 seconds than it does at the 4 seconds you see here. If the results of an 8- or 16-second exposure will look the same as those of a 4-second exposure, why not shoot at the shorter exposure?

When you are shooting any composition with a hint of motion, ask yourself, "Just how long of an exposure do I need to convey the motion here?" When you are shooting a busy highway against a backdrop of a city skyline, a 16-second exposure might makes sense. But when you are shooting a frame filled with primarily stationary subjects and only a hint of moving traffic (cars, boats, and trains), the 4-second exposure you see here is sufficient.

Additionally, I seldom use those "super-high" ISOs, such as 1600. Despite promises made by the likes of Nikon and Canon that these high ISOs have a very low noise factor (which they do), they are seldom practical in the world of creative exposures. As this shot demonstrates, I was able to get the smooth-water effect I wanted at 4 seconds and $f/11$ with ISO 200. And as you will learn soon, $f/11$ is considered a "who cares?" aperture, meaning that optical sharpness reigns supreme at this setting. If I had been using a high ISO such as 1600 and wished to shoot at $f/11$, my correct exposure would have been 1/2 sec., and at that 1/2-sec. exposure, there would not be smooth water and the overall color and contrast wouldn't be nearly as vivid.

Nikon D800E, Nikkor 70–300mm at 280mm, $f/11$ for 4 sec., ISO 200

THE HEART OF THE TRIANGLE: THE LIGHT METER

Now it's time to introduce you to what I call the heart of the photographic triangle: the light meter. At the center of every exposure is your camera's light meter, which is a precalibrated device designed to react to any light source no matter how bright or dim that light source may be.

In the example of Prague and its many bridges on the previous page, the camera's light meter knew that the aperture was set to *f*/11, and it also knew that the ISO was set to 200. As a result, it reacted and directed me to adjust the shutter speed; then, as I adjusted the shutter speed dial while pointing it at the dusky blue overhead, an indication of a "correct exposure" was offered up in the viewfinder, and that is when I knew that according to my light meter I had reached the correct shutter speed. It's the light meter that is ultimately behind the calculations of every correct photographic exposure.

To set this idea in stone, let me offer this final illustration: Imagine that your lens opening, say, *f*/11, is the same diameter as your kitchen faucet opening. Now imagine that your faucet handle is your shutter speed dial and that waiting in the sink below are 200 worker bees, each with an empty bucket. The water coming through the faucet is the light. It's the job of the camera's light meter to indicate how long the faucet stays open to fill up all the buckets of the waiting worker bees below. The light meter knows that there are 200 worker bees and that the opening of the faucet is *f*/11. With this information, the light meter can now tell you *how long* to leave the faucet open, and assuming that you turn on the faucet for this correctly indicated

amount of time, you will record a correct exposure. In effect, each worker bee's bucket is filled with the exact amount of water necessary to record a correct photographic exposure.

What happens if the water (the light) is allowed to flow longer than the light meter says? The buckets will become overfilled with water (too much light). In photographic terms, this is called an *overexposure*. If you've ever taken an overexposed image, you've undoubtedly commented that the colors look "washed out." Conversely, what happens if the water (the light) coming through the faucet is not allowed to flow as long as the light meter says? The buckets will get only a few drops (not enough light). In photographic terms, this is an *underexposure*. If you've ever taken an underexposed photo, you've found yourself saying, "It's hard to see what's there since it's so dark."

Now that you have learned how simple the basic concept of exposure is, is it safe to say you can record perfect exposures every time? Not quite, but you're closer than you were when you started reading this book. You can certainly say that you understand how an exposure is made, and you now understand the relationship between *f*-stops, shutter speeds, and ISOs. However, most picture-taking opportunities rely on the *one* best aperture choice or the *one* best shutter speed choice. What's the *one* best aperture? The *one* best shutter speed? Learning to "see" the multitude of creative exposures that exist is a giant leap toward photographic maturity.

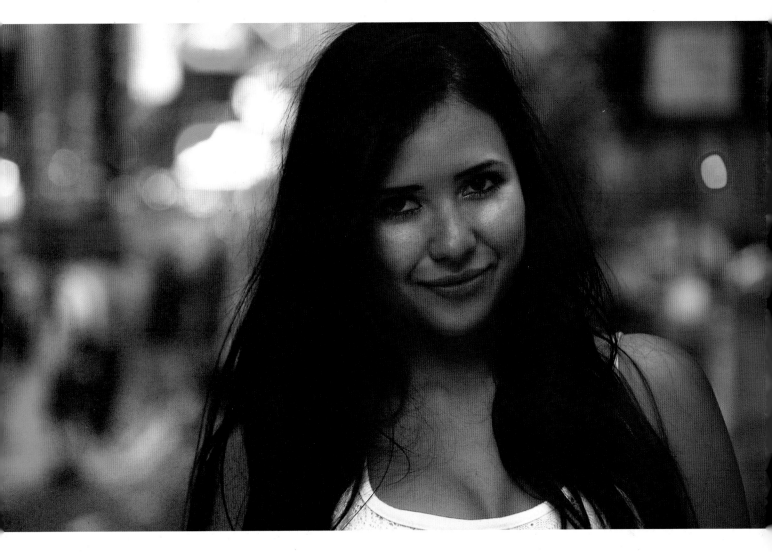

As I raised my camera to my eye and framed the model, Diana Praha, the light meter was quick to "see" the soft light falling on Diana's face, but as I moved the camera and lens a bit to the left and right, the light meter was quick to react to the brighter out-of-focus lights of Times Square behind her.

To maintain a correct exposure, I determined that the light on Diana's face was far more important than the brighter lights behind her. She was the subject! So I made the choice to move in close to her, filling up the frame with just her face and setting my exposure for this light only. With this emphasis on her, I chose to use the large lens opening of f/5.6 to keep the depth of field to a minimum. At f/5.6, my light meter indicated a correct exposure for

the light on her face of 1/80 sec., with an ISO of 200. It was then that I backed off a bit to include some of the bright lights behind her. At this point, the sensitive light meter reacted to the inclusion of those distant lights and was indicating that I was about to shoot a 1-stop overexposure. I ignored this indication since I knew that the light meter was "just doing its job," and since I was in full manual exposure mode (M), I would go ahead and shoot at that manual exposure setting of f/5.6 at 1/80 sec. It was the right choice!

Nikon D800E, Nikkor 70–300mm at 300mm, f/5.6 for 1/80 sec., ISO 200

UNDERSTANDING THE EXPOSURE INFORMATION IN YOUR VIEWFINDER

What do I mean when I say, "I then adjusted the shutter speed until a correct exposure was indicated"? And how will *you* know when a correct exposure is indicated? When you look through your camera's viewfinder while you are in *manual exposure mode*, you'll see your light meter indicating whether there is an overexposure (the tracking dot is on the *plus* side) or an underexposure (the tracking dot is on the *minus* side). Your goal is to simply adjust your shutter speed (or, in some cases, your aperture) until the tracking dot is at 0.

Sometimes you may not be able to get a "dead-center" exposure indication because of various and changing light values in your scene. If you're within 1/3 or even 2/3 of a stop, your exposure in all likelihood will turn out just fine—*as long as you set the exposure on the minus side* (bottom right image). Whenever possible, you want to avoid "blown highlights," and shooting exposures that are a wee

bit underexposed is more favorable than shooting exposures that are overexposed.

Note: Shooting in Shutter Priority or Aperture Priority mode eliminates the need to align the tracking dot at 0, because the camera will "automatically" set the correct exposure for you—in theory, at least. Also, by default, the camera make determines which side of 0 is plus (+) and which is minus (–); on Canon, for example, the plus (+) is often to the right of 0 and the minus (–) is to the left. Also, some cameras, including Canon and Nikon, offer models that display the exposure information on the right side of the viewfinder instead of at the bottom. Finally, most of you can customize your light meter display indicators so that the + or – falls on the side you are more comfortable with: the right or the left. The ability to do this is usually found in the menu under "Custom Functions."

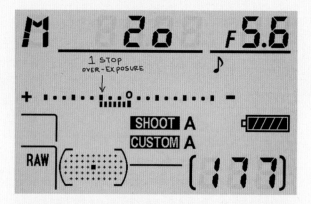

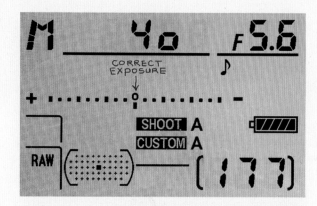

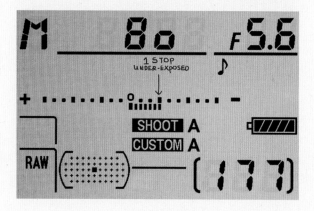

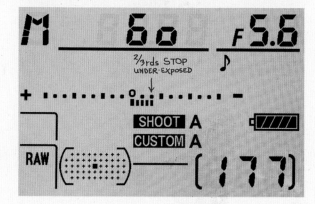

WHITE BALANCE

Are you confused about white balance? It's my opinion that next to the histogram (aka "hysteria-gram"), the white balance (WB) setting is one of the most overrated controls on a digital camera. I have actually seen forums on the Internet discussing white balance, and there are some very strong feelings by some about the importance of white balance in your photography. But until someone can show me otherwise, I will continue leaving my white balance set to Sunlight 99 percent of the time when shooting in natural light. (The other 1 percent I might use Tungsten or Flourescent, for interiors or cityscapes at dusk or dawn).

Before I get to what exactly white balance is and to my one chosen setting of Daylight, I want to briefly discuss the colors red, green, and blue, along with color temperature. Every color picture ever made has some degree of each of these colors in it, but how much depends on the color temperature of the light. Yes, that's right. Light, just like the human body, has a temperature. Unlike the human body, though, the temperature of light is measured by its color, and this is where it gets kind of funny. Blue light has a higher temperature than red light in photography. If you were red in the face, you'd probably also have sweat coming out of your pores, and anyone who looked at you would say, "You're burning up!" Not so with the temperature of light.

Color temperature is measured by what is called the Kelvin scale, which is nothing more than an extension of the Celsius scale. On any particular day, the color temperature of the light that falls on our world is measured in degrees Kelvin (K), from roughly 2,000 K to 11,000 K. A color temperature between 7,000 and 11,000 K is considered "cool" (bluer shades would fall in this range), a color temperature between 2,000 and 4,000 K is considered "warm" (reds would fall in this range), and a color temperature between 4,000 and 7,000 K is considered "daylight" (or the combination of red, green, and blue).

Cool light is found on cloudy, rainy, foggy, or snowy days and in areas of open shade on sunny days (the north side of your house, for example). Warm light is found on sunny days, beginning a bit before dawn and lasting for about 2 hours tops and then beginning again about 2 hours before sunset and lasting for another 20 or 30 minutes after the sun has set.

During my last 6 years of using film, I made 90 percent of my images with Fujichrome Velvia and Kodak's E100VS, both of which are highly saturated color slide films. One of the problems I had with digital photography in the beginning was its inability to produce in the raw file these highly saturated colors—until I stumbled upon the Cloudy white balance setting, that is.

Over the years, I found myself out shooting film in overcast, rainy, snowy, foggy, or open-shade/sunny-day conditions. To eliminate much of the blue light present at those times, I would use my 81-A and 81-B warming filters. They would add red to a scene, in effect knocking down, if not out, the blue light. I prefer my images warm.

That brings me to my current choice in white balance settings: Daylight. Until recently, and as was the case when using my Nikon D3X and my D300, I would leave my white balance (WB) on Cloudy since it would replicate the effect of using warming filters. But with the purchase of my current camera, the Nikon D800E, I found that a Cloudy WB is now too warm! With my new Nikon D800E and a much warmer color processor, I now use the Daylight WB setting for almost everything; it's not too warm and not too cool, but as Goldilocks is fond of saying, "it's just right!" (If you also feel that the Cloudy white

balance setting is a bit much, you should consider Daylight too, but oh my, *please* do not remain on Auto WB. In fact, the aim of this book is to get you off of anything marked with A, including autofocus, Auto-ISO, Auto-Exposure, and of course Auto WB! Yes, I know you can always change your WB in the postprocessing phase, assuming, of course, that you're shooting in raw mode (if you are not shooting in RAW, you should be!), but in the interest of saving time, just set your WB to Cloudy or Daylight for most of your outdoor photo shooting. Again, *when* you have the occasional image that needs some WB adjusting, you can do it in postprocessing.

Perhaps you're shocked by my white balance choice, but hear me out. I seldom, if ever, shoot interiors, whether they're lit by available daylight, tungsten, fluorescent, sodium, or mercury vapor. *If* I were shooting interiors that had a great deal of artificial light, then and *only* then would I shift my white balance to the appropriate setting—for example, Tungsten/Incandescent (for ordinary household lighting) or Fluorescent (for ordinary office lighting). I am, for the most part, a natural light photographer, as most of the photographs in this book illustrate. The only exception to this is when I call upon my Nikon SB-900 flashes. As you will discover, in the last chapter of this book, there are a number of creative opportunities to call upon your flash. Some of those flash images were shot with the WB in Tungsten/Incandescent, Cloudy, and Sunlight.

I'm also a "very specific time of day" photographer. On sunny days, I shoot in the early morning or from late afternoon to dusk. Midday light, between 11:00 a.m. and 3:00 p.m., is what I call poolside light, and if there's a pool nearby, that's where you'll find me—sitting by the pool, with a bit of sunblock, of course.

My Daylight white balance setting seldom changes whether I shoot on a sunny, cloudy, rainy, foggy, or snowy day. And in case you're convinced that I'm truly an idiot, don't forget that if I determine on those rarest of occasions—and I want to stress *rare*—that I might have been better off with a different WB setting, I can always change it in postprocessing after downloading my raw images into the computer.

I want to add an important note here. Most shooters are out shooting at midday, when the light is harsh and not warm at all, and the added warmth from a Cloudy WB setting (that's usually associated with early or late times of day) will surely get your attention. You can fool your friends into thinking that you've become a morning person or that you were out shooting in late-afternoon light, but watch out for the discerning eye! Morning and late-afternoon light reveals lots of long shadows, whereas midday light is "shadowless."

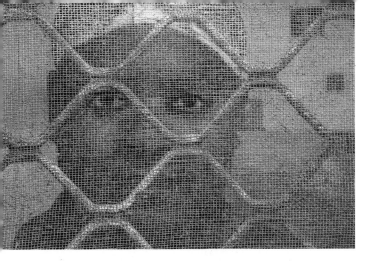

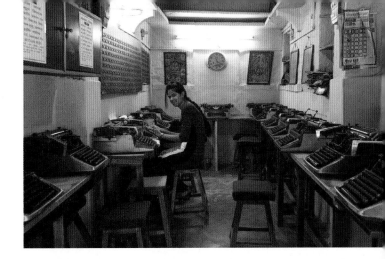

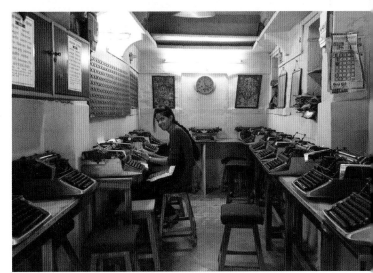

This image is a classic example of midday overcast light. I was conducting a workshop in Dubai, and we came upon a cook who was outside smoking a cigarette. I suggested that we pose him in front of the screen door that leads into the kitchen at the restaurant where he cooks. The use of the screen door adds some welcome lines and textures to what otherwise would be a fairly static portrait.

The tendency here would be to choose a Cloudy WB, which I often do when using my Nikon D3X and D300S. But as you can see, unlike the welcome warmth offered up when one is using a Cloudy WB with those two cameras, the D800E delivers far too much warmth in Cloudy WB. When seen here together, the excessive warmth of Cloudy is obvious (top). A Sunny WB has proved to be the best way to go, at least for me. The choice is, of course, a personal one, but if you haven't considered shooting with your white balance set to Sunny, it might be worth a look.

Both images: Nikon D800E, Nikkor 24–120mm at 75mm, f/8 for 1/125 sec., ISO 200

Just when I think I have this WB issue figured out, I am thrown a curve and the argument for using Auto WB raises its ugly head. But I am an honest guy, so I must confess that even I have resorted at times, sparingly, to using one of the A settings on my camera. On this day, my use of Auto WB was in response to a unique lighting situation that I came upon at a typing school on the streets of Old Jodhpur. Anyone with my experience would quickly deduce that the lights inside this room were old-fashioned fluorescent lights, and so I was quick to shoot a few frames in the Flourescent WB setting without bothering to check the results; as I was about to move on, I took a quick look and was aghast to discover that every picture had a magenta cast (top)! How is that possible? Oh my, you don't suppose that these fluorescent lights were closer to Daylight in terms of the Kelvin scale? At a time like this, just throw caution to the wind and set the WB to Auto and see what happens. That is exactly what I did, and as near as I can tell, the camera got it right.

Both images: Nikon D800E, Nikkor 24–120mm at 29mm, f/16 for 1/25 sec., ISO 640

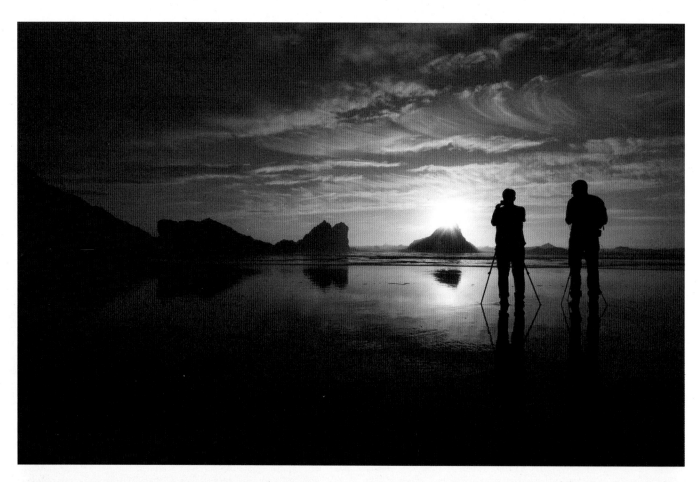

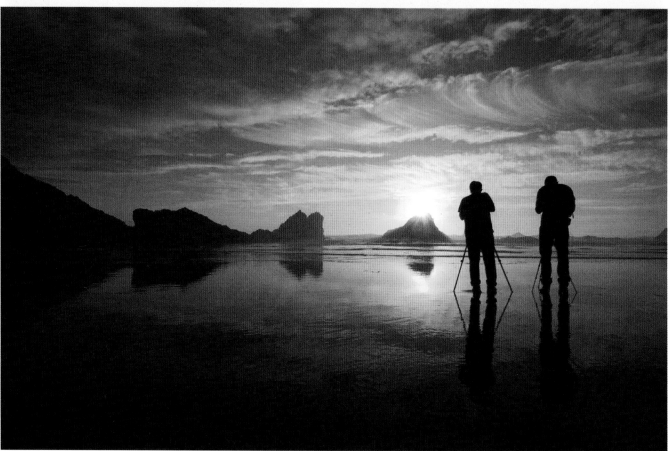

Because the Daylight WB setting imparts a more natural and richer overall feel to my images, I will shoot 99 percent of my images on Sunny when outdoors, 24/7, rain or shine, sunny or cloudy. But when I shoot at dusk, I'll often switch over to the Tungsten WB setting and shoot at least one or two exposures and then switch over to Shade WB and take a few pictures. Then I can compare how the much deeper dusky blue sky I get in Tungsten affects the overall composition and compare that with the much more golden and warmer colors generated by the Shade WB setting.

As an example, the only difference in these first two photographs of several of my students at a workshop on the shores of Seal Rock State Park in Oregon is the white balance setting. Both images were shot at the same exposure with the same lens, but the first one (top, left) was taken with the Tungsten WB setting and is certainly cooler than the second image (bottom, left), which was taken moments later with the Shade WB setting. To enlighten you even more about the wonders of your WB choice, consider the final image (above), which was shot at a Flourescent WB setting *and* with the addition of an FLW magenta filter.

Granted, if you're shooting in raw format and forget to try out the Tungsten setting, you can always change it in postprocessing, but for those of you shooting *only* in JPEG format, this is the time to try both Shade and Tungsten WB settings. (Some camera manufacturers also call the Tungsten setting Incandescent, and its WB symbol is the light bulb shape in your WB menu.)

All images: Nikon D800E, Nikkor 24–120mm at 28mm, f/16 for 1/160 sec., ISO 100

SIX CORRECT EXPOSURES VERSUS ONE CREATIVELY CORRECT ONE

It's not uncommon to hear at least one student in my on-location workshops say to me, "What difference does it make which combination of aperture and shutter speed I use? If my light meter indicates a correct exposure, I'm taking the shot!" Perhaps you are like this, too. Whether you shoot in Program mode, Shutter Priority mode, Aperture Priority mode, or even manual mode, you may think that as long as the light meter indicates that a correct exposure has been reached, it must be okay to shoot.

The trouble is that this kind of logic makes about as much sense as deer hunters who fire off their rifles at anything that moves. They may eventually get a deer, but at what cost? If you want to shoot only "correct" exposures of anything and everything, be my guest. Eventually, you might even record a *creatively* correct exposure. But I'm assuming that most of you who bought this book are tired of the shotgun approach and want to learn how to *consistently record creatively correct exposures*.

Most picture-taking situations have at least six possible combinations of f-stops and shutters speeds that will *all* result in a correct exposure. Yet normally, *just one* of these combinations of f-stops and shutter speeds is the creatively correct exposure.

As we've already learned, every correct exposure is nothing more than the quantitative value of an aperture and a shutter speed working together within the confines of a predetermined ISO. But a creatively correct exposure *always* relies on *the one f-stop* or *the one shutter speed* that will produce the desired exposure.

Let's pretend for a moment that you're at the beach taking pictures of the powerful surf crashing against the rocks. You're using an ISO of 100 and an aperture of f/4. After adjusting the shutter speed, you get a correct exposure (indicated in the viewfinder) of 1/500 sec. This is just one of your exposure options. There are other combinations of apertures (f-stops) and shutter speeds you can use and still record a correct exposure. If you cut the lens opening in half with an aperture of f/5.6 (f/4 to f/5.6), you'll need to increase the shutter speed a full stop (to 1/250 sec.) to record a correct exposure. If you use an aperture of f/8, again cutting the lens opening in half, you'll need to increase the shutter speed again by a full stop (1/500 sec. to 1/125 sec.). Continuing in this manner would produce the following pairings of apertures and shutter speeds to achieve a correct exposure: f/11 at 1/60 sec., f/16 at 1/30 sec., and finally f/22 at 1/15 sec. That's six possible correct exposures for the scene—six possible combinations of aperture and shutter speed that will all result in exactly the same exposure. I want to stress that the word *same* here means the same in terms of *quantitative value only*! Clearly, a picture of crashing surf taken using f/4 at 1/500 sec. would capture action-stopping detail of the surf as it hits the rocks; a correct exposure of that surf using f/22 at 1/15 sec., in contrast, would capture less action-stopping detail and show the surf as a far more fluid and wispy, somewhat angelic element.

This creative approach toward exposure will reap countless rewards *if* you get in the habit of looking at a scene and determining what combination of aperture and shutter speed will render the most dynamic and creative exposure for that subject. The choice in exposure is always yours, so why not make it the most creative exposure possible?

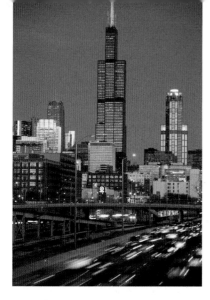

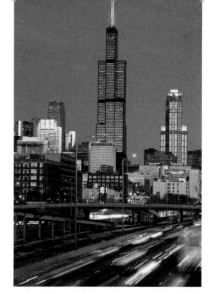

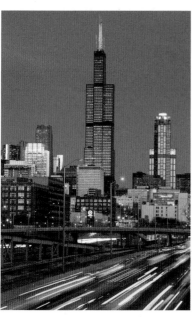
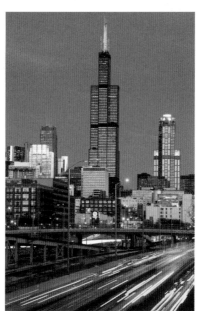
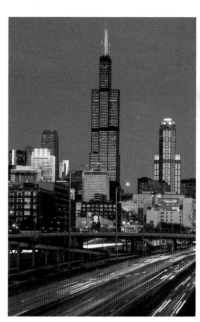

Shooting Chicago traffic at 5 p.m. and at dusk means you will find yourself out on the streets during the harsh cold of a Chicago winter. Granted, the combined time to shoot a series of shots like this, from setup to finish, was all of 8 minutes, but with a wind chill of –28 degrees Fahrenheit, it doesn't take long at all to lose feeling in your fingers and toes!

As you look at all six of these quantitatively *identical* exposures, what do you notice in their overall appeal? There is a distinct difference between the first exposure (top, left), made at f/4 for 1/2 sec., and the last exposure (bottom, right), made at f/22 for 15 seconds. That difference lies in the traffic flow as indicated by the sea of taillights.

Keep in mind that each of these images is a 100 percent correct exposure. The quantitative value of each of these shots *is the same*, and the sea of red taillights that becomes more evident as the exposure time increases is the result of using an aperture and a shutter speed that allowed for a long and creatively correct exposure!

An exercise such as this is truly eye-opening. The next time you head out to shoot a city skyline with an emphasis on the traffic, don't hesitate to use the slower shutter speeds, since the ones with the slower shutter speed are the most creative and interesting.

All images: Nikon D800E, Nikkor 70–300mm at 80mm, ISO 100, (top, left) f/4 for 1/2 sec., (top, middle) f/5.6 for 1 sec., (top, right) f/8 for 2 sec., (bottom, left) f/11 for 4 sec., (bottom, middle) f/16 for 8 sec., (bottom, right) f/22 for 15 sec.

EXERCISE: SEEING THE CREATIVELY CORRECT EXPOSURE

One of the best lessons I know is very revealing. Not surprisingly, it will lead you farther into the world of creatively correct exposures. Choose a stationary subject such as a flower or have a friend stand for a portrait. Also choose a moving subject such as a waterfall or a child jumping. If possible, photograph on an overcast day and choose compositions that crop out the sky so that it is not part of the scene.

With your camera and lens mounted on a tripod and your ISO at 200, put your camera in manual exposure mode. Get used to being in manual mode, as this is where you'll now be spending all of your "quality time." Now set the aperture wide open—that will be the smallest number on your lens, such as $f/2$, $f/2.8$, $f/3.5$, or $f/4$. Do your best to fill the frame with your stationary subject (whether the flower or the portrait), adjust your shutter speed until a correct exposure is indicated (in the viewfinder), and then shoot one frame.

Now decrease your aperture 1 stop (for example, from $f/4$ to $f/5.6$), readjust your shutter speed 1 stop to maintain a correct exposure, and shoot one frame. Then change the aperture from $f/5.6$ to $f/8$ and so on, each time remembering to change the shutter speed

to keep the exposure correct. For each exposure, write down the aperture and shutter speed you used. Depending on your lens, you will have no fewer than six different aperture/shutter speed combinations, and even though each and every exposure is exactly the same in terms of its quantitative value, you should certainly notice a difference in the overall definition and sharpness of the images. A once-lone subject is really "alone" only in a few frames; it gets lost in a sea of background when you use apertures of $f/16$ and $f/22$. A portrait picks up some distracting elements in the background, too, when you use those bigger f-stop numbers.

And what about the person jumping? That blurred ghostly effect doesn't appear until you use an aperture of $f/16$ or $f/22$. And isn't that motion-filled photograph of your child on a swing really something? It's funny how at the faster shutter speeds, motion is "frozen," but at the slower shutter speeds, figures in motion look ghostlike. Look at your notes and decide which combination of aperture and shutter speed resulted in the most *creatively correct* exposure for you.

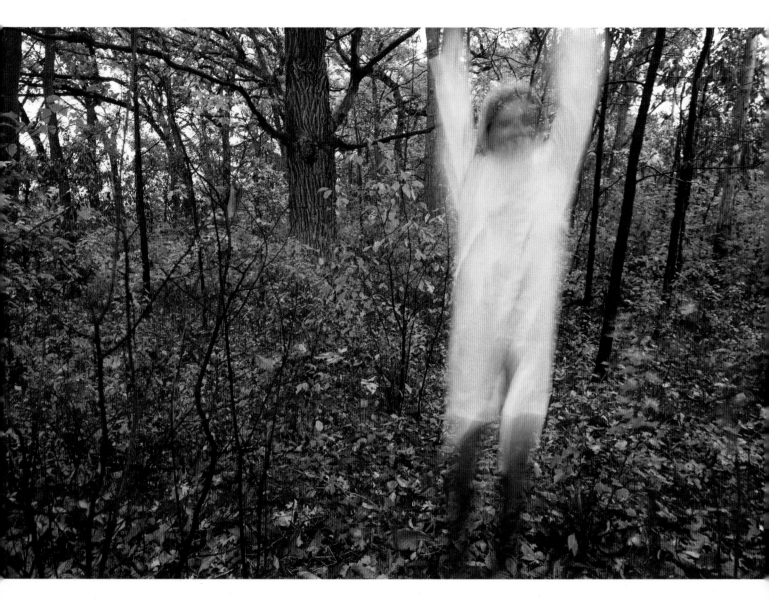

One of the joys of doing these exercises is that you'll soon be seeing ghosts! In this case it's all due to the subject flapping arms and jumping up and down during an exposure at a slow shutter speed. And with the aid of a bright yellow rain slicker, we have the perfect combination of color and contrast in this small wooded area that is beginning to show signs of fall color. Perhaps an idea like this will lend itself to the making of a custom Halloween party invitation!

Nikon D3X, Nikkor 24–85mm at 35mm, *f*/16 for 1/8 sec., ISO 100, tripod

FINDING CREATIVE EXPOSURE OPTIONS

Since every picture-taking opportunity allows for no fewer than six possible aperture and shutter speed combinations, how do you determine which combination is the best? You must decide first and foremost if you want to simply make an exposure or if you want to make a creative exposure. As we just saw, you can make many different exposures of a specific scene, but only one or maybe two are the creative exposures.

You can break down the three components of exposure—ISO, shutter speed, and aperture—to get seven different types of exposures, and among these components, it's either the aperture or the shutter speed that's most often behind the success of a creative exposure, so I'll start there: Small apertures (*f*/16, *f*/22, and *f*/32) are the creative force behind what I call *storytelling* exposures (this is exposure option 1)—images that show great depth of field. Large apertures (*f*/2.8, *f*/4, and *f*/5.6) are the creative force behind what I call *singular-theme* or *isolation* exposures (option 2)—images that show shallow depth of field. The middle-of-the-road apertures (*f*/8 and *f*/11) are what I call *who cares?* exposures (option 3)—those in which depth of field is not a concern.

Fast shutter speeds (1/250 sec., 1/500 sec., and 1/1000 sec.) are the creative force behind exposures that *freeze action* (option 4), whereas slow shutter speeds (1/60 sec., 1/30 sec., and 1/15 sec.) are the creative force behind *panning* (option 5). The superslow shutter speeds (1/4 sec., 1/2 sec., 1 second, and beyond) are the creative force behind exposures that *imply motion* (option 6). These factors make up a total of six creative exposure tools to call upon when reaching for your goal of achieving the one most creative exposure. The next two chapters take a closer look at aperture and shutter speed, respectively, as they pertain to all six of these situations.

Welcome to Amsterdam, a European city known for having far more bicycles than cars, among other notable attributes! Not surprising, it's difficult to shoot a simple portrait without including a bicycle or two or three. Considering it is Amsterdam, why not include the bicycles and give it a real sense of place by throwing in a bouquet of tulips as well!

But let's be clear about one thing with these three images; you are looking at three absolutely identical

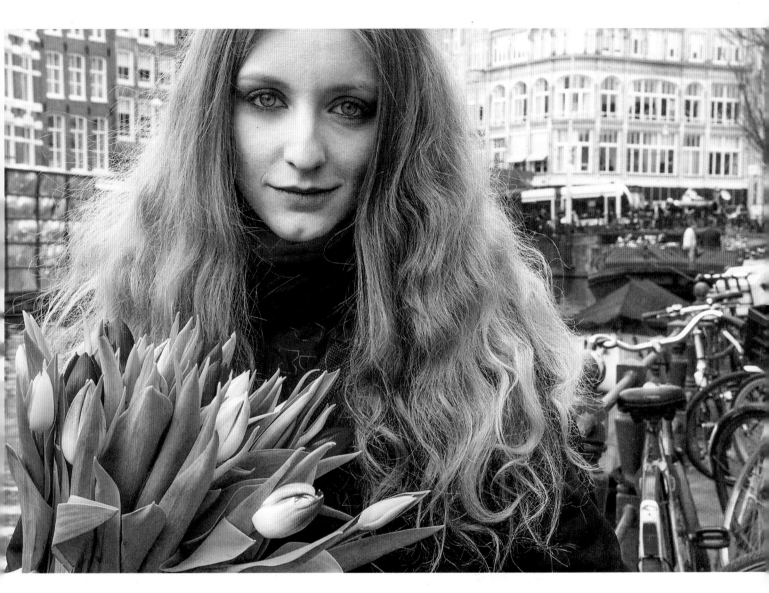

exposures, at least in their quantitative value. The first image (left, top) was shot at *f*/4 for 1/1000 second, the second image (left, bottom) was shot at *f*/11 for 1/125 and the third (above) at *f*/22 for 1/30 second.

Upon closer inspection, do you notice that there is a distinct difference in their visual weight? The background becomes progressively sharper as we move from the first image to the third image (above) and this is simply due to one simple optical law: as the lens opening gets smaller and

smaller, sharpness, a.k.a. depth of field, increases. Over the course of the next few pages, you will feel even more empowered in your understanding of exposure and depth of field!

All images: Nikon D800E, Nikkor 24mm-120mm at 120mm, (left, top) *f*/4 for 1/1000 sec., (left, bottom) *f*/11 for 1/125 sec. and (above) *f*/22 for 1/30 sec., ISO 200

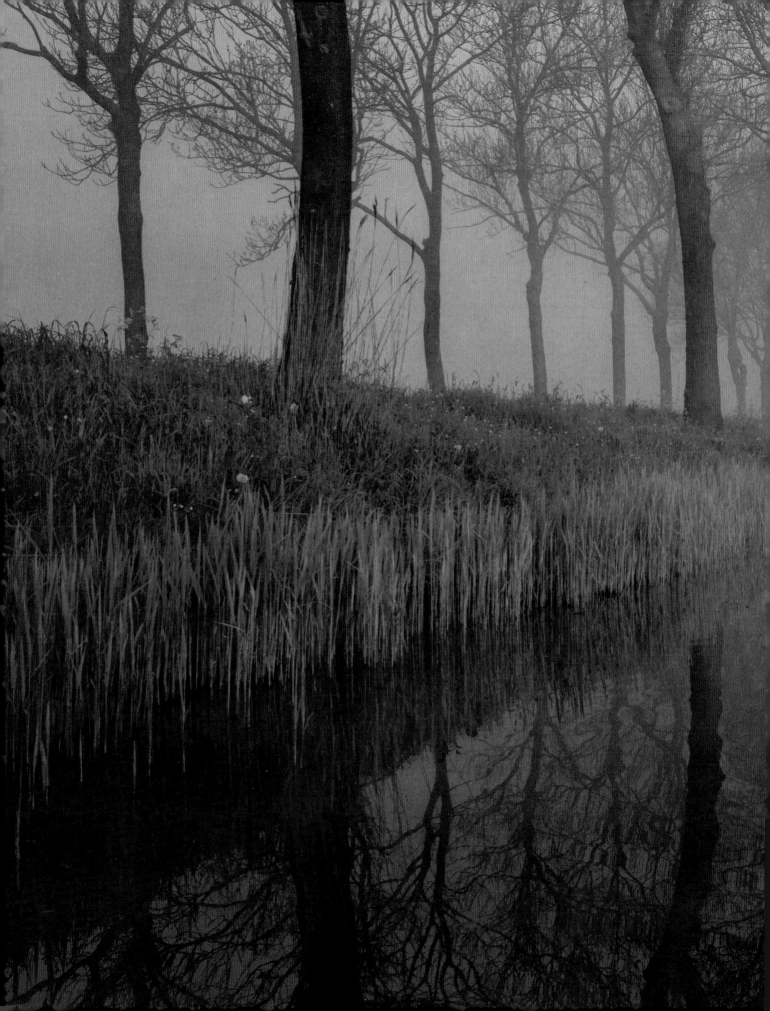

APERTURE

APERTURE AND DEPTH OF FIELD

The aperture is a "hole" inside the lens. Also known as the diaphragm, this hole is formed by a series of six overlapping metal blades. Depending on your camera, you either make aperture adjustments on the lens or you push buttons or turn dials on the camera. As you do this, the size of the hole in the lens either decreases or increases. This in turn allows more light or less light to pass through the lens and onto the digital media (or film).

For all lenses, the smallest aperture number— 1.4, 2, 2.8, or 4, depending on the lens—reflects the widest opening and will always admit the greatest amount of light. Whenever you set a lens at its smallest numbered aperture (or f-stop), you are shooting "wide open." When you shift from a smaller aperture number to a larger one, you are reducing the size of the opening and "stopping the lens down."

The largest aperture numbers are usually 16, 22, or 32 (or 8 or 11 with a fixed-lens digital camera).

Why would you want to be able to change the size of the lens opening? Well, for years, the common school of thought has been that since light levels vary from bright to dark, you want to control the flow of light reaching the sensor. And of course, the way to do this is simply by making the hole (the aperture) smaller or larger. This logic suggests that when you're shooting on a sunny day on the white sandy beaches of the Caribbean, you should stop the lens down, making the hole very small. Back in the days of film, doing that would ensure that the brightness of the sand didn't burn a hole in your film, and although you would never burn a hole in your digital sensor today, stopping down prevents too much light from getting into the scene. The same logic also implies that when you're in a dimly lit fourteenth-century cathedral, you should set the aperture wide open so that as much light as possible can pass through the lens and onto the digital media/film.

Although these recommendations are well intentioned, I could not disagree with them more. They set up the unsuspecting photographer for inconsistent results. Why? Because they give no consideration to a far more important function of an aperture: its ability to determine depth of field.

Just what is depth of field? It's the area of sharpness (from near to far) within a photograph. As you've undoubtedly noticed when looking at photographs, some contain a great deal of sharpness. You might be mystified by the "technique" professional photographers use to record extreme sharpness throughout an image, for example, from the flowers in the immediate foreground to the distant mountains beyond. When you try to achieve overall sharpness in a composition like this, you may find that when you focus on the foreground flowers, the background mountains go out of focus, and when you focus on the mountains, the flowers go out of focus. I've had more than one student say to me over the years, "I wish I had one of those 'professional' cameras that would allow me to get exacting sharpness from front to back." They can't believe it when I tell them that they already have one! They just have to use depth of field to their advantage. Similarly, exposures of a lone flower against a background of out-of-focus colors and shapes (see page 33) are the direct result of creative use of depth of field.

What exactly influences depth of field? Several factors come into play: the focal length of the lens, the distance between you and the subject you want to focus on, and the aperture you select. I feel strongly that of these three elements, aperture choice is the most important.

In theory, a lens is able to focus on only one object at a time; as for all the other objects in your composition, the farther away they are from the in-focus subject—whether in front of or behind

it—the more out of focus they will be. Since this theory is based on viewing a scene through the largest lens opening, it's vital that you appreciate the importance of understanding aperture selection. Of course, the light reflecting off a subject makes an image on digital media (or film), but the chosen aperture dictates how well this image is "formed" on your sensor. Optical law states that the smaller the opening of any lens (large *f*-stop numbers—16, 22, and 32), the greater the area of sharpness or detail in the photo. When you are using apertures at or near wide open (smaller *f*-stop numbers—2.8, 4, and 5.6), only the light that falls on the focused subject will be rendered as "sharp"; all the other light in the scene—the out-of-focus light—will "splatter" across the sensor or film. In effect, this unfocused light records as out-of-focus blobs, blurs, and blips.

Conversely, when the same object is photographed at a very small lens opening such as *f*/22, the blast of light entering the lens is reduced considerably. The resulting image contains a greater area of sharpness and detail because the light didn't splatter across the sensor (or film plane) but instead was confined to a smaller opening as it passed through the lens. Imagine using a funnel with a very small opening and pouring a 1-gallon can of paint though it into an empty bucket. Compare this process to pouring a 1-gallon can of paint into the same empty bucket without the aid of the funnel. Without the funnel, the paint gets into the bucket more quickly, but it also splatters up on the bucket's sides. With a funnel, the transfer of paint to the bucket is cleaner and more contained.

Keeping this in mind, you can see that when light is allowed to pass through small openings in a lens, a larger area of sharpness and detail always results. Does this mean that you should always strive to shoot "neat" pictures instead of "messy and splattered-filled" ones? Definitely not! The subject matter and the depth of the area of sharpness you want to record will determine which aperture choice to use—and it differs from image to image.

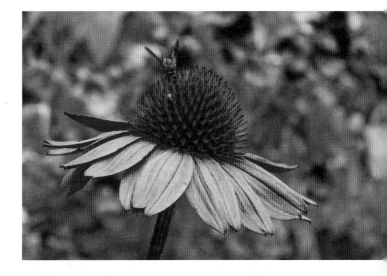

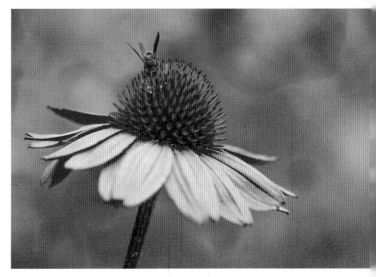

The choice of backgrounds can always be yours if you know how to control the area of sharpness. This is especially true when you are using a telephoto lens. I made the top image you see here of a bee on a flower at the aperture of *f*/32, assuring not only that the bee and flower would be in sharp focus but also that the nearby background of other flowers would be rendered to a small degree. I then made the bottom exposure, also a "correct" exposure, at the aperture of *f*/5.6, and not surprisingly, the background is now much softer and more out of focus. Personally I prefer the second image, since in the absence of the busy background, the bee is able to be the star of the show without distraction.

Both images: Nikon D3X, Nikkor 70–300mm at 300mm, ISO 100, Canon 500D close-up filter, (top) *f*/32 for 1/30 sec., (bottom), *f*/5.6 for 1/1000 sec.

A NOTE ABOUT LENS CHOICE

As I mentioned a moment ago, every picture-taking opportunity is filled with no fewer than six potential exposure options, but I want to take a slight detour here and look briefly at the first two options—storytelling and isolation or singular-theme theme ideas—since these two options rely quite heavily on a specific lens choice. What is the most obvious difference in these two images? Both have a similar composition—my daughter Sophie is filling up approximately the same space in the frame—but note the *vast* difference in the overall angles of view. The left image was taken with my 24–85mm at the 28mm focal length. The approximate 75-degree angle not only shows Sophie but also leaves no doubt that she is standing in a vineyard near a very *distant* village, a village made distant by lens choice! It is the wide-angle lens to be exact that "pushes" distant subjects even farther back into the frame. Now compare the second image of Sophie on the right with the first, and right

away the much narrower angle of view of the telephoto lens (an 11-degree angle of view of the 200mm lens) has in effect removed the vineyard, *and* although the village is now of out of focus, it does indeed appear to be closer to her, just over her shoulder! Yes, they are both correct exposures, but the first image was shot at *f*/16 for 1/60 sec., and the second image was shot at *f*/5.6 for 1/500 sec.

When you wish to create a storytelling exposure, you will more often than not call upon your wide-angle lens, and when you combine it with small lens openings such as *f*/16 or *f*/22, you will record maximum depth of field. When you wish to isolate a subject from its "busy" surroundings, call upon the telephoto lenses: 100mm to 400mm. As a result of their much narrower front-to-back angle of view, you can often render all that "busyness" into out-of-focus tones and colors much more easily in combination with large lens openings such as *f*/5.6 or *f*/4.

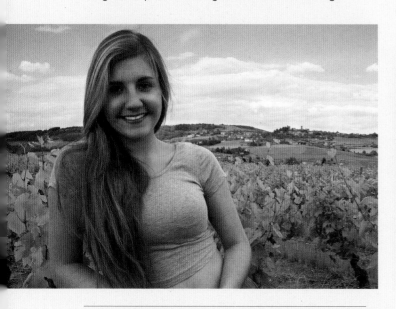 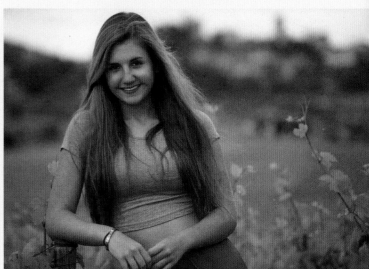

Both images: Nikon D800E, ISO 200, (left) Nikkor 24–85mm at 28mm, *f*/16 for 1/60 sec., (right) Nikkor 70–300mm at 280mm, *f*/5.6 at 1/500 sec.

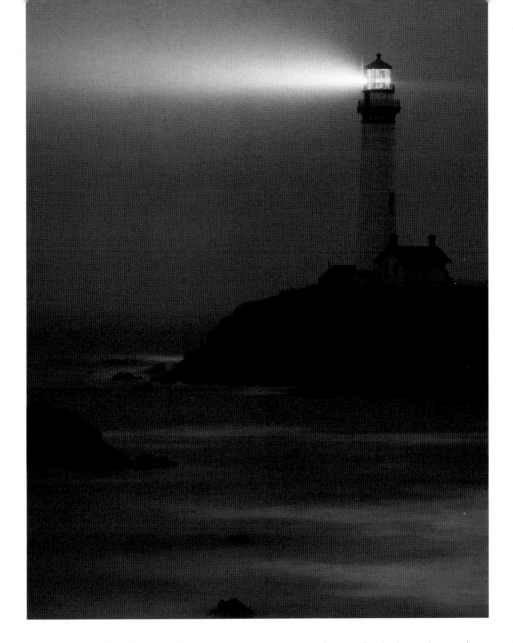

Pigeon Point Lighthouse is one of my favorite lighthouses to shoot along the northern California coastline. The weather is often unpredictable, but that is perhaps its attraction. During the final minutes of dusk, the opportunity to shoot long exposures begins, and rain or shine, a long exposure of any lighthouse is a truly rewarding experience. This is another reason why it is important to familiarize yourself with the six possible creative exposures. My *only* thought was to shoot a long exposure of the lighthouse, implying motion from the moving surf and having ample time to record the ray of lighthouse light in the thin veil of fog. With my camera and 70–300mm lens mounted on tripod and my ISO set to 100, I was quick to set the aperture to *f*/16 first and then adjusted the shutter speed until 13 seconds indicated a correct exposure. Because this overall scene was dominated by a thin pea soup kind of fog, the exposure levels throughout were quite even,

except of course for the beam that was being emitted by the lighthouse. And because it was dusk, the overall color temperature of the light began to turn blue. The long exposure time of 13 seconds allowed me to record an exposure of not only the beam but also of the normally wild and crashing surf that was now calm and ethereal. It's important to note that when shooting a scene such as this, you begin your exposure at the point when the light makes its first beam out in the fog-shrouded air. Over the course of my 13-second exposure, I was able to record three passes of the beam, Also, it has been my experience that you will *not* record much of a beam unless you have a good layer of pea soup fog in the area. This is another example of why inclement weather is often a good thing!

Nikon D800E, Nikkor 70–300mm at 190mm, *f*/16 for 13 sec., ISO 100, tripod

STORYTELLING APERTURES

There are three picture-taking situations for which your attention to aperture choice is paramount. The first is what I call a *storytelling* composition. This is simply an image that, as the name implies, tells a story. And like any good story, there's a beginning (the foreground subject), a middle (the middle-ground subject), and an end (the background subject). Such an image might contain stalks of wheat (the foreground/beginning) that serve to introduce a farmhouse 50 to 100 feet away (the main subject in the middle ground/middle), which stands against a backdrop of white puffy clouds and blue sky (the background/end).

When using a digital camera *with a full-frame sensor*, experienced amateurs and professionals call most often upon the wide-angle zoom lenses and the focal lengths within the ranges of 14 to 24mm. When using a digital camera *with a "cropped" sensor*, an experienced photographer will also call upon the wide-angle zooms and use the 10–16mm range.

We saw her sitting in her open doorway at the same time, but it was one of my students who engaged her first since he spoke fluent Italian. We were on the island of Burano, about a 45-minute ferry ride from Venice. She was very gracious about posing for all of us in her open doorway under the overcast late afternoon skies. I pointed out to the students that when we set our exposure for the bright overcast light falling on her face and clothing, the much darker area behind her, the interior of her house, would be rendered very dark, if not black. And even though we were all able to see some detail with our own eyes in that dark area—furnishings and a painting on a wall—the exposure latitude of a camera still falls short of what the human eye can see. (The human eye can see approximately 16 stops of exposure whereas most digital cameras can record only 7 stops.)

Handholding my camera and lens and with the aperture set to the "who cares?" choice of *f*/8, I moved in close and filled the frame, and simply adjusted my shutter until a correct exposure was indicated, after which I fired off several frames.

Nikon D300S, Nikkor 105mm, *f*/8 for 1/200 sec., ISO 200

It can sometimes happen that a storytelling composition needs to be shot with a moderate telephoto (75–120mm) or with the "normal" focal lengths (45–60mm), but regardless of the lens choice, there is one constant in making a storytelling composition: a small lens opening (the biggest *f*-stop numbers) is the rule!

Once you start focusing your attention on storytelling compositions, you may find yourself asking a perplexing question: "Where the heck do I focus?" When you focus on the foreground stalks of wheat, for example, the red barn and the sky go out of focus, and when you focus on the red barn and the sky, the foreground wheat stalks go out of focus. The solution to this common dilemma is simple: you don't focus the lens at all, but instead preset the focus via the distance settings.

There was a time when most photographers used single-focal-length lenses instead of using zooms simply because those lenses were sharper. Additionally, all single-focal-length lenses had—and still have—what is called a depth-of-field scale. This scale makes it very easy to preset your focus for the scene before you, and it offers tremendous assurance that you'll get the area of sharpness that you desire in your image. But with the proliferation of high-quality zoom lenses, most photographers have abandoned single-focal-length lenses in favor of zoom lenses. The trade-off, of course, is that we are running around with lenses that don't have depth-of-field scales.

But what we do have are *distance settings*. These settings are similar to the depth-of-field scale in that they allow you to preset the depth of field *before* you take a shot. And since every storytelling composition relies on the maximum depth of field, you would first choose to set your aperture to *f*/22 and then align the distance of *1 meter* directly above the distance-setting mark on the lens. **This 1-meter setting applies only to the following**: when using the focal lengths of 16–24mm on a full-frame camera (DX sensor) and when using the focal lengths of 10–16mm on a crop sensor camera (FX sensor).

Again, it is vitally important that you set the distance mark to 1 meter (or 3 feet) and that you *turn off autofocus* whenever you wish to record storytelling sharpness! When you do this, the resulting depth of field will be between 14–20 inches and infinity, depending on which focal length between 14mm and 24mm you are using with your full-frame camera (FX) or which focal length between 10mm and 16mm you are using with your crop sensor camera (DX).

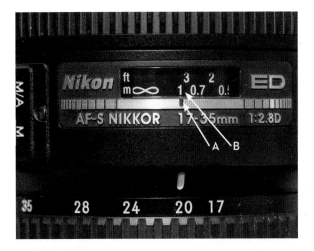

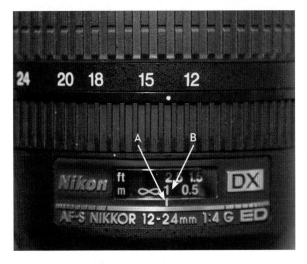

FX Lens (top), DX Lens (bottom): A is the distance marker, and B marks where I have set 1 meter directly above the distance marker.

DIFFRACTION VERSUS SATISFACTION

Almost weekly, I receive emails from students at my online school as well as from readers of my books who are concerned about shooting pictures at apertures of f/16 or f/22.

It seems that a couple of those "big" photography forum Web sites have unleashed some really *old news* that when a lens is set to the smaller apertures, such as f/16 and f/22, lens diffraction is more noticeable (in layman's terms, *lens diffraction* means a loss of contrast and sharpness).

I want to set the record straight about lens diffraction and share what thousands of commercial freelance photographers all over the world know: shooting at f/22 can be a *great idea*, and any worries about loss of sharpness and contrast are just as overblown as the Y2K fears were!

In over 35 years of shooting commercially, I can't remember a time when a client said, "Bryan, whatever you do, don't shoot at f/22." Nor can I remember a single instance when either Getty or Corbis (the two largest stock photo agencies in the world) called me to say, "Bryan, *don't* send us any of your pictures for our stock files if they were shot at f/22." The reason I can't remember is that it *never happened* and it *never will*.

The aperture of f/22 produces a massive depth of field, in particular when combined with a wide-angle lens. When using your wide-angle lens, *if* you have even an ounce of creativity, you'll want to have some foreground interest in your overall composition, since it will be the foreground interest that will create the illusion of depth and the subsequent perspective in the shot. And the only way to record sharpness from front to back when you are including an immediate foreground is to use f/22—the smallest lens opening, which in turn produces the greatest depth of field (the greatest area of acceptable sharpness).

The long and the short of it is this: The question of using f/22 was *never* an issue during the days when we all shot film, and it should *not* be an issue today. Diffraction is a real event, but it should never get in the way of shooting compositions that demand extreme depth of field. Satisfaction is your reward, so get out there and get creative at f/22!

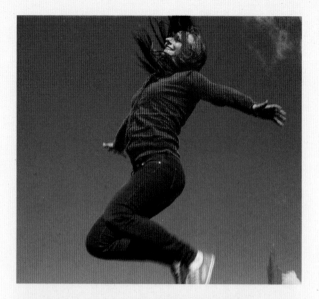

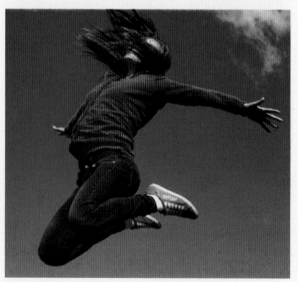

Both images: 400 percent magnification

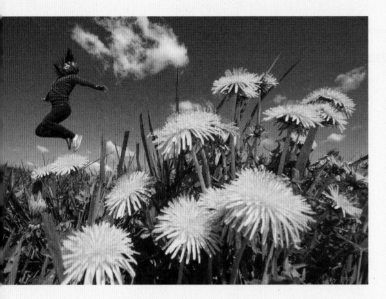

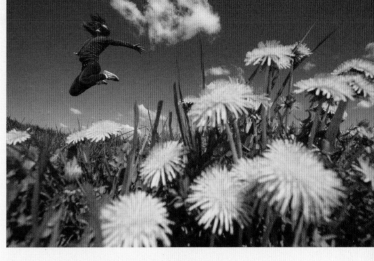

Along many of the small dikes and ditches that line the countryside in Holland, clusters of dandelions are yours for the taking every spring. As one who is proud to help you reach new "low points" in your life, this is an opportunity to get down low and call upon that "dreaded" f/stop, 22! For all of you naysayers who mistakenly tell others not to use f/22, this is what you are missing; the opportunity to use immediate foreground interest and record a massive depth of field!

Both of these images were shot with the same lens at the same focal length, and they are both the same exact exposure in terms of quantitative value, but is there ever a noticeable difference in their overall sharpness—especially in the foreground! The first image (above, left) was shot at the "dreaded" f/22 and the second (above, right) at the "highly recommended" f/11.

I don't know about you, but I prefer the image taken at f/22 (above, left) because it shows the overall area of acceptable sharpness that we really need to convey

here—front to back, immediate foreground sharpness on the flowers all the way back to the jumper and blue sky. In the image taken at f/11 (above, right), clearly we don't have front-to-back sharpness; note the obviously soft, out-of-focus flowers in the foreground. So, with the proof staring at you, what do you think? Will you embrace the use of f/22? You should, if you have any intention of being a creative photographer, because you'll never record those great landscape shots unless you choose f/22.

And take a look at the details at a 400 percent magnifications at left. The difference in the sharpness is almost nil, although I'll be the first to admit that there is a wee bit greater sharpness in the models feet but this has nothing to do with the dreaded lens diffraction, but rather it has everything to do with the difference in shutter speed.

Both images: Nikon D800E, Nikkor 17-35mm at 17mm, ISO 400, (left) f/22 for 1/200 sec. (right) f/11 for 1/800 sec.

ABOVE: For a scene like this, I know I need great depth of field to achieve sharpness from the blooming cactus to the distant rocky hillside. So here, with my 17–35mm wide-angle lens, I set the aperture to *f*/22 and preset that focus so that the distance of 1 meter (3 feet) was aligned directly above the center mark near the front of the lens. Of course, when I looked through the viewfinder, the scene looked anything but sharp. This was the case because the viewfinders of all current cameras allow for wide-open viewing, meaning that even when the aperture is *f*/22, the image in the viewfinder is seen at a wide-open aperture (*f*/2.8). The lens won't stop down to the picture-taking aperture of *f*/22 *until the shutter release is pressed*. It's at that point that the sharpness will be recorded. I obtained the desired depth of field not by refocusing the lens but by combining a wide-angle lens with a storytelling aperture and presetting the focus via the distance scale. As you can *clearly* see, the second image did in fact record the sharpness from front to back.

Both images: Nikon D800E, Nikkor 17–35mm at 20mm, *f*/22 for 1/30 sec., ISO 200

OPPOSITE PAGE: If you wanted to embrace the idea of using *f*/22 and setting your focus to 1 meter (3 feet), it would *not* make sense to do so, at least from a standing position, in this lavender field in Provence. Why? You have no immediate foreground in this standing, eye-level composition, and using *f*/22 here and prefocusing to 1 meter would be a "waste" of depth of field. This eye-level composition (top) was in fact made at an aperture of *f*/11 *because* there are no immediate depth-of-field concerns. When I speak of immediate foreground interest, I am speaking about subject matter that is within several inches of your wide-angle lens. Obviously, in this first example, there is no immediate foreground interest to be found at this eye-level point of view, but when I fall to my knees and belly, as I did in the second example (bottom), I have immediate foreground interest and a definite need to call upon *f*/22! And now, from the foreground flowers to the distant sky, the depth of field in this image is extreme.

Both images: Nikon D800E, Nikkor 16–35mm at 16mm, ISO 100, (top) *f*/11 for 1/200 sec., (bottom) *f*/22 for 1/200 sec.

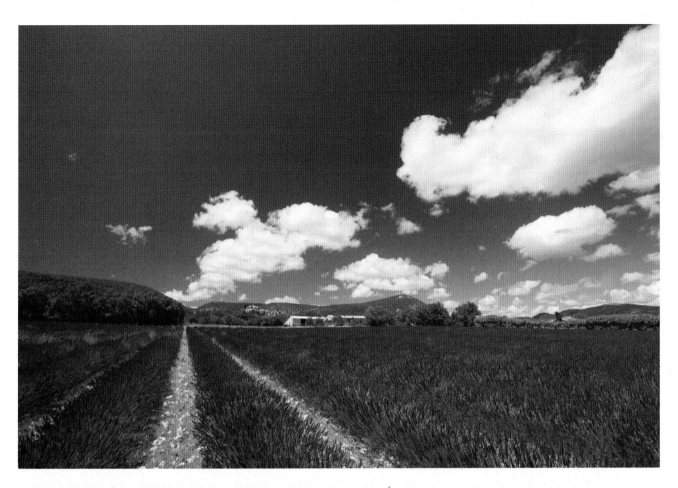

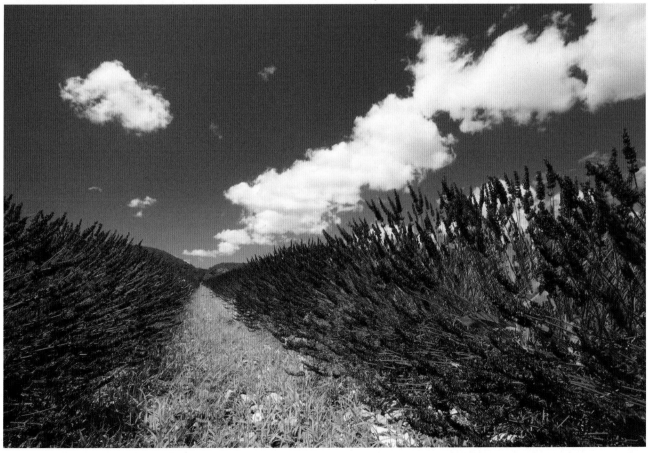

THE VISION OF THE WIDE-ANGLE LENS

Developing a vision for the wide-angle lens isn't as hard as you might think. Dispelling the rumor that a wide-angle lens makes everything small and distant is one of the keys to understanding why you should call on the wide-angle lens most often when you wish to do effective storytelling.

The wide-angle lens *does* push everything in a scene to the background, so to speak, and it does so because it is expecting *you* to place something of great importance in that now empty and immediate foreground—and I can't stress *immediate foreground* enough, since therein lies the key.

Imagine for a moment that you're preparing for a party that will find everyone dancing on your living room floor. What do you do with all the furniture?

You might find yourself pushing it all to the back wall, which will open up the floor so that there is lots of room for dancing. It is initially an empty floor, and I'll be the first to admit it looks wrong: the empty floor calls attention to the fact that no one is dancing. But here comes one couple, followed by another and another, and before you know it, the floor is filled with dancing feet—and now the floor looks like a fun place to be! So, with your dance party in mind, I want you start thinking of using your wide-angle lens in the same way. Do understand that the "vision" of this lens will push everything back time and time again, and it does that solely because you're planning on having a dance party in what is initially an empty foreground—but not for long, of course!

In both of these examples, the dance floor is now filled with fallen leaves. In the case of the cherry orchard, those fallen leaves were "natural," but in the image of the waterfall and stream, I purposely placed the leaves on the rock. (Mother Nature is sometimes overworked and unavailable, so I at times do my part to do what Mother Nature intended.)

As far as the exposure goes, both images were made under overcast skies where the light levels were balanced throughout the composition, making a correct exposure much easier to determine. After setting the aperture to *f*/22, I simply adjusted the shutter speed until a correct

exposure was indicated. It should be noted, however, that in the waterfall composition, I chose to shoot at an ISO of 50 (LO 1.0 on most DSLRs that offer it). I chose an ISO of 50 to assure myself a slow shutter speed so that I would record not only the great depth of field I was wanting but also the angel hair effect of the moving water. Both images were shot with the camera on tripod.

Left image: Nikon D800E, Nikkor 17–35mm at 17mm, *f*/22 for 1/15 sec., ISO 200, tripod. Right image: Nikon D800E, Nikkor 17–35mm at 21mm, *f*/22 for 1 sec., ISO 50, tripod

While we are on the subject of massive depth of field, it must be noted that when you are shooting reflections, a massive depth of field is often necessary *if* your intention is to record sharpness from front to back. Because a puddle of water is only a few inches deep (or less than a half inch in this case), the necessary depth of field would be almost 300 feet deep!

Coming upon a small puddle of rain, a remnant of the previous night's rainfall, I saw the 98-meter-tall clock tower in San Marco Square reflecting in the puddle along with one of the many light posts. With my camera and 24–120mm lens mounted on tripod, I was quick to fill up the frame with the image you see here and just as quick to call upon the aperture of *f*/22, knowing full well that I would need as much depth of field as I could muster. In this case I chose to focus about 15 feet into the puddle of water, and with my focal length at 60mm and my aperture set to *f*/22, sharpness reigned supreme from the surface of the puddle to the distant clock tower.

Nikon D800E, Nikkor 24–120mm at 60mm, *f*/22 for 1/30 sec., ISO 100, tripod

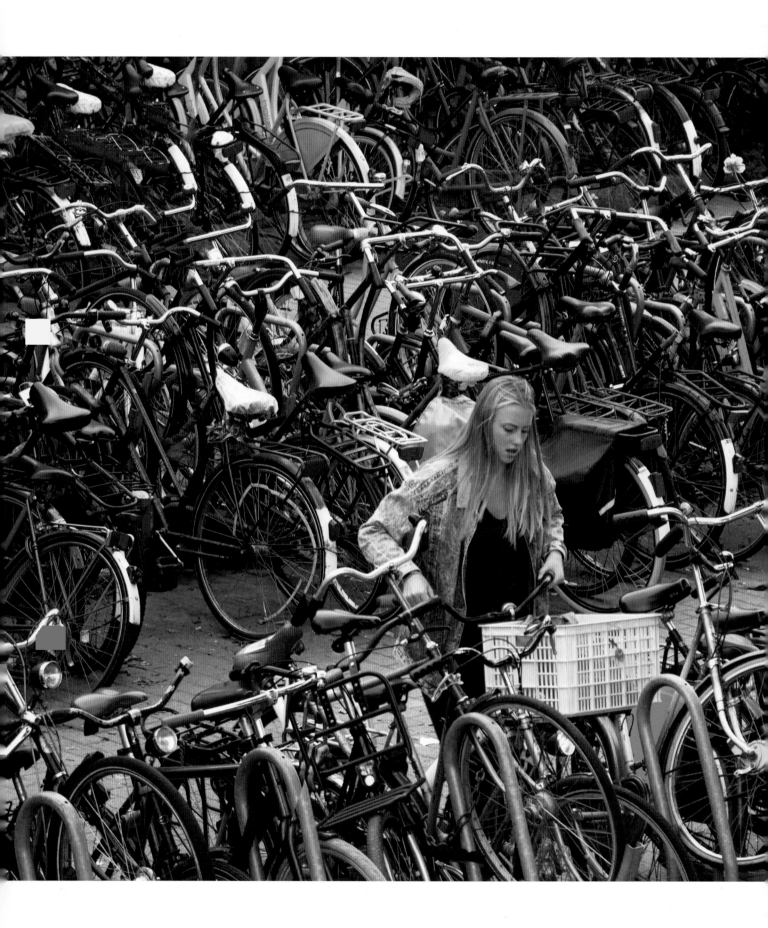

Are you limited to wide-angle lenses when making storytelling compositions? Absolutely not, but the wide-angle focal lengths are most often called upon for their ability to encompass wide and sweeping landscapes—and, of course, for their ability to render great depth of field. There are certainly other compositions for which you use your telephoto lens and also want to make the entire composition sharp. In these cases, I often tell my students to focus one-third of the way into the scene and set the lens to the smallest opening. Then simply fire away.

Near the Amsterdam train station you will find several "bike garages." It's hard to imagine anyone being able to find his or her bike once it is parked.

Some of my favorite vantage points are the ones that offer views from above. From atop one of the bike garages I was able to get a perfect look down onto another large bike parking area. Shooting a composition of just bikes wasn't compelling, so I waited a few minutes for a hoped-for bike owner to come into the scene and claim her bike. This young girl brings not only a sense of scale to the scene but also a human element. I set up my camera and 70–300mm lens on a tripod, and at the 180mm focal length I immediately chose the aperture of *f*/22. I then adjusted the shutter speed until 1/100 sec. indicated a correct exposure and then focused about a third of the way into the scene. (In this case, that one-third of the way into the scene was right about where the girl was pulling out her bike.)

Nikon D800E, Nikkor 70–300mm at 180 mm, *f*/22 for 1/100 sec., ISO 400, tripod

APERTURE CONVERSIONS FOR FIXED-LENS DIGITAL CAMERAS

Your fixed-lens digital camera is hopelessly plagued with an uncanny ability to render a tremendous amount of depth of field even when you set your lens to $f/2.8$; an aperture of $f/2.8$ is equivalent to an aperture of $f/11$ on an SLR camera! And when you're at $f/4$, you're able to record a depth of field equivalent to $f/16$. At $f/5.6$, you're equivalent to $f/22$. At $f/8$, you're equivalent to $f/32$, and if your lens goes to $f/11$, you're at a whopping $f/64$! Those of us who use SLRs can only dream of the vast depth of field that would result from apertures such as $f/64$.

One added benefit of having apertures that render such great depth of field is in the area of exposure times. For example, if I were shooting a storytelling composition with my SLR and 35mm wide-angle lens, I would use $f/22$ for maximum depth of field. Combined with an ISO of 100 and assuming I'm shooting a sidelit scene in late-afternoon light, I'd use a shutter speed of around 1/30 sec. With this slow a shutter speed, I'd more than likely use a tripod. You, in contrast, could choose to shoot the same scene at an aperture of $f/5.6$ (equivalent in depth of field to my $f/22$), and subsequently, you would be able to use a shutter speed that's *4 stops faster*—a blazing 1/500 sec. Who needs a tripod at that speed?

Likewise, when shooting close-ups of flowers or of dewdrops on a blade of grass (assuming you have a close-up/macro feature), you can shoot at $f/8$ or $f/11$ (the equivalent of $f/32$ or $f/64$ on an SLR) and once again record some amazing sharpness and detail that SLR users can only dream of. And as every SLR user knows, when photographing with a macro lens at $f/32$, we always use our tripods since the shutter speeds are often too slow to safely handhold the camera and lens. But here again, with your aperture at $f/8$

(an $f/32$ equivalent) you can photograph the same dewdrop at much faster shutter speeds—more often than not without the need for a tripod.

Is there a downside to these fixed-zoom-lens digital cameras? Yes, and other than the absence of the ability to shoot with a truly wide-angle lens (90 degrees or greater), you will not be nearly as successful when shooting *singular-theme/isolation* compositions as you can be with a DSLR. Even with your lens set to the telephoto length and your aperture wide open, you'll struggle with most attempts to render a background that remains muted and out of focus. Remember, even when the lens is wide open—at $f/2.8$, for example—you still have a depth of field equivalent to $f/11$ on a DSLR. There are accessories coming onto the market that can help at times like this (auxiliary lenses, close-up filters, and such), but by the time you add it all up, you realize that you could have spent about the same amount of money for a DSLR system.

Finally, most fixed-zoom-lens digital cameras *do not* have any kind of distance markings on the lens, and so you won't be able to manually set the focus for maximum depth of field as I've described for SLR users. Instead, you'll have to rely on estimating the focused distance when you are shooting storytelling compositions. To make it as easy as possible, do the following: With the lens set to $f/8$ or $f/11$ and at the widest focal length, focus on something in the scene that's 5 feet from the camera. Then adjust the shutter speed until a correct exposure is indicated and simply shoot! Even though objects in the viewfinder will appear out of focus when you do this, you'll quickly see on your camera's display screen that those objects record in sharp focus after you press the shutter release.

I will say that we're getting closer to the day when most of us will be able to travel really light *and* with a camera that offers it all; my dream is a camera similar to the Sony RX100 (my current choice in digital point-and-shoots) that offers a 20-megapixel sensor but with a zoom with an effective focal length of 20–400mm. At the speed technology continues to develop, we may be at most 2 to 3 years away from my dream, and I can't wait (neither can my back)!

I was recently in Kuwait City at the old market and met many friendly merchants, including this seller of dates. On this particular day I was traveling really light, having only my Sony RX100 with me along with its 28–105mm DSLR-equivalent focal length lens. I can cover a lot of ground with that kind of a zoom, or in this case I can cover a lot of dates! Because the light in this case was 100 percent tungsten

light bulbs, it was a quick decision to change from the normal Cloudy WB setting that I use with the Sony to the Tungsten setting, and as you can see, I recorded "white" light instead of the normal yellow/orange light that tungsten is noted for when you are shooting in a daylight WB setting such as Cloudy.

With the aperture set to *f*/8, I adjusted the shutter speed until a correct exposure was indicated and fired off several frames, and the second of the three frame is shown here. I love this man's confident expression and also the warmth it exudes.

Sony RX100, Sony 28–105mm at 28mm, *f*/8 for 1/100 sec., ISO 200

ISOLATION OR SINGULAR-THEME APERTURES

The second picture-taking situation in which your attention to aperture choice is paramount is when you are making what I call *isolation* or *singular-theme* compositions. Here sharpness is deliberately limited to a single area in the frame, leaving all other objects—both in front of and behind the focused object—as out-of-focus tones and shapes. This effect is a direct result of the aperture choice.

Since the telephoto lens has a narrow angle of view and an inherently shallow depth of field, it's often the lens of choice for these types of photographic situations. When it is combined with large lens openings (*f*/2.8, *f*/4, and *f*/5.6), a shallow depth of field results. A portrait, either candid or posed, is a good candidate for a telephoto composition, as is a flower and any other subject you'd like to single out from an otherwise busy scene. When you deliberately selectively focus on one subject, the blurry background and/or foreground can call further attention to the in-focus subject. This is a standard "visual law" often referred to as *visual weight*: whatever is in focus is understood by the eye and brain to be of greatest importance.

THE DEPTH-OF-FIELD PREVIEW BUTTON

Is there any tool on the camera that can help determine the best aperture choice for singular-theme compositions? Yes: the depth-of-field preview button (DOF). However, this button isn't found on all cameras. And unfortunately, even when it is present, it's often the most misunderstood feature on the camera.

The purpose of this button is simple: when the button is depressed, the lens stops down to whatever aperture you've selected, offering you a preview of the overall depth of field you can expect in the final image. This enables you to make any necessary aperture adjustments, allowing you to correct an instance of "incorrect" or unwanted depth of field before recording the exposure.

Take note of the "newborn" branch that has recently sprouted from this tree along a dike in West Friesland, Holland. Take additional note of the wonderful rows of colorful tulips in the background. Are you thinking what I am thinking? Yes, exactly!

Let's grab our tripod and tele-zoom lens and *isolate* that one leaf and compose it against much of that background color.

With my camera and 70–300mm lens on tripod, I moved in as close I could focus while at the 300mm focal length and was quick to call upon the depth-of-field preview function on my camera. Once I had pressed that button and after setting an aperture of $f/16$, I was able to see what kind of depth of field would be rendered in the background at $f/16$. Not surprisingly, it was a bit more than I wanted, and so with the DOF preview button still pressed, I began to turn the aperture wheel on the camera toward a larger lens opening. As I did that, two things began to happen: The viewfinder image was becoming brighter since more light was now striking the mirror and coming up into the viewfinder, and the field in the background was becoming less defined, turning more into bands of color instead of rows of out-of-focus tulips. It was at $f/7.1$ that I felt I had the perfect background, the one you see here.

Right image: Nikon D800E, Nikkor 70–300mm at 300mm, $f/7.1$ for 1/400 sec., ISO 100, tripod

EXERCISE: MASTERING THE DEPTH-OF-FIELD PREVIEW BUTTON

As simple as the depth-of-field (DOF) preview button is to use, it initially confuses many photographers. A typical comment I hear from students in my workshops is, "I press it, and everything just gets dark." Overcoming this distraction isn't at all difficult; it just takes practice. If your camera does indeed have a depth-of-field preview button, try this exercise: First, set your aperture to the smallest number—*f*/2.8, *f*/3.5, or *f*/4, for example. With a 70mm or longer lens, focus on an object close to you, leaving enough room around the object that an unfocused background is visible in the composition. Then depress the DOF preview button while looking through the viewfinder. Nothing will happen. But now change the aperture from wide open to *f*/8 and take a look, especially at the out-of-focus background. You no doubt noticed the viewfinder getting darker, but did you also notice how the background became more defined? If you did not, set the aperture to *f*/16 and depress the button again, paying special attention to the background. Yes, I know the viewfinder got even darker, but that once-blurry background is quite defined now, isn't it?

Each time the lens opening (the aperture) gets smaller, objects in front of and behind whatever you focus on will become more defined. In other words, the area of sharpness (the depth of field) is extended.

Now head outside with a telephoto lens, say, a 200mm, and set your aperture to *f*/16. Frame up a flower or a portrait. Once you focus on your subject, depress the DOF preview button. Things will become quite a bit darker in the viewfinder since you have stopped down the aperture, but more important, take note of how much more defined the areas both in front of and behind the subject become. If you want to tone down all that busy stuff around the subject, set the aperture to *f*/5.6. The background will be less defined. Overly busy compositions that are meant to convey a singular theme can easily be fixed with the aid of the depth-of-field preview button.

I shot this first example of a poppy and a lavender stalk at the aperture of *f*/22 (left). Note how busy the background is and how the main flowers are not really alone. Fortunately, I was able to see just how busy the background was when I depressed the depth-of-field preview button, and I moved down toward the smaller aperture numbers—larger openings—all the while looking through the viewfinder

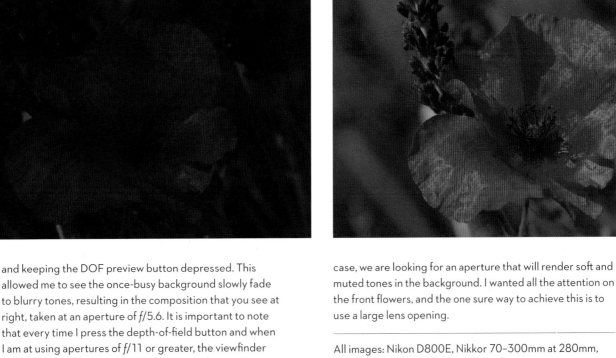

and keeping the DOF preview button depressed. This allowed me to see the once-busy background slowly fade to blurry tones, resulting in the composition that you see at right, taken at an aperture of *f*/5.6. It is important to note that every time I press the depth-of-field button and when I am at using apertures of *f*/11 or greater, the viewfinder becomes quite dark (middle). But despite it being dark, you can see how much more (or less) defined the image is. In this

case, we are looking for an aperture that will render soft and muted tones in the background. I wanted all the attention on the front flowers, and the one sure way to achieve this is to use a large lens opening.

All images: Nikon D800E, Nikkor 70–300mm at 280mm, (left) *f*/22 for 1/30 sec., (right) *f*/5.6 for 1/500 sec.

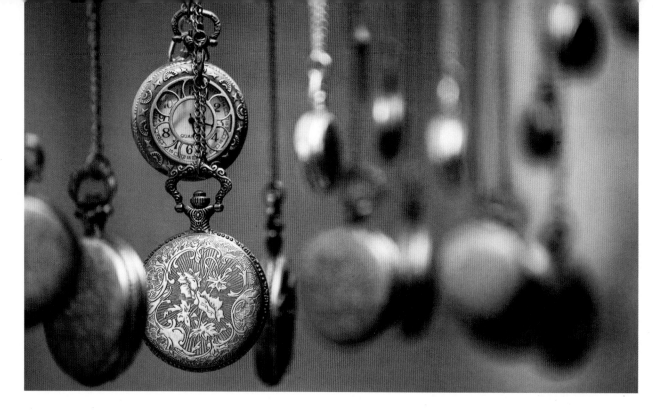

Much like wildflowers in a meadow, these hanging watches at a street market in New York City lent themselves to the idea of selective focus/singular-theme compositions. Fortunately, I was able to find a point of view that allowed me to place the watches against some color in the background (a pink-colored storefront), and when I combined that viewpoint with a large lens opening and a close focus,

I was able not only to pick out just one watch but also to render all the other watches as "supporting actors," allowing the star of the show to have its fifteen minutes of fame—pun intended!

Nikon D800E, Nikkor 70–300mm at 300mm, *f*/5.6 for 1/400 sec., ISO 100

I love to shoot images in which the hands are involved. I happened to be in Thimphu, Bhutan, the largest city in a country whose number one export is "happiness," when I came across this priest. It was during the *tsechu* (festival) when my eyes caught sight of this colorfully dressed Buddhist walking through the crowds assembled for this four-day event at the Tashichho Dzong. I must have followed this guy around for at least fifteen minutes trying to get a shot of his hand with the half-sliced apple and the money he was collecting from those in the crowd. The money represented individual payments for a blessing by the priest. Finally, the priest stood still long enough for me to get a clean shot. Fortunately, I was also able to shoot from a point of view that showed much of the colorfully dressed crowd behind him.

Nikon D800E, Nikkor 70–300mm at 237mm, *f*/7.1 for 1/320 sec., ISO 200

Although not often called upon to create singular-theme images, the wide-angle lens can be a useful tool for isolating subjects *if* you combine the close-focusing abilities of the lens with an isolating aperture such as *f*/2.8 or *f*/4. Here, because of a large lens opening, the depth of field is severely limited, keeping the visual weight of the image where I wanted it: on the face of the young boy in the Chandni Chowk Market of Old Delhi.

Nikon D800E, Nikkor 24–120mm at 35mm, *f*/4 for 1/800 sec., ISO 100

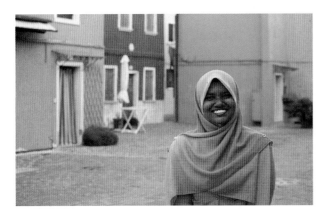

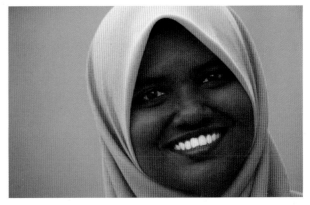

Rendering colorful backgrounds is an easy proposition if you combine the use of a telephoto lens, a large lens opening, and a colorful background subject. Take a look at this portrait (right). I used a telephoto lens and shallow depth of field to render the background an area of colorful muted tones. The woman was about 30 feet from the background, a green house on the island of Burano, Italy. Like me, she was a tourist, but unlike me, she was going to medical school in Prague, was from Malaysia, and was taking time off from school to do a bit of traveling. Little did she know when she woke up that morning that she would be shot by all eight of my students and myself as well! I know her in-box was filled with wonderful portraits of herself by the end of this particular evening.

Right image: Nikon D800E, Nikkor 70–300mm at 280mm, *f*/6.3 for 1/320 sec., ISO 100

"WHO CARES?" APERTURES

If it's not a storytelling opportunity and it's not a singular-theme/isolation opportunity, does it really matter what aperture you use? Yes and no. Let me explain. The world is filled with "who cares?" compositions: "Who cares what aperture I use when shooting a portrait against a stone wall?" "Who cares what aperture I use when shooting autumn leaves on the forest floor?" Or, put another way, "Who cares what aperture I use when everything in my frame is at the same focused distance?"

In the storytelling and singular-theme/isolation sections, not one of the images was made with an aperture of f/8 or f/11. That's certainly not because I never use those apertures; I use them a lot actually,

but *only* when depth of field is not a concern. Both f/8 and f/11 are what I refer to as middle-of-the-road apertures; they rarely tell a story (rendering all the visual information within a great depth in sharp focus), and they rarely isolate (rendering only a limited, selective amount of visual information in sharp focus).

Pretend for a moment that you find yourself walking along a beach. You come upon a lone seashell that has washed up on the smooth sand. You raise your camera and 28–80mm lens to your eye, set the focal length to 50mm, look straight down, and then simply set the aperture to f/8 or f/11. In this instance, both the lone seashell and

Who cares what aperture I use for this wonderful remnant of a painted portrait at a once bustling cement plant in Montreal, Quebec? The face and of course the wall that it is painted on are both at the same focused distance, and so concerns about the right depth of field were nonexistent. And with a "who cares?" opportunity, it's time for f/8 or f/11. Handholding my camera and 70–300mm lens, I set

my aperture to f/8, pointed my camera at *only* the wall, adjusted the shutter speed until 1/400 sec. indicated a correct exposure, and fired off several frames with subtle shifts in the overall composition.

Right image: Nikon D800E, Nikkor 70–300mm, f/8 for 1/400 sec., ISO 100. (1) at 70mm, (2) at 240mm

the sand are at the same focused distance, and so you could photograph this scene at any aperture. This approach of "not caring" about what aperture you use applies to any composition in which the subjects are at the same focal distance. However, rather than randomly choose an aperture as some shooters do, I recommend that you use the *critical aperture*. This is simply whichever aperture yields the optimum image sharpness and contrast. Apertures from *f*/8 to *f*/11 are often the sharpest and offer the greatest contrast in exposure.

To understand why apertures between *f*/8 and *f*/11 are so sharp, you need to know a little bit about lens construction and the way light enters a lens. Most lenses are constructed of elliptically shaped glass elements. Imagine for a moment that within the central area of these elliptical elements is a magnet—which is often called the "sweet spot"—designed to gather a specific amount of light and then funnel it through to the waiting sensor (or film). The approximate diameter of this sweet spot is equivalent to the diameters of *f*/8 to *f*/11. Thus, for example, when the light enters a lens through a wide-open aperture such as *f*/2.8, the amount of light exceeds the area of the sweet spot and scatters across the entire elliptical range and onto the sensor. The effect is similar to pouring milk onto an upside-down bowl: Only a little milk remains on the center, whereas most of the milk spills off to the sides. As a result of the scattering of the light, a wide-open aperture doesn't provide the kind of edge-to-edge sharpness that apertures of *f*/8 to *f*/11 can. When light passes through apertures of *f*/8 to *f*/11, it is confined to the sweet spot on the elliptical glass.

So, who cares what aperture you use when shooting compositions in which depth-of-field concerns are minimal at best? You should! And ironically, you should use "who cares?" apertures (*f*/8–*f*/11) if you want critical sharpness and great contrast.

As I was coming around one of the corners of the narrow streets of the Chandni Chowk Market in Old Delhi, I almost stumbled into the woman you see above. She was seated just under a rainbow of color, and I immediately thought "background." Within seconds, I was on my knees, looking up at her against the colorful umbrella behind her. The even light and the midtones of all the colors presented me with an easy exposure; I could have easily shot this in Aperture Priority mode, but I didn't. With my aperture set to *f*/9, I quickly adjusted the shutter speed until 1/160 sec. indicated a correct exposure and then fired off several frames. Her name was Ella, and aside from the wide smile she gave me when I showed her the picture I had taken of her, that was all I was able to get out of her.

Bottom image: Nikon D800E, Nikkor 24–120mm at 50mm, *f*/9 for 1/160 sec., ISO 200

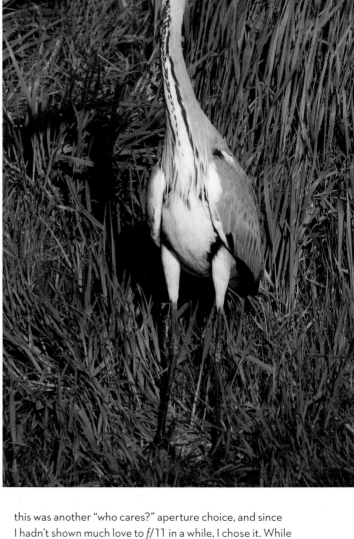

I do not have the patience for wildlife photography, but I am not going to run away from it when the opportunity presents itself, as it did on this warm afternoon in West Friesland, Holland.

After pulling off a small country lane, I managed to get off a number of frames of this heron, which was far more interested in getting its next meal than in me. Considering the "wall" of green grass behind it, this was a no-brainer;

this was another "who cares?" aperture choice, and since I hadn't shown much love to f/11 in a while, I chose it. While framing up the heron, I quickly adjusted my shutter speed until 1/250 sec. indicated a correct exposure.

Right image: Nikon D800E, Nikkor 70–300mm at 300mm, f/11 for 1/250 sec., ISO 100

Despite the complexity of this composition, do not lose sight of a simple fact: almost everything in it is at the same focused distance, and thus it presents another "who cares?" opportunity. And considering the even illumination of this scene, you can even shoot in Aperture Priority mode if you wish (as I did) and you will be happy with the exposure, I am sure (as I was).

I had spent most of my morning shooting in Old Jodhpur, India, and a feeling of complacency was starting to take hold since it had been a truly bountiful morning.

In this particular instance I was quick to remind myself, "Pretend this is the first start to your day. You do not live in Jodhpur, India, so who knows when you will get back this way again?"

Nikon D3X, Nikkor 24–85mm at 35mm, *f*/9 for 1/200 sec., ISO 200

There was a time when you could go to Paris and add your own "love story" via a padlock to an already crowded bridge of "love-locks," but shortly after this photograph was made, the mayor of Paris announced the locks would all be removed, as their weight was a potential hazard to the structure of the bridge to which they were all attached.

Perhaps you could care less, and in this case that would actually be an appropriate response, at least, when the locks were still there. You see, this is merely another "who cares?" aperture opportunity since all of the locks are at the same focused distance.

Since everything is at the same focused distance, just choose *f*/8, *f*/9, f/10, or f/11 and then adjust your shutter speed until a correct exposure is indicated. That's all there is to it, really! And you thought love was hard.

Nikon D800E, Nikkor 24–120mm at 120mm, *f*/11 for 1/200 sec., ISO 200

APERTURE AND MACRO PHOTOGRAPHY

Close-up, or macro, photography continues to be popular with both amateurs and professionals. Although such obvious subjects as flowers and butterflies and other insects are ideal for beautiful close-up images, don't overlook other close-up opportunities that await you in junkyards and parking lots. In my courses, I've noticed more and more that my students are turning their macro gear toward the abstract and industrial worlds and coming away with some truly compelling close-ups.

When it comes to working at such close proximity to your subject, you'll soon discover that many of the same principles about aperture in the "big world" apply equally to the small world of the close-up. For instance, although the world is smaller—much, much smaller in some cases—you still must decide if you want great depth of field (1 to 2 inches of sharpness in the macro world) or limited depth of field ($^1/_4$ of an inch). Or maybe your subject is a close-up that falls into the "who cares?" aperture category.

There are differences between regular photography and macro photography, however.

When you shoot close-ups, it's not at all uncommon to find yourself on your belly, supporting your camera and lens with a steady pair of elbows, a small beanbag, or a tripod with legs level to the ground. The slightest shift in point of view can change the focus point dramatically. And since the close-up world is magnified, even the slightest breeze will test your patience—what you feel as a 5-mph breeze appears as a 50-mph gust in your viewfinder.

In addition, since depth of field *always* decreases as you focus closer and closer to your subject, the depth of field in macro photography is extremely shallow. The depth of field in close-up photography extends one-fourth in front of and one-half beyond the focused subject, whereas in regular photography the depth of field is distributed one-third in front of and two-thirds beyond the focused subject. Needless to say, critical focusing and, again, a steady pair of elbows, a beanbag, or a tripod are essential in recording exacting sharpness when you are shooting close-ups.

If you haven't noticed just how quickly depth of field diminishes when you focus close with your telephoto lens, you will surely notice it when you start shooting with a macro lens or a combination of a telephoto lens and either a close-up filter or an extension tube. Simply put, the closer you focus with *any* lens, the shallower the depth of field becomes, and the only antidote for this visual phenomenon is to be as parallel to the subject as possible and shoot at the smallest possible aperture(s).

To further illustrate the rapid fall-off of sharpness when you are focusing close, notice in the image above, left, that one of my students is holding some flowers. These flowers will soon be held up in the background to provide some out-of-focus color. As you look at the resulting photograph on the right and remember that one of my students was holding a flower mere inches from the stalk of grass, what aperture do you suppose allowed me to render the background flower out of focus? Most of you are guessing an aperture of *f*/5.6 to *f*/8, yet in the world of close-up photography, all of what we learned about singular-theme/isolation exposures is now pretty much useless. This image was shot at *f*/18! This is a normally "massive" depth of field on a wide-angle lens and at least a moderate depth of field on a telephoto lens, but with a macro lens, it is merely inches of depth of field, or in this case fractions of inches. It bears repeating: The closer you focus with any lens, the progressively shallower the resulting depth of field becomes!

Right image: Nikon D300S, Micro Nikkor 105mm, *f*/18 for 1/160 sec., ISO 200, tripod

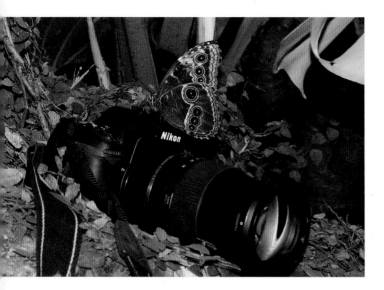

At no time is an exacting point of view more critical than when shooting extremely detailed close-ups. Without fail, it is vitally important that your camera's film plane is parallel to the subject you are shooting. Do not approach the subject at an angle unless you are deliberately trying to create a shallow and very narrow line of focus. From a moderate distance of about 1 foot, I was able to frame up this butterfly, resting comfortably on a fellow student's camera. It seemed to me that the butterfly was quite happy to be settled in on the camera so I moved in closer, so close that I could not focus any closer. With my camera and 105mm Micro lens on tripod, and an aperture of *f*/11, I adjusted the shutter speed until a 1/100 sec. indicated a correct exposure and then proceeded to fire off several frames of this extreme close-up of its folded wing. It was essential that I choose a point of view with my camera's film plane parallel to the wing of the butterfly. It's situations like this that will test your patience when shooting macro images, but stay the course! I promise that the rewards will far outweigh the moments of frustration when you find your focus was off just a bit!

Right image: Nikon D800E, Micro Nikkor 105mm, *f*/11 for 1/100 sec., ISO 200, tripod

Do you need an excuse to visit your local junkyard? Well then, here it is: Fine art close-up shots are yours for the taking. On countless workshops over these past fifteen years, I have taken many students to junkyards and although many are reluctant in the beginning, most of the students do not want to leave when they hear it's time to go.

Color and textures abound in these junkyards and the opportunity to practice effective composition is at every turn. Still, it's absolutely vital that you keep your point of view first and foremost in your mind as you move from one subject to the next. Sharpness must reign supreme with most of these "fine art" compositions, and that means keeping the camera's film plane totally parallel to the subject! A tripod is essential, too.

Rummage through the scrap heap long enough and you are bound to see several "landscapes" for the taking, when seen through the eyes of a macro lens. Coming upon a tired and worn out boat trailer in a Santorini, Greece, harbor proved to be another one of those "fine art" gold mines. I had a really hard time to get the students to turn away and shoot some nearby crashing surf against the backlight of the setting sun! As for yourself, make this single discovery reason enough to get off that couch or push yourself away from the office desk and start finding your own landscapes amongst the rubble of the local junkyard!

Top image: Nikon D800E, Micro Nikkor 105mm, *f*/18 for 1/100 sec., ISO 200, tripod

SHUTTER SPEED

THE IMPORTANCE OF SHUTTER SPEED

The function of the shutter mechanism is to admit light into the camera—and onto the digital media or film—for a specific length of time. All SLR cameras, digital or film, and most digital point-and-shoot cameras offer a selection of shutter speed choices. Shutter speed controls the effects of motion in your pictures, whether that motion results from you deliberately moving the camera while making an image or from your subjects moving within your composition. Fast shutter speeds freeze action, and slow ones can record the action as a blur.

Until now, our discussion has been about the critical role aperture plays in making a truly creative exposure. That's all about to change as shutter speed takes center stage. There are two situations in which you should make the shutter speed your first priority: when the scene offers motion or action opportunities and when you find yourself shooting in low light without a tripod. The world is one action-packed, motion-filled opportunity, and choosing the right shutter speed first and then adjusting the aperture is the order of the day for capturing motion in your images.

Not only did the rain bring out the rich colors of this Singapore street scene, it also meant that the day was darker than a normal sunny day. As a result, I was able to use slower shutter speeds that would make some wonderful and color-filled compositions of motion.

Notice the rain-soaked bikes along the railing that borders Serangoon Road in Little India. Now let's turn our attention to just one of those bikes, a bike that is parked directly in front of a bus stop. If my hunch is correct, we should be able to record a vivid streak of color directly behind that bicycle as the fast-moving buses head down Serangoon Road.

With my camera and 70–300mm lens mounted on tripod and with my aperture set to f/16, I was able to get a correct exposure indication at 1/2 sec. shutter speed—perfect! I tripped the shutter release on my camera with my locking cable release just as the bus zoomed past the bike, and during this 1/2 sec. exposure I recorded a streak of very vivid color. Voilà; it turned out exactly as I had envisioned. Get in the habit of shooting motion-filled subjects while focusing on a stationary subject and you will soon discover this still-untapped reservoir of compelling images.

Above image: Nikon D800E, Nikkor 70–300mm at 300mm, f/16 for 1/2 sec., ISO 200, tripod

THE RIGHT SHUTTER SPEED FOR THE SUBJECT

If ever there was a creative tool in exposure that could "turn up the volume" of a photograph, it would have to be the shutter speed. It is *only* via the shutter speed that photographers can freeze motion, allowing the viewer's eye to study the fine and intricate details of subjects that otherwise would be moving too quickly. And *only* with the aid of the shutter speed can photographers imply motion, emphasizing existing movement in a composition by panning along with it.

As an example, the waterfall is one of the most common motion-filled subjects. When shooting them, you can creatively use the shutter speed two ways. You can either freeze the action of the water with a fast shutter speed or make the water look like cotton candy with a much slower shutter speed. Another action-filled scene might be several horses in a pasture on a beautiful autumn day. Here you can try your hand at panning, following and focusing on the horses with the camera as you shoot at shutter speeds of 1/60 or 1/30 sec. The result will be a streaked background that clearly conveys the action with the horses rendered in focus. Freezing the action of your child's soccer game is another motion possibility. Any city street scene at dusk is yet another. Using shutter speeds as slow as 8 or 15 seconds (with a tripod, of course) will turn the streets into a sea of red and white as the headlights and taillights of moving cars pass through your composition.

I have often told my students that when shooting street photographs, they should make it a point to stay put for at least 1 hour during the course of the day. In other words, lean on a lamppost or up against a wall. Trust me; the action will come to you.

I found myself hanging out recently on a street corner in Chandni Chowk Market in Old Delhi, and soon I was setting up my camera and 24–120mm lens on my tripod and deliberately choosing to shoot motion-filled compositions of the flurry of nonstop activity that was unfolding before me. I had fired off about twenty frames when I saw the shopkeeper across the street take notice of me, and although it was obvious to anyone that my camera was pointed in the direction of his shop, he had no idea that I was shooting at really slow shutter speeds and recording a lot of blurry people. Fortunately for me, he seemed to think I was shooting his colorful shop, and so he took a seat, facing head-on into the camera, and I smiled at my good fortune. After shooting another thirty or forty frames I felt confident that I had several good shots, and this was certainly one of them.

Nikon D800E, Nikkor 24–120mm at 33mm, *f*/16 for 1/15 sec., ISO 100

BASIC SHUTTER SPEEDS

Although standard shutter speeds are indicated on the shutter speed dial or in your viewfinder as whole numbers—such as 60, 125, 250, and 500—they are actually fractions of time (i.e., fractions of 1 second): 1/60 sec., 1/125 sec., 1/250 sec., and 1/500 sec. If you bought your camera recently, you may find that it offers shutter speeds that fall between these numbers, for example, going from 1/60 sec. to 1/80 sec. to 1/100 sec. to 1/125 sec. to 1/160 sec. to 1/200 sec. to 1/250 sec. and so on. These additional shutter speeds are useful for fine-tuning your exposure, and I discuss this idea in greater detail in the chapter on light.

In addition to these numbers, most cameras offer a B setting as part of the shutter speed selection. B stands for "bulb," but it has nothing to do with electronic flash. It's a remnant from the early days of picture taking, when photographers made an exposure by squeezing a rubber bulb at the end of the cable release, which was attached to the camera shutter release. Squeezing the bulb released air through the cable, locking the shutter in the open position until the pressure on the bulb was released. Today, when photographers want to record exposures that are longer than the slowest shutter speed the camera will allow, they use the B setting, along with a cable release and a tripod or very firm support.

At the end of the Charles Bridge, while I was waiting for the light to change, several bright red trams passed right before me and I noticed that the crowd around me was reflected in the glass windows of the tram. I also noticed the nearby traffic light, and that was when I got the idea to frame up the light on the right side of a composition and, I hoped, be able to fill up the frame with a moving train. It didn't take me long to set up, and once in place, I was merely waiting for one of those bright red trams.

With my camera and 17–35mm lens mounted on tripod and my exposure set for f/16 at 1/15 sec., I knew I would record a motion-filled streak of color as the train passed by (literally within 3 feet of me) in addition to a reflection of waiting people in the windows of the train. As you can see here, my hunch paid off.

Nikon D800E, Nikkor 17–35mm at 20mm, f/16 for 1/15 sec., ISO 100, tripod

FREEZING MOTION

The first photograph I ever saw that used the technique of freezing action showed a young woman in a swimming pool throwing back her wet head. All the drops of water and the woman's flying hair were recorded in crisp detail. Since the fast-moving world seldom slows down enough to give us time to study it, pictures that freeze motion are often looked at with wonder and awe.

More often than not, to freeze motion effectively you must use fast shutter speeds. This is particularly critical when the subject is moving parallel to you, such as when a speeding race car zooms past the grandstand. Generally, these subjects require shutter speeds of at least 1/500 or 1/1000 sec. Besides race cars on a track, there are many other action-stopping opportunities. For example, the shoreline provides a chance to freeze the movement of surfers as they propel themselves over the water. Similarly, rodeos enable you to freeze the misfortunes of falling riders. And on the ski slopes, you can capture snowboarders soaring into the crisp cold air.

When you want to freeze any moving subject, you need to consider three factors: the distance between you and the subject, the direction in which the subject is moving, and your lens choice. First, determine how far you are from the action. Ten feet? One hundred feet? The closer you are to the action, the faster the shutter speed must be. Next, determine whether the action is moving toward or away from you. Then decide which lens is the most appropriate one.

For example, if you were photographing a bronco rider at a distance of 10 to 20 feet with a wide-angle or normal lens, you'd have to use a shutter speed of at least 1/500 sec. to freeze the action. If you were at a distance of 100 feet with a wide-angle or normal lens, his size and motion would diminish considerably, so a shutter speed of 1/125 sec. would be sufficient. If you were at a distance of 50 feet and using the frame-filling power of a 200mm telephoto lens, 1/500 sec. would be necessary (just as if you were 10 feet from the action). Finally, you'd need a shutter speed of 1/1000 sec. if the bronco rider was moving parallel to you and filled the frame (through your lens choice or your ability to physically move in close).

MOTOR DRIVES

Most cameras today come fully equipped with a built-in motor drive or winder that allows photographers to attain a higher degree of success when recording motion. Without the aid of a motor drive or winder, it's often a hit-and-miss proposition as you try to anticipate the exact right moment to fire the shutter. With the aid of a winder or motor drive, you can begin firing the shutter several seconds ahead of the peak action and continue firing through until a second or two afterward, and it's a very safe bet that one—if not several—of the exposures will succeed! Depending on your camera, you may have one "continuous shooting mode" speed or several. Some cameras offer a "low" mode, which fires off about two frames per second, and others offer also offer a "high" mode, which can fire off upward of seven frames per second.

If you are a fan of some truly beautiful graffiti and if you are in Chicago or are coming soon, you won't be at all disappointed with the remarkable display of talent in the Pilsen neighborhood in that city. Among the many fun photo things I did on this particular afternoon with my willing model, Aya, photographing her "jumping" for the ball in front of a soccer mural produced the image that provided the most laughter. It may be hard to imagine at first glance, but Aya is of course the one seen jumping in the middle of the composition, wearing her dark jacket and red sweater. There are several keys to why she blended in so well to this mural, and the first of course is the correct use of a fast shutter speed that would fully freeze the action of her jump, catching her at the top of the jump. The use of the camera's CH (Continuous High) setting also meant that during this 1/800 sec. shutter speed, the camera would fire off several frames, further assuring me that one of the three or four images I would be taking in rapid succession would be the one!

Above image: Nikon D800E, Nikkor 24–120mm at 70mm, ƒ/6.3 for 1/800 sec., ISO 200

ABOVE: If not for the need to use the Porta-Potty, I would not have come across this part of the motocross track where the bikers were coming off a large jump, hidden behind the pine trees. There was plenty of time to set this shot up, too, since each race had as many as twelve to fifteen riders. As the first few came through, I was able to set my focus, manually focusing on the area through which they all seemed to be flying. With the camera and a 70–300mm lens mounted on tripod and with my ISO set to 200, I was able to use an aperture of *f*/13 and still maintain the action-stopping speed of 1/500 sec. I wanted the extra depth of field just in case my focus was off a bit, and when it was all said and done, I ended up with a number of good shots, such as the one you see here.

Nikon D3X, Nikkor 70–300mm at 240mm, *f*/13 for 1/500 sec., ISO 200

OPPOSITE PAGE: I knew this brightly lit house in Italy would make for a very graphic and colorful exposure *if* I could persuade one of my fellow photographers to take to the air like a young and limber Mary Poppins. With the aid of a colorful umbrella for contrast, I was able to get the very talented photographer Susana Heide Schellemberg to do this.

Since the action would be going up and down, a shutter speed of at least 1/500 sec. would be necessary. With my shutter speed set to 1/500 sec., all that remained was to set a correct exposure for the late-afternoon frontlight that was hitting the colorful wall. I metered off of the wall and adjusted my aperture until *f*/10 indicated a correct exposure. I was now all set, and within a minute or so, the resounding applause from the students who had photographed her jump confirmed that 1/500 sec. was the action-stopping speed we needed.

Nikon D800E, Nikkor 24–120mm at 120mm, *f*/10 for 1/500 sec., ISO 200

One of my favorite setups to shoot falling objects is in the great outdoors, out on my deck, taking full advantage of midday light. Yes, I shoot during that god-awful time of day called high noon. You can get some really cool studio flash-like exposures when shooting at midday, and you can work on your tan while doing so. Now that's some darn good time management!

In the first image, you will see my setup for shooting falling food photographs. Along with a simple glass vase filled with bubbly mineral water that is sitting atop a small table and an open reflector, *silver side up*, I have added a seamless blue backdrop (nothing more than a large piece of colored poster-size paper that can be found at any art supply store). My camera, along with the macro lens, is mounted on tripod, set to focus close on what will soon be fruits falling very fast through this water (strawberries in

this case). With an ISO of 800, I am able to record a correct exposure at *f*/10 at 1/2000 sec., a shutter speed that is just fast enough to freeze the action of the strawberries as they move quickly through the water

Once I was all ready to go, I asked my daughter Sophie to drop a single strawberry into the water, and after a few minutes of repeating this task I discovered that I had recorded too many images in which the strawberry either was not far enough into the composition or had dropped too near the bottom of the composition, but by golly, in and among all of these missed opportunities, (eighty-seven to be exact), I found several jewels, one of which you see here.

Right image: Nikon D3X, Micro Nikkor 105mm, *f*/10 for 1/2000 sec., ISO 800

PANNING

Unlike photographing motion while your camera remains stationary (as described on the previous pages), panning is a technique photographers use in which they deliberately move the camera parallel to—and at the same speed as—the action. Most often, slow shutter speeds are called for when panning: from 1/60 sec. down to 1/8 sec.

Race cars, for example, are a common panning subject. To shoot them from your spot in the grandstand you would begin to follow a race car's movement with your camera as the car entered your frame. Next, while holding the camera, you would simply move in the same direction as the car, left to right or right to left, keeping the car in the same spot in your viewfinder as best you could and firing at will. You should make a point to follow through with a smooth motion. (Any sudden stop or jerky movement could adversely alter the panning effect.) The resulting images should show a race car in focus against a background of a streaked colorful blur.

The importance of the background when panning cannot be overstated. Without an appropriate background, no blurring can result. I'm reminded of one my first attempts at panning years ago. Two of my brothers were playing Frisbee. With my camera, a 50mm lens, and a shutter speed of 1/30 sec., I shot over twenty exposures as the toy streaked across the sky. Twenty pictures of a single subject seemed almost nightmarish to me back then, but I wanted to be sure I got at least one good image. Unfortunately, not a single image turned out! With the Frisbee against only a clear and solid-blue sky, there was nothing behind it to record as a streaked background. Keep this in mind; panning is a good reason to take note of potentially exciting backgrounds.

I use a tripod frequently, but when it comes to panning, a tripod can be a hindrance. (I can hear the roar of thunderous applause!) But keep in mind that since you're panning moving subjects, you must be free to move, so *do not* lock down the tripod head—keep it loose so that it is free to move left to right or right to left as the case may be.

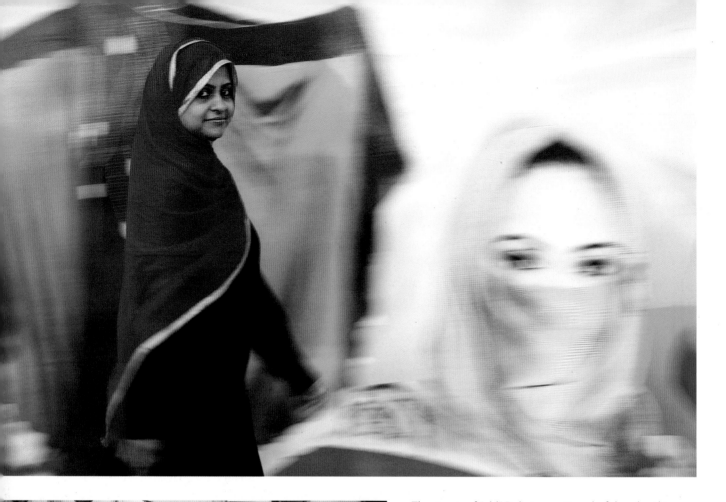

The streets of "old" Dubai are quite colorful, and nothing will add more to a successful panning shot than a colorful background. Fortunately for the students in this workshop, we had a willing model to simply walk down the street while we panned her. In fact, Fatina was gracious enough to walk back and forth until all the students were satisfied with their panning attempts. I purposely chose this particular wall for Fatina to walk in front of because of the background of painted murals of models wearing similar clothing.

Handholding my camera and 24–120mm lens and with my shutter speed set to 1/20 sec. *and* with my camera in Shutter Priority mode, I made several exposures as Fatina walked from left to right as she passed in front of the wall of painted models.

Of the three images that I shot, this one is the sharpest and most effective.

The reason I chose to shoot in Shutter Priority mode was simple. The light was even throughout this scene, and there were no excessively bright or excessively dark areas that might fool the light meter.

Above image: Nikon D800E, Nikkor 24–120mm at 100mm, *f*/18 for 1/20 sec., ISO 100

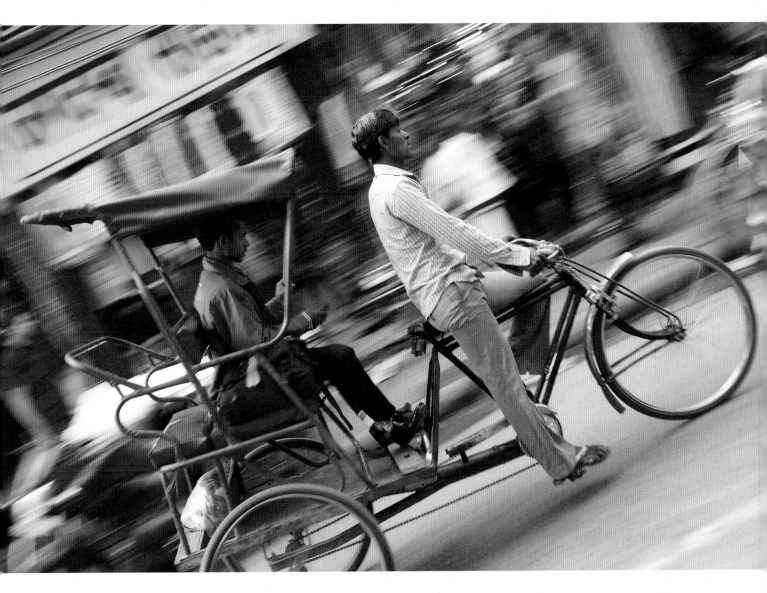

Once again I found myself in Chandni Chowk Market in Old Delhi, and over the course of one hour, I shot more than several hundred shots of bicycle taxis as they traveled down this very colorful street. Successful panning relies not only on a steady hand and fluid motion but also a colorful background for contrast. Of the more than two hundred images I shot that morning, fourteen of them were keepers. The remaining images all suffered from an absence of sharpness that resulted from my not being steady or moving too fast or slow as I tried to follow the subject. So why keep "soft" images? I have a hunch that there may come a program that will sharpen up images that are just a wee bit off in their initial sharpness. Yes, I know about sharpening images in Photoshop, but using that sharpening tool assumes that your image is already in focus. I did recently see a camera phone that will sharpen an otherwise blurred subject, so why not bring this technology to the DSLR? Maybe it's already on the way. We'll see.

Nikon D800E, Nikkor 24–120mm at 50mm, *f*/22 for 1/25 sec., ISO 100

IMPLYING MOTION

When the camera remains stationary—usually on a firm support such as a tripod—and there are moving subjects, the photographer has an opportunity to imply motion. The resulting image will show the moving subject as a blur, whereas stationary objects are recorded in sharp detail. Waterfalls, streams, crashing surf, airplanes, trains, automobiles, pedestrians, and joggers are but a few of the more obvious subjects that will work. Some of the not so obvious include a hammer striking a nail, toast popping out of the toaster, hands knitting a sweater, coffee being poured from the pot, a ceiling fan, a merry-go-round, a seesaw, a dog shaking itself dry after a dip in the lake, windblown hair, and even a rustling field of wildflowers.

Choosing the right shutter speed for many of these situations is often a matter of trial and error. If ever there was a time to embrace the digital camera, this would be it. Unlike in years past, the cost of trial and error is no longer almost prohibitive because of film processing prices. Digital camera LCD screens offer another advantage, since they instantly show the results of your shutter speed choices.

If slow shutter speeds can work for water, why not for industrial sparks? This past spring I was afforded the opportunity to shoot some blue-collar workers in Dubai, something I had never done before.

With my camera and lens mounted on my tripod and at a focal length of 300mm, I chose a 1/2-sec. shutter speed—the same speed that has worked so well for waterfalls and streams over the years. As the pipe lay on the track, the man would bear down on the cutting handle, and that would send the sparks flying! It was all over in about eight seconds, but this was his job for the next eight hours, so I didn't have to wait long for him to start cutting another section of steel pipe. It is important to mention that I set my exposure off the light reflecting from the man's shirt and *before* sparks started flying. This assured me that the man would have the correct exposure yet the sparks would be a bit overexposed. If we only saw sparks, how could we account for them?

Nikon D800E, Nikkor 70–300mm at 300mm, *f*/11 for 1/2 sec., ISO 400, tripod

There are certainly some general guidelines to follow for implying motion, and if nothing else, they can provide a good starting point for many of the motion-filled situations that abound. For example, 1/2 sec. will definitely produce the cotton effect in waterfalls and streams. An 8-second exposure will reduce the headlights and taillights of moving traffic to a sea of red-and-white streaks. A 1/4-sec. exposure will make hands knitting a sweater appear to be moving at a very high rate of speed. A wind of 30 mph moving through a stand of maple trees, coupled with a 1-second exposure, can render stark and sharply focused trunks and branches that contrast with wispy, windblown, overlapping leaves.

Silver Falls State Park in Oregon continues to be one of my favorite locations for waterfall shooting, and the two best times are late spring and fall. Waterfalls are perhaps the most sought-after motion-filled subject among amateur photographers. In this image, there are a few things working in my favor to get that slow shutter speed. With my tripod-mounted camera, I have chosen a viewpoint to include foreground leaves. This means that for depth-of-field reasons, I will be using the smallest aperture of f/22. Interestingly enough, f/22 assures that I'll record the slowest possible exposure with my setting of ISO 100. (The smallest aperture number in use will always guarantee the slowest possible shutter speed.)

Additionally, the heavy overcast conditions meant it would be dark in the woods, which further supported my need for a long exposure. Finally, I am a big believer in using a polarizing filter on overcast/rainy days (to reduce, if not eliminate, the dull gray glare off the surface of the water and surrounding flora), and I knew that the 2 stops of light reduction with the filter would also force a much slower shutter speed. The resulting long exposure accounts for the soft water, and f/22 accounts for the front-to-back storytelling sharpness. (During this 2-second exposure a slight breeze came up; this is why the "softness" of the leaves is evident in a few of the branches.)

Nikon D800E, Nikkor 24–85mm at 35mm, f/22 for 2 sec., ISO 100, tripod

EXERCISE: MOTION WITH A STATIONARY CAMERA

Shooting movement while the camera remains stationary *relative to the subject* offers an array of possibilities. Try your hand at this exercise the next time you visit the local playground or amusement park. I promise it will help you discover many more motion-filled subjects. At a playground, find a swing set with a stand of trees in the background. As you sit in the swing with your camera and wide-angle lens, set the shutter speed to 1/30 sec. and point and focus the camera on your outstretched legs (preferably with bare feet). Then adjust the aperture until a correct exposure is indicated by the camera's meter. All set? Start swinging (keeping both arms carefully wrapped around the chains or ropes of the swing, of course). Once you get a good swinging action, press the shutter release. Don't hesitate to take a number of exposures. The results will be sharp legs surrounded by a sea of movement—an image that says, "Jump for joy, for spring has sprung!"

Next, move to the seesaw. Place the camera so that its base rests flat on the seesaw about a foot in front of where you'll be sitting. Focus on the child or adult sitting on the other end with your shutter speed set to 1/8 sec. and then adjust the aperture. Then begin the up-and-down motion of the ride—keeping one hand on the camera, of course—and shoot a number of exposures at different intervals while continuing to seesaw. The end result is a sharply focused person against a background of streaked blurs.

At an amusement park, walk over to the merry-go-round and hop on. Wait until the ride gets moving at a good pace, and with the shutter speed set to 1/30 sec., focus on a person opposite you. Adjust the aperture and fire away. The end result is once again a sharply focused person against a background of swirling streaks. Would that make a great advertisement for Dramamine or what?

OPPOSITE PAGE: If there is one tool that can truly change the way the world looks, it would be what is often referred to as the Big Stopper, which is a very dark filter that allows you to record substantially longer exposure times. Normally, one would have to wait for dusk to shoot 30-second or 1-minute exposures, but with any 10-stop neutral-density filter, you can start shooting long exposures at high noon. Once this filter is threaded onto the front of your lens, you will have trouble seeing anything. That is why it is vitally important that you first set up a pleasing composition, determine the slowest possible exposure without benefit of the filter, have the camera in full manual exposure mode, have your locking cable release hooked up to the camera, and set your shutter speed dial so that B is showing. If it isn't obvious, you also need to put the camera on a tripod.

At a "normal" exposure and without benefit of any filters, the slowest exposure I can record of the Chicago skyline with an ISO of 50 is f/32 at 1/15 sec. With the 10-stop filter in place, I must now "add" ten stops of exposure; f/32 at 1/8 sec. (+1-stop), f/32 at 1/4 sec. (2-stops), f/32 at 1/2 sec. (3-stops), f/32 at 1 sec. (+4-stops), f/32 at 2 sec. (+5-stops), f/32 at 4 sec. (+6 stops), f/32 at 8 sec. (+7 stops), f/32 at 16 sec. (+8 stops), f/32 at 32 sec. (+9 stops), and f/32 at 64 sec. (+10 stops).

With my stopwatch engaged at the moment I click the shutter with my locking cable release, and with my shutter speed dial set to B, I release the shutter and 64 seconds later I have recorded the movement of the clouds overhead.

Both images: Nikon D800E, 24–85mm at 85mm, ISO 50, tripod, (left) f/32 for 1/8 sec.; (right) ND filter, f/32 for 64 sec.

ABOVE: Using this filter is not limited to clouds, and so I recommend that you head out the door and try these long exposures the next time you are in the woods or even Times Square—your 1- to 2-minute exposures could turn Times Square into a sea of colorful motion! But this is *not* a filter to call upon when you are shooting star trails. In fact, you don't need any filter when shooting star trails at night. It's already dark enough!

With my camera and 70–300mm lens on tripod and with *only* an added polarizing filter, I was able to record an exposure time of 4 seconds on this very stormy day of wind and rain in Oregon's Willamette Valley. I had come across a tree farm, and the timing could not have been better since many of the trees were full of fall color blooms and the windy condition also meant I would record some "painterly" effects as the leaves were being tossed about by the wind during the 4-second exposure. This was certainly one of my favorite images from that day, and it bears repeating: Inclement weather should be embraced with zeal, for it allows us to achieve some very creative exposures and compositions that a "perfect" sunny 75-degree day just can't offer.

Right image: Nikon D800E, Nikkor 70–300mm at 220mm, f/32 for 4 sec., ISO 50 (LO 1.0), tripod, polarizing filter

IMPLYING MOTION WITH STATIONARY SUBJECTS

How do you make a stationary subject "move"? You zoom in on it or otherwise move the camera during the exposure. In other words, you press the shutter release *while* zooming the lens from one focal distance to another or *while* moving the camera upward, downward, from side to side, or in a circle.

Zooming the lens while pressing the shutter release will produce the desired results, *but not without practice*. Don't be disappointed if your first few attempts don't measure up. For those of you using a point-and-shoot digital camera, you may feel your patience being tried. Unless you can figure out a way to override the motorized zooming feature on your camera (and you'd be the first to make this discovery, by the way), you'll be unsuccessful in your attempts. The biggest reason for this is that these cameras won't let you change any settings (this includes zooming) while the exposure is being made.

With my camera and 24–85mm lens on a tripod, I first composed the lone tree you see here at a focal length of 24mm. Directly behind this tree was a wall of colorful pipes, and it was a welcome background! With my aperture set to *f*/22, I adjusted the shutter speed until 1/30 sec. indicated a correct exposure and shot the first composition (top, left). But let's have some fun and start making some e-motion-filled images!

With the aid of my polarizing filter I was able to render an exposure of *f*/22 at 1/8 sec. (The polarizer reduced the intensity by 2 stops, so I have to recover those 2 stops by adding 2 stops more of time to my shutter speed: *f*/22 at 1/30 sec. to 1/15 sec. (1 stop), 1/15 sec. to 1/8 sec. (2 stops). In terms of their quantitative value, both exposures are still the same, but look what I can do when I quickly zoom the lens from 24mm to 85mm during this 1/8-sec. exposure!

Case in point: The first shot I made of the tree and the colorful wall is sharp and correctly exposed, and it's a good shot but perhaps a bit ho-hum. But when I handhold the camera and simply move it in an upward direction while pressing the shutter release, do I produce *art* (bottom, left)? Well, how about this next trick?

This is a rather simple technique, but you will want to call upon your wide-angle zooms first and foremost *and* your polarizing filter.

Remember that when we are creating these abstract works of art, we are calling upon the polarizing filter primarily to decrease the intensity of the light, thus allowing us to use slower than normal shutter speeds while maintaining a correct exposure. With my 24–85mm set to the focal length of 24mm, I rotated the camera in a right-to-left circular motion as if drawing a circle, and at the same time, with my left hand, I zoomed the lens from 24mm to 85mm. Keep in mind that all of this took place in 1/8 sec., so you are right to assume that one must be quite fast in turning the camera in that circular motion and zooming at the same time. The spiral effect that results (top, middle), as if water is going down a drain, is *not* something you do in Photoshop but right here in camera! Are we having fun or what!?

All images: Nikon D800E, Nikkor 24–85mm, (left, top) *f*/22 for 1/30 sec., tripod, (all others) *f*/22 for 1/8 sec., polarizing filter

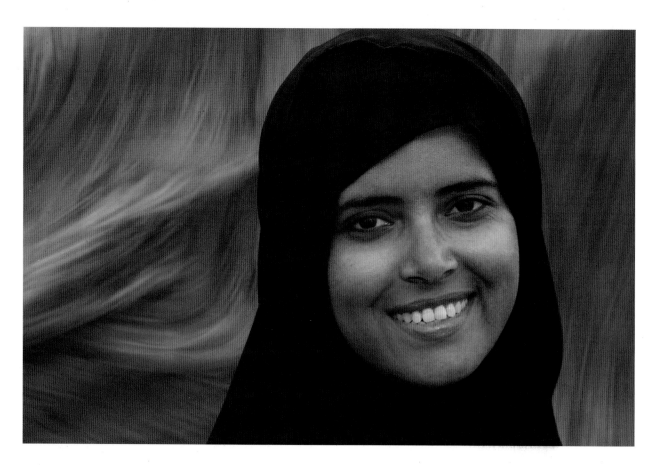

Are you looking for a surefire way to create some truly dramatic backgrounds the next time you are called upon to shoot a portrait or even a still life? Good, because I have just the solution. Head out to the fabric store and purchase some really colorful fabrics and then enlist the help of your children, friends, coworkers, or that neighbor you've wanted to talk to but couldn't come up with a good enough reason.

With your helpers holding the fabric, tell them to start shaking it in a random up-and-down and side-to-side motion, quickly!

Before your "model" shows up, shoot this moving background at a shutter speed of 1/30 sec. and see what kind of "hurricane" results you are recording. You should be seeing some exciting compositions of streaked colors and textures at that 1/30-sec. shutter speed; if you are not, your helpers are shaking the fabric too fast or much too slowly.

Now bring your model into the scene and tell him or her to hold still and just smile (or not) and again fire away at the 1/30-sec. exposure.

As you can see in the example here, we made a pleasing portrait of one of my Dubai students, in a parking lot no less!

Top image: Nikon D800E, Nikkor 24–120mm at 120mm, f/16 for 1/30 sec., ISO 100

MAKING "RAIN"

The "rain" effect that I have been shooting for years is easy to achieve. Whether you choose to set up your "rain" in the early morning or the late afternoon, it is important that you use an oscillating sprinkler since it is best at making realistic falling rain, *and* you must place it in an area of the yard that has lots of unobstructed low-angled sunshine, *and* you must face in the direction of the sun when you shoot, or, as we call it in photography terms, shoot your subjects backlit. If you try to do this when your subjects are frontlit or sidelit, you will *not* record much rain at all since it is the backlight that creates the contrast that allows the rain to stand out. Now grab some props, including some cut flowers or a bowl of cherries, strawberries, or in this case red roses, and you are almost ready to produce the look of falling rain, *but* you must adhere to one simle rule: You can make rain only at 1/60 sec.!

The first thing to do is set your shutter speed to 1/60 sec. and for sure use an ISO of 100 to 200. Now all that remains is to get the correct meter reading, and the best way to do that is to move in close so that the backlit flowers or fruits fill most of the frame *before* you turn on the water. Now you simply adjust your aperture until the light meter indicates a correct exposure. Move back a bit and frame up your overall composition and, with the camera on tripod and your exposure set, fire up the sprinkler. The falling rain must be cascading down across the entire flower or fruit area; if this is not happening, move the flowers or fruit so that they are completely covered by the falling rain. Finally, you will probably have a bit better results when you use a reflector, too. A reflector is nothing more than a white, gold, or silver piece of fabric that has been attached to a pliable ring that allows for a quick and easy setup. A reflector that is 10 inches in diameter while stored in its zippered pouch opens up to a 30-inch-wide reflector (and it weighs almost nothing by the way).

When you aim this reflector into the sun's light, it acts in many ways like a mirror, bouncing this light right back toward the sun. However, it is not the sun you want to reflect light back into but the subject that is facing you. So in effect, it is like having *two* suns: one that backlights your subject and one that "frontlights" your subject.

Now that everything is perfect, simply start firing away when the sweeping arc of the oscillating sprinkler begins to fall just behind and then onto the flowers.

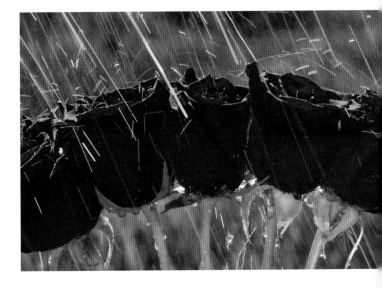

A quick trip to the grocery store or florist and you have your roses, and now all that is needed is a small vase to put them in. Fire up the lawn sprinkler, and presto, at 1/60 sec., you now have your very own custom-made wedding invitation!

With my camera and lens on tripod, my ISO set to 100, and my lens set to 300mm, I set my shutter speed to 1/60 sec. and then moved in close so that the frame was filled with the backlit flowers (before turning the sprinkler on). I then adjusted the aperture until *f*/11 indicated a correct exposure. I moved back a bit, recomposed, opened my reflector, turned on the water, and fired away.

Nikon D3X, Nikkor 70–300mm at 300mm, *f*/11 for 1/60 sec., ISO 100

LIGHT

THE IMPORTANCE OF LIGHT:
THE IMPORTANCE OF EXPOSURE

"What should my exposure be?" is, as I've already said, a question I frequently hear from my students. Again as I stated earlier, my frequent reply—although it may at first appear flippant—is simply, "Your exposure should be correct—*creatively correct, that is!*" As I've discussed in countless workshops and online photo courses, achieving a creatively correct exposure is vital to a photographer's ability to be consistent. It's always the first priority of every successful photographer to determine what kind of exposure opportunity he or she is facing: one that requires great depth of field or shallow depth of field or one that requires freezing the action, implying motion, or panning. Once this has been determined, the real question isn't "What should my exposure be?" but *"From where do I take my meter reading?"*

However, before I answer that question, let's take a look at the foundation on which every exposure is built: light. Over the years, well-meaning photographers have stressed the importance of light or have even been so bold as to say that "light is everything." This kind of teaching—"See the light and shoot the light!"—has led many aspiring students astray.

Am I anti-light? Of course not! I couldn't agree more that the right light can bring importance and drama to a composition. But more often than not, the stress is on *the light* instead of on the (creatively correct) exposure. Whether you've chosen to tell a story, to isolate, to freeze action, to pan, or to imply motion in your image, the light will be there regardless. I can't tell you how many times I've met students who think an exposure for light is somehow different from an exposure for a storytelling image or for a panning image, and so on. But what is so different? What has changed all of a sudden?

Am I to believe that a completely different set of apertures and shutter speeds exists *only for the light*? Of course not! A correct exposure is *still* a combination of aperture, shutter speed, and ISO. And a creatively correct exposure is *still* a combination of the right aperture, the right shutter speed, and the right ISO—with or without the light. As far as I'm concerned, the light is the best possible frosting you can put on the cake, but it has never been—and never will be—*the cake*.

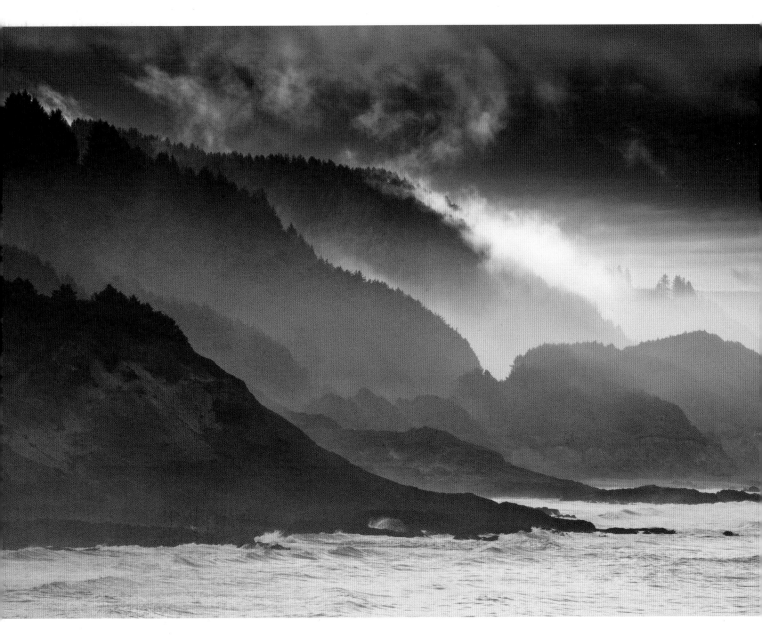

Although the light is important in any image, it was the *exposure* that was the integral part of making this shot. Any exposure is the correct combination of aperture and shutter speed in conjunction with the ISO, but a creative exposure needs to be the most creative combination regardless of how compelling the light may be!

Getting a true storytelling exposure that rendered everything in sharp focus was the key to this shot. From the foreground water to the distant sky and low-hanging clouds, sharpness was the key. When I use my 70–300mm lens for

a shot like this, it is almost automatic that I call upon the smaller apertures such as *f*/22 and *f*/32. As far as the actual meter, experience has taught me that bright white can fool the meter, so before tripping the shutter release here, I purposely set an exposure to +1 to compensate for the meter's tendency to underexpose a scene when presented with bright whites.

Nikon D800E, Nikkor 70–300mm at 300mm, *f*/32 for 1/30 sec., ISO 100, 1 stop overexposed, tripod

THE BEST LIGHT

Where do you find the best light for your subjects? Experienced photographers have learned that the best light often occurs at those times of day when you would rather be sleeping (early morning) or sitting down with family or friends for dinner (late afternoon/early evening, especially in the summer). In other words, shooting in the best light can be disruptive to your normal schedule.

But unless you're willing to take advantage of early-morning or late-afternoon light—both of which reveal textures, shadows, and depth in warm and vivid tones—your exposures will continue to be harsh and contrasty, without any real warmth. Such are the results of shooting under the often flat light of the midday sun. Additionally, one can argue that the best light occurs during a change in the weather—incoming thunderstorms and rain—that's combined with low-angled early-morning or late-afternoon light.

You should get to know the color of light as well. Although early-morning light is golden, it's a bit cooler than the much stronger golden-orange light that begins to fall on the landscape an hour before sunset. Weather, especially inclement weather, can affect both the quality (as mentioned above) and the *color* of light. The ominous and threatening sky of an approaching thunderstorm can serve as a great showcase for a frontlit or sidelit landscape. Then there's the soft, almost shadowless light of a bright overcast day, which can impart a delicate tone to many pastoral scenes as well as to flower close-ups and portraits.

Since snow and fog are monochromatic, they call attention to subjects such as a lone pedestrian with a bright red umbrella. Make it a point also to sense the changes in light through the seasons. The high, harsh, direct midday summer sun differs sharply from the low-angled winter sun. During the spring, the clarity of the light in the countryside results in delicate hues and tones for buds on plants and trees. The same clear light enhances the stark beauty of an autumn landscape.

OPPOSITE PAGE: Learning to "see" light is paramount to the ongoing success of every photographer, and often that means one must wait for the light. There's a clear difference between these two photographs (the harbor in Deira, a few kilometers from the heart of downtown Dubai), and the difference is simply a matter of the *light*. Beginning photographers are often so seduced by a place or subject that they fail to note the subtle changes taking place overhead. As the sun nears the horizon, it's a clear indication that something magical is about to happen. The once bright light of daylight is soon to be replaced with the low light of dusk and become a blue-magenta color. This welcome low light allows for long exposures, and as a result of those long exposures, some landscapes and cityscapes become quite ethereal when water is present. Shooting during these times of day will require the use of a tripod (welcome news to most shooters) as the opportunity to convey motion is presented once again.

With my camera and 24–120mm lens mounted on tripod and with an exposure time of 8 seconds at *f*/11, I was able to capture the streaks of boats as they meandered across the water and the numerous passing cars on the highway below, all against the backdrop of a wonderful blue-magenta sky.

Both images: Nikon D800E, Nikkor 24–120mm at 30mm, ISO 100, tripod, (top) *f*/11 for 1/30 sec., (bottom) *f*/11 for 8 sec.

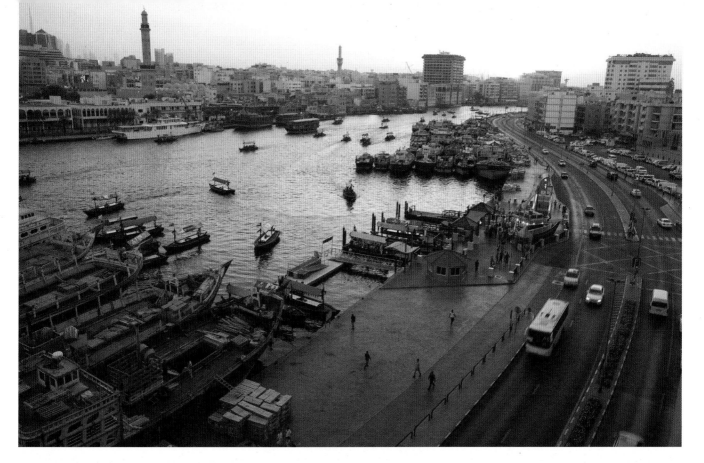

EXERCISES: EXPLORING LIGHT

You can do one of the best exercises I know near your home whether you live in the country or the city, in a house or an apartment. Select any subject, for example, the houses and trees that line your street or the nearby city skyline. If you live in the country, in the mountains, or at the beach, choose a large and expansive composition. Over the course of the next twelve months, document the changing seasons and the continuously shifting angles of the light throughout the year. Take several pictures a week, shooting to the south, north, east, and west and in early-morning, midday, and late-afternoon light. Since this is an exercise, don't concern yourself with making a compelling composition. At the end of the twelve months, with your efforts spread out before you, you'll have amassed knowledge and insight about light that

few professional photographers—and even fewer amateurs—possess.

Photographers who use and exploit light are not gifted! They have simply learned about light and have thereby become motivated to put themselves in a position to receive the gifts that the "right" light has to offer.

Another good exercise is to explore the changing light on your next vacation. On just one day, rise before dawn and photograph some subjects for one hour after sunrise. Then head out for an afternoon of shooting, beginning several hours before and lasting twenty minutes after sunset. Notice how low-angled frontlight provides even illumination, how sidelight creates a three-dimensional effect, and how strong backlight produces silhouettes. After a day or two of this, you will be well on your way to becoming a lighting expert!

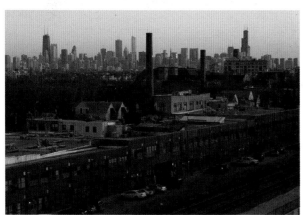
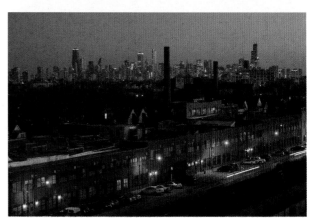

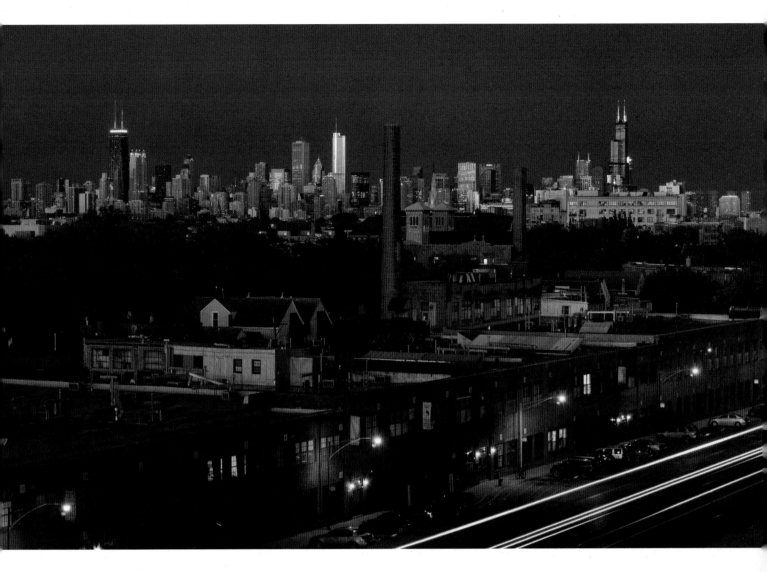

Returning to my rooftop repeatedly, I am able to make a study of light at all different times of day. You can do this, too, whether you shoot in your front yard or backyard. This is not about an effective or compelling composition but is a valuable lesson about light; it is not necessary to go anywhere. After you do this over the course of one day, don't be surprised if you start paying more attention to the light and eventually even the seasons. That sunrise you saw this morning will be coming up in a completely different location six months from now, as you will learn when studying light.

From backlight to frontlight to dusk light, as you look at these images, your reaction to each is different. The light (or absence of light) creates a unique "personality" for each of these exposures. This is an example of what I said earlier: Each of the photographs shows a cake, but the light is the frosting.

All images: Nikon D800E, Nikkor 70–300mm at 280mm, ISO 200, (opposite, upper left) f/16 for 1/500 sec., (opposite, upper right) f/16 for 1/200 sec., (opposite, lower left) f/16 for 1/30 sec., (opposite, lower right, and above) f/16 for 4 sec.

FRONTLIGHT

What is meant by frontlight or frontlighting? Imagine for a moment that your camera lens is a giant spotlight. Everywhere you point the lens, you light the subject in front of you. This is frontlighting, and this is what the sun does—on sunny days, of course. As a result of frontlighting's ability to, for the most part, evenly illuminate a subject, many photographers consider it to be the easiest kind of lighting to work with in terms of metering, especially when they are shooting landscapes with blue skies.

Is it really safe to say that frontlight doesn't pose any great exposure challenges? Maybe it doesn't in terms of metering, but in terms of testing your endurance and devotion, it might. Do you mind getting up early or staying out late, for example? The quality and color of frontlighting are best in the first hour after sunrise and during the last few hours

It was in the city of Thimphu, Bhutan that I visited a Buddhist temple one early morning and found a number of people walking in these wide circles around the temple, chanting prayers as they walked. One such woman caught my eye because of her colorful dress, her hands, and the scepter she was holding. I motioned to her in a way that suggested I would like to take her photograph, and she was quick to oblige. After I snapped a few shots of her, I explained that my next shot would be just of her hands, and the result is shown here. Note the warmth of this early morning light, in contrast to the "colorless" overhead light on the boy, opposite. This is the chief reason many seasoned pros and serious amateurs head out early: They can be assured of capturing warm frontlit and sidelit scenes.

Nikon D800E, 70–300mm at 140mm, f/11 for 1/250 sec., ISO 100

of daylight. The warmth of this golden-orange light will invariably elicit an equally warm response from viewers. This frontlighting can make portraits more flattering and enhance the beauty of both landscape and cityscape compositions.

In addition, frontlighting—just like overcast lighting—provides even illumination, making it relatively easy for the photographer to set an exposure; you don't have to be an exposure expert to determine the spot in the scene where you should take your meter reading. Even first-time photographers can make successful exposures in frontlight, whether their cameras are in manual or autoexposure mode.

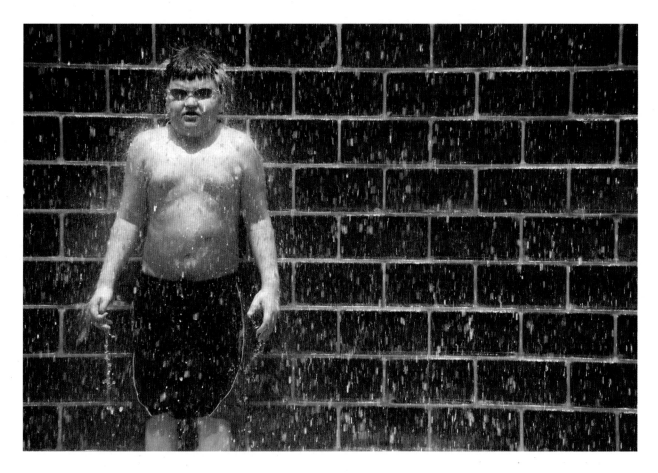

I shot this young boy enjoying a summer day at Millennium Park in Chicago from a bit overhead. It is often the case with frontlit subjects that they are easy to meter for *unless* they are excessively bright or dark. In this case, the light levels were fairly average and uniform. I would have no problem at all if you wished to shoot scenes like this in Aperture Priority mode, but of course, I stayed the course like the old dog I am and shot in manual mode. It is clear that this is a "who cares?" exposure, so f/8 it was, and I simply adjusted the shutter speed until 1/320 sec. indicated a correct exposure.

Nikon D800E, Nikkor 24–120mm at 90mm, f/8 for 1/320 sec., ISO 100

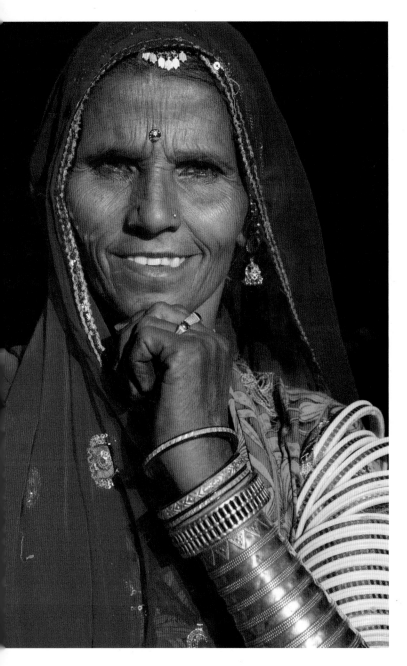

As the late-afternoon frontlight cast its glow across this large antique furniture warehouse outside the city of Jodhpur, India, a number of "shadow pockets" were seen among the many small and large storage facilities. This kind of frontlight situation is what many seasoned pros and serious amateurs look for as it allows them to serve up great contrast when placing subjects in frontlight against the backdrop of these shadow pockets. That is what I did with this Indian woman who worked at this antique store. Note how the black background serves to further heighten her colorful dress and jewelry. Since the exposure is for the sunlight that is falling on the woman (obviously a much brighter light source than the shadow behind her), the resulting shadow is recorded as a severe underexposure, so much so that it records as black. Learning to see shadow pockets is a great stride toward becoming a lighting master.

Left image: Nikon D800E, Nikor 24–120mm at 120mm, ƒ/11 for 1/160 sec., ISO 100

OVERCAST FRONTLIGHT

Of all the different lighting conditions that photographers face, overcast lighting is the one that many consider the safest. This is because overcast light illuminates most subjects evenly, making meter reading simple. (This assumes, of course, that the subject isn't a landscape under a dull gray sky and that sky will be part of the composition. *If* that is the case, it's time to use a graduated ND filter, but we'll talk about that later.)

Overcast light also allows one to use the semiautomatic modes such as Shutter Priority and Aperture Priority, since overall illumination is balanced. The softness of this light results in more natural-looking portraits and richer flower colors, and it also eliminates the contrast problems that a sunny day creates in wooded areas. Overcast conditions are the ones in which you may find me shooting in a semiauto mode: either Aperture Priority if my exposure concerns are about depth of field or the absence thereof or Shutter Priority if my concern is about motion (i.e., freezing action or panning).

If I had not stopped to grab a cup of tea, I surely would have missed this street vendor at Chandni Chowk Market in Old Delhi. He and I were on one of the most crowded backstreets in the market, and only because I had stopped to get some tea did I notice the comings and goings all around me, including this man sitting across from the tea shop set up against the wall you see here. Note the even illumination that the overcast skies provide. It is indeed a soft light and much kinder to the face than low-angle sunlight from the front or side. Because this was another "who cares?" composition, I called upon *f*/11.

Nikon D800E, Nikkor 24–120mm at 50mm, *f*/11 for 1/80 sec., ISO 200

Because photographing in the woods on sunny days is problematic—yielding images that are often far too contrasty—it is best to wait for cloudy days, perhaps with a bit of rain if you are so lucky! Waiting for overcast days will make getting a correct exposure much easier, and you can certainly shoot in Aperture Priority mode without fear. Along Oregon's Columbia Gorge, up near Hood River, you will find the Rowena Gorge, which is one of the most picturesque drives in all of Oregon. On this day we had a bit of rain that would add a kind of glossy sheen to everything, but in this situation do get out your polarizer so that you can better see that glossy sheen. The polarizer will eliminate the otherwise dull glare that is on all of those wet surfaces and allow the glossy sheen to shine through.

Although this scene before me looks like a "who cares?" it is actually "deep" with detail, and so I opted to shoot it at *f*/16 and focus on the tree trunk itself, knowing that at *f*/16 the resulting depth of field would reach into the "deep" and render it sharp. I would say my plan of using *f*/16 worked.

Nikon D800E, Nikkor 24–120mm at 35mm, *f*/16 for 1/30 sec., ISO 200, polarizing filter

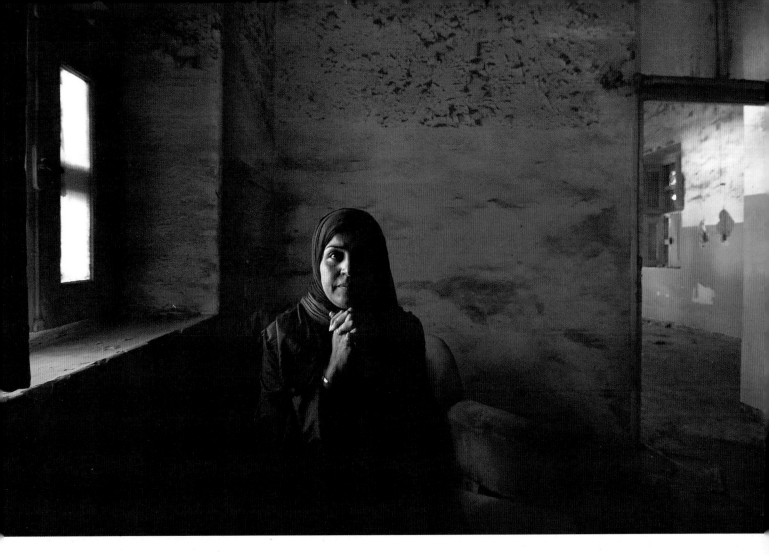

Portraits are another fine subject for overcast lighting. The soft, even illumination of a cloudy day or the soft, even illumination of light coming in from a north-facing window on sunny day makes getting an exposure easy.

It was during one of my workshops in Kuwait that I asked one of my students to be a model, and she gladly obliged. I placed my camera and lens on a tripod because the light levels in this old abandoned hospital were quite low. Even at my chosen aperture of *f*/5.6, a correct exposure was being indicated at 1/20 sec., far too slow to handhold with this particular lens, the Nikkor 35–70mm. (At this writing there are a number of lenses on the market that offer VR and IS, which are terms used for stabilization control. This is a technology that allows one to shoot at shutter speeds much slower than what is considered the norm; usually you should not handhold any lens/camera at a shutter speed slower that the lens's maximum focal length. My Nikkor 35–70mm does not offer VR.)

I chose to shoot at *f*/5.6 because I wanted to keep the depth of field limited to the woman, and as you can see behind her, the area of softness increases the farther you go. Since I was using Aperture Priority automatic exposure, I only had to focus on my subject's pleasant demeanor and shoot.

Nikon D3X, Nikkor 35–70mm at 35mm, *f*/5.6 for 1/20 sec., ISO 100, tripod

SIDELIGHT

Frontlit subjects and compositions photographed under an overcast sky often appear two-dimensional even though your eyes tell you the subject has depth. To create the illusion of three-dimensionality, you need highlights and shadows; in other words, you need sidelight. For several hours after sunrise and several hours before sunset, you'll find that sidelit subjects abound when you shoot toward the north or south.

Sidelighting has proved to be the most challenging exposures for many photographers because of the combination of light and shadow, but it also provides the most rewarding picture-taking opportunities. As many professional photographers would agree, a sidelit subject—rather than a frontlit or backlit one—is sure to elicit a much stronger response from viewers because it better simulates the three-dimensional world they see with their own eyes.

About ten kilometers outside of the city of Jaipur, India, is the Monkey Temple, and as its name implies, one will find not only people at this temple but a large number of monkeys, too. Near the top of the stairs at this temple there is a large reservoir-like body of water, and it was there that I witnessed a number of local people bathing. As usual, it was the young kids who were having the most fun, but what really caught my eye was an elderly woman being bathed by whom I assume was her daughter, or a relative at the least. The strong sidelight of the late afternoon accounted for this dramatic exposure. Directly behind them was a huge shadow pocket, and because I was metering for the much stronger sidelight that was casting its glow on them, I was assured that this large and looming shadow pocket in the background would indeed be rendered as one giant black canvas. I was equally fortunate to have been able to be set up just as she was dumping a pitcher of water across the back of the elderly woman. Because I was shooting with the "who cares?" aperture of f/8, my shutter speed was quite fast, which proved to be pivotal as the fast shutter speed also managed to freeze the action of the cascading water.

Nikon D800E, Nikkor 24–120mm at 35mm, f/8 for 1/500 sec., ISO 100

In the absence of sidelight, these letters above this small shop in the town of Cassis, France, would not appear to be "dancing" at all. It is the sidelighting and the resulting shadows that give this image its depth and dimension.

Because of the high contrast of the bright surface reflecting off the building, this was not a simple exposure. Much like snow on a sunny day, the high reflectance of this building could have caused me to record an underexposure, but experience has taught me that in situations like this, I need only shoot at a +1 overexposure.

Top image: Nikon D800E, Nikkor 70–300mm at 300mm, f/11 for 1/200 sec., ISO 100

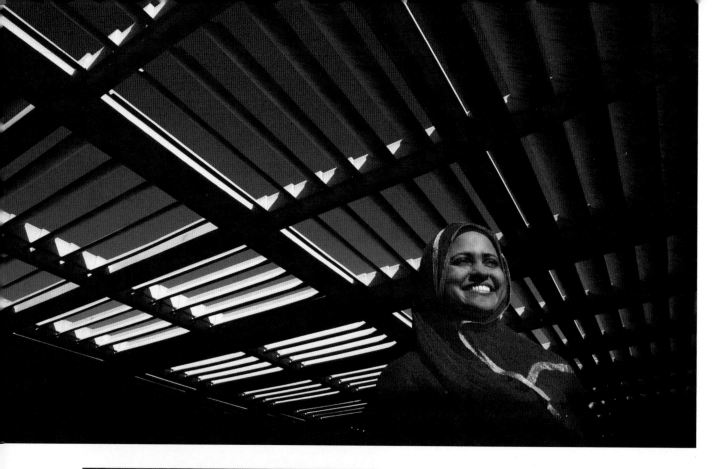

The spaces in which I work are sometimes quite surprising to some. I mean, who would have ever thought without looking at the "before" photo seen here that this image was made on the top floor of a dirty, dusty parking garage? Yet as you can plainly see, it was! If nothing else, it certainly lends itself to the saying "Bloom where you are planted." In other words, "Hey, we got some great sidelight right now, so let's make this work!"

Fortunately, one of the students, Fatina, volunteered to model, and soon we were making quick work of this warm sidelight, showcasing her portrait against the white-painted wood slats of the garage's roof. This quite graphic background also is in marked contrast to the circular shape of Fatina's head, and so the distinction between *line* and *shape* is made evident. Because we did want a large depth of field here, we all shot at *f*/16.

Top image: Nikon D800E, Nikkor 24–120mm at 35mm, *f*/16 for 1/100 sec., ISO 100

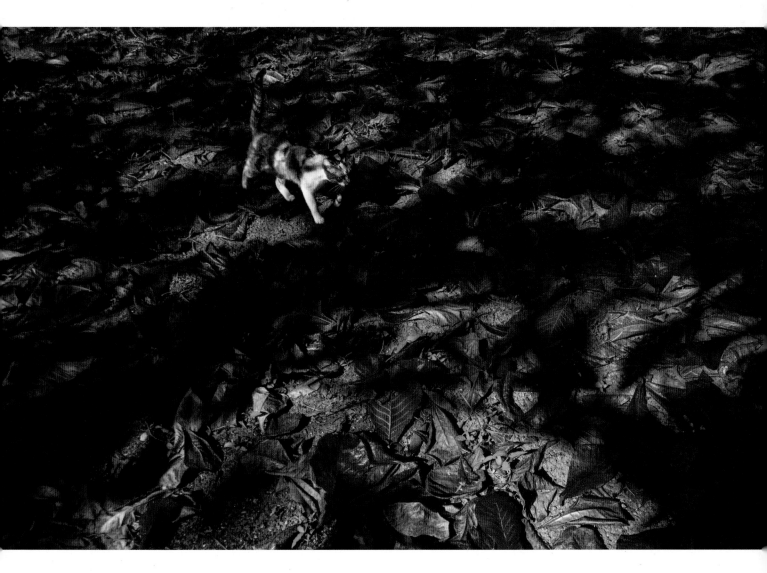

While in Puerto Rico a few years ago, I was quick to notice the number of cats running wild in Old San Juan. While I was shooting some pigeons at a local park, I caught site of a young calico cat walking in the dappled light of a large tree. The spots of light and the numerous shadow pockets that dotted the ground intrigued me. I felt that the repeating contrast of light and dark might make an interesting photograph, but only if that repeating was pattern was interrupted. In this case, that cat became the interruption. Metering for a scene like this is really not complicated.

I made it a point to move in really close and fill the frame with only a large spot of sunlight and then set my exposure accordingly. As you can see, that method worked just fine, but keep in mind that only the exposures in which the cat is seen walking in a sunny spot were effective. When he walked into a shadow pocket, he was of course too dark.

Nikon D3X, 24–85mm at 24mm, *f*/16 for 1/160 sec., ISO 200

BACKLIGHT

Backlight can be confusing. Some beginning photographers assume that backlighting means that the light source (usually the sun if you're outdoors) is behind the photographer, hitting the front of the subject. However, the opposite is true: the light is *behind the subject*, hitting the front of the photographer and the back of the subject. Of the three primary lighting conditions—frontlighting, sidelighting, and backlighting—backlighting continues to be the biggest source of both surprise and disappointment.

One of the most striking effects achieved with backlight is silhouetting. Do you remember making your first silhouette? If you're like most photographers, you probably achieved it by accident. Although silhouettes are perhaps the most popular type of image, many photographers fail to get the exposure correct. This inconsistency is usually a result of lens choice and metering location. For example, when you use a telephoto lens, such as a 200mm lens, you must know where to take your meter reading. Since telephoto lenses increase the image magnification of very bright background sunrises and sunsets, the light meter sees this magnified brightness and suggests an exposure accordingly. If you were to shoot at that exposure, you'd end up with a picture of a dark orange or red ball of sunlight while the rest of the frame faded to dark. And whatever subject is in front of this strong backlight may merge into this surrounding darkness. To avoid this, *always* point a telephoto lens at the bright sky to the right or left of the sun (or above or below it) and then manually set the exposure or press the exposure-lock button if you're in autoexposure mode.

When photographing a backlit subject that you don't want to silhouette, you can certainly use your electronic flash to make a correct exposure; however, there's a much easier way to get a proper exposure without using flash. Let's assume your subject is sitting on a park bench in front of the setting sun. If you shoot an exposure for this strong backlight, your subject will be a silhouette, but if you want a pleasing and identifiable portrait, move in close to the subject, fill the frame with his or her face (it doesn't have to be in focus), and then set an exposure for the light reflecting off the face. Either manually set this exposure or, if shooting in autoexposure mode, press the exposure-lock button and return to your original shooting position to take the photo. The resulting image will be a wonderful exposure of a radiant subject.

Backlight is favored by experienced landscape shooters, as they seek out subjects that by their very nature are somewhat transparent: leaves, seed heads, and dew-covered spiderwebs, to name but a few. Backlight always provides a few exposure options: You can silhouette the subject against the strong backlight, meter for the light that's usually on the opposite side of the backlight (to make a portrait), or meter for the light that's illuminating the somewhat transparent subject. Although all three choices require special care and attention to metering, the results are always rewarding. As with so many other exposure options, successful backlit scenes result from a conscious and deliberate metering decision.

This was my first trip to Toronto and my first evening to shoot a dusk shot of the Toronto skyline. Based on the others who were also shooting near me, the sky on this night was far more dramatic than the norm. A young woman nearby was tossing bits of bread to this mallard couple, making for some wonderful foreground subject matter against the background of what was truly a stunning sunset sky!

Using the tripod I kept my 24-120mm low to the ground with the focal length at 24mm, and my aperture set to *f*/22 and manual focus pre-set to 1 meter. I adjusted my shutter speed until a 1/8 second indicated a correct exposure for the light reflecting off the water. Also, to impart a bit more blue to the scene, I used a White Balance of Fluorescent, which did add a bit more magenta and definitely a bit more blue to the sky.

The duck on the right is a bit soft, but not due to any focus issue but rather due to the slow shutter speed of a 1/8 sec. Why didn't I change my ISO to 400 or 800, which would have increased my shutter speed by two or three stops, and perhaps eliminated the soft duck? I simply forgot to exercise that option!

Nikon D800E, Nikkor 24-120 mm at 24mm, *f*/22 for 1/8 sec., ISO 100

The area of West Friesland, Holland, is one of those places where it's hard *not* to make a photograph with a strong graphic design and bold color. The many meandering dikes, perfect rows of tulips, and "walls" of trees lend themselves to exciting compositions at every turn. And almost without fail, as the sun begins its descent in the direction of the North Sea, the thick salt air diffuses the intensity of the sun's light so that for almost the last 45 minutes of daylight, a thick orange-yellow ball hangs in the western sky.

Having witnessed this scene many times, I was excited to share it with a group of students for whom this would be their first time. As the sun did start to set, it put on a great show. Along the dike in the small town of Rustenburg, one of my students was set up on a small footbridge against the backdrop of a windmill and the setting sun. Because the sun was so diffused at this point, I simply focused on the student with my lens at f/22 and adjusted my shutter speed until a correct exposure was indicated.

When shooting backlight photos with any telephoto lens at a focal length of 100mm or more, I normally set my exposure from the sky to the right or left of the setting sun, but here, because of the strong diffusion of the sun, it was not necessary.

Nikon D3X, Nikkor 70–300mm at 165mm, *f*/22 for 1/60 sec., ISO 200

When backlit, many solid objects (such as people, trees, and buildings) will be rendered as dark silhouetted shapes. Not so with many transparent objects, such as feathers and flowers. When transparent objects are backlit, they seem to glow. Such was the case when I shot a single stalk of bear grass near Glacier National Park a few years ago. I chose a low viewpoint so that I could showcase the flower against the deep blue sky. Although this may appear to be a difficult exposure, it really isn't. Holding my camera and 17–35mm lens, I set the focal length to 20mm. With an aperture of f/22, I moved in close to the flower, adjusting my position so that the sun was hidden behind the flower. I then adjusted the shutter speed until 1/100 sec. indicated a correct exposure in the viewfinder. But before I took the shot, I moved away from the flower and to the right just enough to let a small piece of the sun from behind the flower be part of the overall composition. With this exposure, I was able to record a dynamic backlit scene that showcases the lone stalk of bear grass. Finally, I used my 5 in 1 reflector and was able to nicely bounce some added light on the back of this bloom.

Nikon D3X, Nikkor 17–35mm at 20mm, f/22 for 1/100 sec., 200 ISO

One of the most colorful places I have seen over the years is the courthouse in Montreal, Quebec. One afternoon the sun was streaming through the many colorful windows so brightly that anything near the windows or directly in their path would be rendered a silhouette. Although it was not planned, I was rewarded when someone came in the courthouse and proceeded to take the escalator up to the next level. At that point I was quick to fire off two frames. I had set my exposure for the strong backlight before that person appeared, so there was no time lost fumbling around with what my exposure should be. Again, as is true of all silhouettes, the light that surrounded the subject here is much brighter than the subject, and since I metered for that much brighter light, she is rendered as a silhouette.

Nikon D800E, Nikkor 70–300mm at 300mm, f/22 for 1/200 sec., ISO 400

EXPOSURE METERS

As was discussed in the first chapter, at the center of the photographic triangle (aperture, shutter speed, and ISO) is the exposure meter (light meter). It's the "eye" of creative exposure. Without the vital information the exposure meter supplies, many picture-taking attempts would be akin to playing pin the tail on the donkey—hit and miss! This doesn't mean that you can't take a photograph without the aid of an exposure meter. After all, one hundred years ago photographers were able to record exposures without one, and even thirty years ago I was able to do that. They had a good excuse, though: there were no light meters available to use one hundred years ago. I, in contrast, simply failed—on more than one occasion—to pack a spare battery for my Nikkormat FTN, and once the battery died, so did the light meter.

Just like the pioneers of photography, I was left having to rely on the same formulas for exposure offered by Kodak, the easiest being the Sunny f/16 Rule. This rule simply states: when shooting frontlit subjects on sunny days, set your aperture to f/16 and your shutter speed to the closest corresponding number of the ISO in use. In my early years, when film was the only option and I used Kodachrome 25, I knew that at f/16 the shutter speed should be 1/30 sec. When I used Kodachrome 64, I knew the shutter speed should be 1/60 sec. Needless to say, this bit of information was valuable stuff when the battery went dead— but only when I was out shooting on sunny days! One of the great advances in photography today is the auto-everything camera; trouble is, when the batteries in these cameras die, the *whole camera* dies, not just the light meter! Make it a point *always* to carry an extra battery or two.

Despite my feelings about this obvious shortcoming in auto-everything cameras, it cannot be ignored that the light meters of today are highly sensitive tools. It wasn't that long ago that many photographers would head for home once the sun went down, since the sensitivity of their light meters was such that they couldn't record an exposure at night. Today, photographers are able to continue shooting well past sundown with the assurance of achieving a correct exposure. If ever there was a tool often built into the camera that eliminates any excuse for not shooting twenty-four hours a day, it would be the light meter.

Exposure meters come in two forms. Either they're separate units not built into the camera, or, as with most of today's cameras, they're built into the body of the camera. Handheld light meters require you to physically point the meter at the subject or at the light falling on the subject and take a reading of the light. Once you do this, you set the shutter speed and aperture at an exposure that is based on that reading. Conversely, cameras with built-in exposure meters enable you to point the camera and lens at the subject while continuously monitoring any changes in exposure. This system is called through-the-lens (TTL) metering. These light meters measure the intensity of the light that reflects off the metered subject, meaning they are *reflected-light meters*. Like lenses, reflected-light meters have a wide or a very narrow angle of view.

Many cameras today offer two if not three types of light-metering capabilities. One of those is *center-weighted metering*. Center-weighted meters measure reflected light throughout the scene but are biased toward the center portion of the viewing area. To use a center-weighted light meter successfully, you must center the subject in the frame when you take the light reading. Once you set a manual exposure, you can recompose the scene for the best composition. However, if you want to use your camera's autoexposure mode (assuming that your camera has one) but don't want to center the subject in the composition, you can press the exposure-lock button

and then recompose the scene so that the subject is off-center; when you fire the shutter release, you'll still record a correct exposure.

Another type of reflected-light meter that many digital cameras are equipped with is the *spot meter*. Until about four years ago spot meters were available only as handheld light meters, but today it is not at all uncommon to see camera bodies that are equipped with them. The spot meter measures light at an extremely narrow angle of view, usually limited to 1 to 5 degrees. As a result, a spot meter can take a reading from a very small area of an overall scene and get an accurate reading from that one very specific area despite how large an area of light and/or dark surrounds it in the scene. My feelings about using spot meters haven't changed much since I first learned of them over thirty years ago: They have a limited but important use in my daily picture-taking efforts.

Finally, there are Nikon's *matrix metering mode* and Canon's *evaluative metering mode*. Matrix (or evaluative) metering came on the market about fifteen years ago and has since been revised and improved. It's rare that you'll find a camera on the market today that doesn't offer a kind of metering system built on the original idea of matrix metering. This holds true for the Pentax, Minolta, Panasonic, Sony, and Olympus brands of digital SLRs. Matrix metering relies on a microchip that has been programmed to "see" thousands of picture-taking subjects, from bright white snowcapped peaks to the darkest canyons and everything in between. As you point the camera toward your subject, matrix metering recognizes the subject ("Hey, I know this scene! It's Mount Everest on a sunny day!") and sets the exposure accordingly. Yet as good as matrix metering is, it still will come upon a scene it can't recognize, and when this happens, it will *hopefully* find an image in its database that comes close to matching what's in the viewfinder.

The type of camera determines which light meter or meters you have built into the camera's body. If you're relatively new to photography and have a camera with several light meter options

(matrix/evaluative as well as center-weighted), I strongly recommend using matrix 100 percent of the time. It has proved to be the more reliable and has fewer quirks than center-weighted metering. On countless field trips, I've witnessed some of my students switching from center-weighted metering to matrix metering repeatedly. Not surprisingly, as a result of each light meter's unique way of metering the light, they would often come up with slightly different readings. Also not surprisingly, they were often unsure which exposure to believe, so they took one of each. This is analogous to having two spouses—and those who have a spouse would certainly agree that dealing with the quirks and peculiarities of one spouse is at times too much, let alone two. But since I was raised on center-weighted metering, I'll stay with it for life. If it ain't broke, don't fix it.

Just how good are today's light meters? Both center-weighted metering and matrix metering provide accurate exposures 90 percent of the time. That's an astounding and, I hope, confidence-building number. Nine out of ten pictures will be correctly exposed (not necessarily creative exposures but correct exposures nonetheless) whether one uses manual exposure mode (still my favorite) or semi-autoexposure mode (Aperture Priority when shooting storytelling or isolation themes and Shutter Priority for freezing action, panning, or implying motion). In either metering mode and when the subject is frontlit, sidelit, or under an overcast sky, you can simply choose your subject, aim, meter, compose, and shoot.

In addition, I recommend taking another exposure at -2/3 stop when you are shooting almost any subject, since this often improves contrast and the overall color saturation of a scene. This extra shot will give you a comparison example so that you can decide later which of the two you prefer. Don't be surprised if you often pick the -2/3 exposure. Often, this slight change in exposure from what the meter indicates is just the right amount of contrast needed to make the picture much more appealing.

With the sophistication of today's built-in metering systems, it's often unnecessary to bracket like crazy.

Finally, there isn't a single light meter on the market today that can do any measuring, calculating, or metering until it has been "fed" one piece of data vital to the success of every exposure you take: the ISO. In the past, photographers using film had to manually set the ISO every time they would switch from one type of film to another.

Digital shooters, despite all the technological advances, must resort to setting the ISO for each and every exposure, in effect telling the meter what ISO to use. (On some DSLRs there is an auto-ISO feature. When it is activated, the camera will determine which ISO to use, based on the light.

I *do not* recommend this approach at all since the camera will often get it wrong, and it doesn't know that you desire to be a "creative photographer," and part of your creativity stems, of course, from having full control over what ISO you use.) Since digital shooters can switch ISO from one scene to the next as well as shift from color to black and white at the push of a button, so much for the old adage that you can't change horses in midstream.

The photo industry has come a long way since I got started. With today's automatic cameras and their built-in exposure meters, much of what you shoot will have a correct exposure. However, keep in mind that the job of recording *creatively correct exposures* is still yours.

Early one summer morning, I arrived at Times Square to discover a member of the maintenance crew mopping the stairs of the large red bleacher in the heart of the square. An easy exposure for sure, since he was bathed in bright overcast light. I quickly determined the need for a storytelling aperture (since I wanted front-to-back image sharpness), so I set the aperture to *f*/22, and with my camera and 24–120mm lens on tripod, I allowed the camera's Aperture Priority mode to select the correct exposure.

Nikon D800E, Nikkor 24–120mm, *f*/22 for 1/200 sec., ISO 100

This image could have been quite challenging to make if I had not used my camera's built-in spot meter. All that black fabric would have played havoc with center-weighted or even matrix/evaluative metering, which would have rendered it an overexposed gray (more about this in a minute). So, with my camera's meter set to spot metering and with my 70–300mm lens at 300mm, I pointed the lens at the advertisement of a model's face in the distance. With an aperture of *f*/16, I adjusted the shutter speed until 1/60 sec. indicated a correct exposure. I then zoomed back out to 70mm and shot the exposure shown here. Keep in mind that once I had my spot meter reading, I switched back to matrix mode, where I normally set the light meter. When I did this, the light meter indicated that I was now way off. Why? Because it was seeing the large view of that "dark" telling me that I should shoot the scene at *f*/16 for 1/15 sec. instead of the spot meter reading that said *f*/16 for 1/60 sec. Of course I ignored it and shot the correct exposure of *f*/16 for 1/60 sec.

Nikon D800E, Nikkor 70–300mm at 300mm, *f*/16 for 1/60 sec., ISO 200

18% REFLECTANCE

Now for what may be surprising news: your camera's light meter (whether center-weighted, matrix/evaluative, or spot) *does not* "see" the world in either living color or black and white but rather as a *neutral gray*. In addition, your reflected-light meter is calibrated to assume that all those neutral-gray subjects will reflect back approximately 18 percent of the light that hits them.

This sounds simple enough, but more often than not, it's the reflectance of light off a subject that creates a bad exposure, not the light that strikes the subject. Imagine that you came across a black cat asleep against a white wall, bathed in full sunlight. If you moved in close and let the meter read the light reflecting off the cat, the meter would indicate a specific reading. If you then pointed the camera at only the white wall, the exposure meter would render a separate, distinct reading. This variation would occur because although the subjects are evenly illuminated, their reflective qualities differ radically. For example, the white wall would reflect approximately 36 percent of the light whereas the black cat would absorb most of the light, reflecting back only about 9 percent.

When presented with either white or black, the light meter freaks ("Holy smokes, sound the alarm! We've got a problem!"). White and black especially violate everything the meter was "taught" at the factory. White is no more neutral gray than black; they're both miles away from the middle of the scale. In response, the meter renders these extremes onto your digital sensor just as it does everything else: as a neutral gray. If you follow the light meter's reading—and fail to take charge and meter the right light source—white and black will record as dull gray versions of themselves.

To meter white and black subjects successfully, treat them as if they were neutral gray even though their reflectance indicates otherwise. In other words, meter a white wall that reflects 36 percent of the light falling on it as if it reflected the normal 18 percent. Similarly, meter a black cat or dog that reflects only 9 percent of the light falling on it as if it reflected 18 percent.

OPPOSITE PAGE: The skies on the Valensole Plain were filled with large cumulus and cirrus clouds that were really messing with my ability to get a correct light-meter reading of the landscape in front of me. In these kinds of situations, there are several ways to get a correct exposure of the landscape before you, but none is more foolproof than the palm of your hand since it is in all likelihood the same as a gray card as you meter your palm at a 1-stop overexposure!

In the first image the meter is being fooled by the bright sky into thinking the scene is brighter than it really is and thus wants to recommend too fast a shutter speed. Sure enough, the shutter speed it recommends creates an underexposure.

But if I stick out the palm of my hand and set an exposure at +1 for the light falling on it, I will for sure record a correct exposure. As proof, take a look at the resulting photograph. Here is the bottom line, and oh my, is it ever a great bottom line. As long as you have your hands, you can always call upon your palm to set a correct exposure. More on this on page 112.

All images: Nikon D800E, Nikkor 24–120mm at 24mm, (top left) *f*/11 for 1/500 sec., ISO 100, (all others) *f*/22 for 1/200 sec., ISO 200

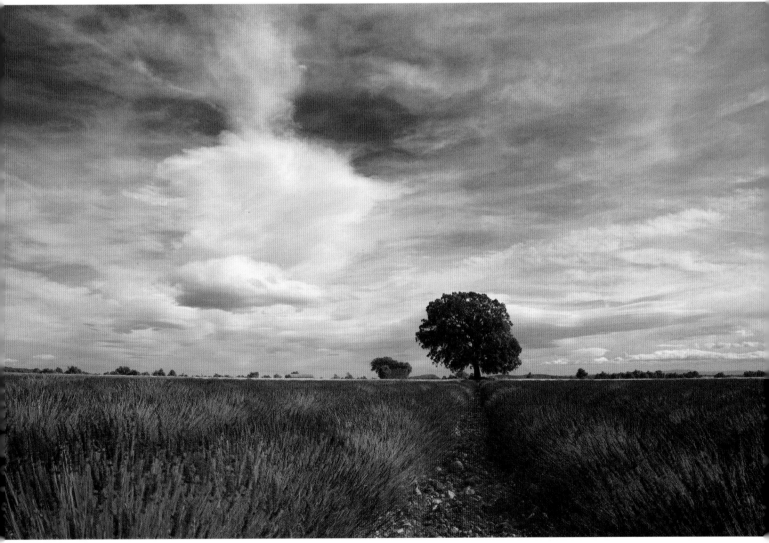

THE GRAY CARD

When I first learned about 18 percent reflectance, it took me a while to catch on. One tool that enabled me to understand it was a gray card. Sold by most camera stores, gray cards come in handy when you shoot bright and dark subjects, such as white sandy beaches, snow-covered fields, black animals, and black shiny cars. Rather than pointing your camera at the subject, simply hold a gray card in front of your lens—making sure that the light falling on the card is the same light that falls on the subject—and meter the light reflecting off the card.

If you're shooting in an autoexposure program, Shutter Priority mode, or Aperture Priority mode, you must take one extra step before putting the gray card away. After you take the reading from the gray card, note the exposure. Let's say the meter indicated f/16 at 1/100 sec. for a bright snow scene in front of you. Then look at the scene in one of these modes. Chances are that in Aperture Priority mode the meter will read f/16 at 1/200 sec. and in Shutter Priority mode it will read f/22 at 1/100 sec. In either case, the meter is now "off" 1 stop from the correct reading from the gray card. You need to recover that 1 stop by using your autoexposure overrides.

These overrides are designated as follows: +2, +1, 0, –1, and –2 or 2X, 1X, 0, 1/2X, and 1/4X. For example, to provide an additional stop of exposure when you are shooting a snowy scene in autoexposure mode, you would set the autoexposure override to +1. Conversely, when shooting a black cat or dog, you'd set the autoexposure override to –1 (1/2X).

Hot gray card tip: After you've purchased your gray card, you need it only once, since you've already got something on your body that works just as well—but you'll need the gray card to help you initially. If you're ever in doubt about any exposure situation, meter off the palm of your hand. I know your palm isn't gray, but you simply use your gray card to "calibrate" your palm—and once you've done that, you can leave the gray card at home.

To calibrate your palm, take your gray card and camera into full sun and set the aperture to f/8. While filling the frame with the gray card (it doesn't have to be in focus), adjust the shutter speed until a correct exposure is indicated by the camera's light meter. Now hold the palm of your hand out in front of your lens. The camera's meter should read that you are about +2/3 to 1 stop overexposed. Make a note of this. Then take the gray card once again into open shade with an aperture of f/8 and again adjust the shutter speed until a correct exposure is indicated. Meter your palm and you should see that the meter now reads +2/3 to 1 stop overexposed. No matter what lighting conditions you do this under, your palm will consistently read about +2/3 to 1 stop overexposed from the reading of a gray card.

So, the next time you're out shooting and have that uneasy feeling about your meter reading, take a reading from the palm of your hand. When the meter reads +2/3 to 1 stop overexposed, you know your exposure will be correct.

(Note: For obvious reasons, if the palm of your hand meters a 2-, 3-, or 4-stop difference from the scene in front of you, either you're taking a reading off the palm of your hand in sunlight, having forgotten to take into account that your subject is in open shade, or you forgot to take off your white gloves.)

THE SKY BROTHERS

The world is filled with color, and in fairness, the light meter does a pretty good job of seeing the differences in the many shades and tones that are reflected by all that color. But in addition to being confused by white and black, the meter can be confused by backlight and contrast. So, are we back to the hit-and-miss, hope-and-pray formula of exposure? Not at all! There are some very effective and easy solutions for these sometimes pesky and difficult exposures: they're what I call the *Sky Brothers*.

Often when you are shooting under difficult lighting situations (sidelight and backlight being the two primary examples), an internal dispute may take place as you wrestle over just where exactly you should point your camera to take a meter reading. I know of no one more qualified to mediate these disputes between you and your light meter than the Sky Brothers. They're not biased. They want only to offer the one solution that works each and every time. So, on sunny days, *Brother Blue Sky* is the go-to guy for those winter landscapes, black

Labrador portraits, bright yellow flower close-ups, and fields of deep purple lavender. This means you take a meter reading of the sunny blue sky and use that exposure to make your image. When you are shooting backlit sunrise and sunset landscapes, *Brother Backlit Sky* is your go-to guy. This means you take a meter reading to the side of the sun in these scenes and use that reading to make your image. When you are shooting city or country scenes at dusk, *Brother Dusky Blue Sky* gets the call, meaning you take your meter reading from the dusk sky. And when you are faced with coastal scenes or lake reflections at sunrise or sunset, call on *Brother Reflecting Sky*, meaning you take your meter reading from the light reflecting off the surface of the water.

With my camera and lens mounted on tripod and using manual exposure mode, I simply framed up this idyllic winter scene just off Chicago's Lakeshore Drive. While pointing the lens and camera to the sky, I adjusted my meter until a correct setting was indicated—and, not surprisingly, I got white snow. We all know snow is white, especially on a clear frontlit afternoon, so if you have any intention of recording pure white snow, you really should take your meter reading from Brother Blue Sky.

Of course, after I metered the blue sky and recomposed the snow scene before me, my light meter told me I was wrong, but sometimes, just as occurs when a 2-year-old throws a tantrum, you have to ignore it!

Nikon D800E, Nikkor 17–35mm at 17mm, *f*/22 for 1/60 sec., ISO 100

Warning: Once you've called upon the Sky Brothers, your camera's light meter will let you have it. You'll notice that once you've used Brother Blue Sky and set the exposure, your light meter will go into a tirade when you recompose that frontlit winter landscape ("Are you nuts? I've got eyes of my own and I know what I'm seeing, and all that white snow is nowhere near the same exposure value of Brother Blue Sky!") Trust me on this one. If you listen to your light meter's advice and subsequently readjust your exposure, you'll end up right back where you started—a photograph with gray snow! So, once you have metered the sky using the Sky Brothers, set the exposure manually or "lock" the exposure if you are staying in automatic before you return to the original scene. Then shoot away with the knowledge that *you are right* no matter how much the meter says you're wrong!

Last spring Chicago had a "late" snowfall, April 11 to be exact (for this city, that is not all that late). Nonetheless, I rushed downtown the next morning in hopes of catching some shots of the "Bean" with some of the late snowfall remnants, and I was in luck! There were still patches of snow clinging to the Bean, and those patches reminded me of cumulus clouds. I made quick work of moving in close and creating the composition of the "clouds" you see here, but *not* before setting my exposure from the blue sky to the right of the Bean.

Top image: Nikon D800E, Nikkor 24–120mm at 80mm, f/22 for 1/100 sec., ISO 200

I met Ivan while shooting near his place of work in Dubai. Ivan left Nigeria to come to Dubai and work as a security guard. We talked about how much he missed his girlfriend, and he hoped that after seeing his portrait, which he planned to send her, "she will immediately come to her senses and join me in Dubai." I do not know how that story ended, but we both agreed that the picture of Ivan would be well received by other ladies if his current girlfriend chose to no longer be in his life.

I had asked Ivan to stand in front of the entrance to his place of work and do nothing more than look at the camera and smile. As if I didn't know better, I proceeded to adjust my shutter speed until a correct exposure was indicated and then shot the first picture you see on top; not surprisingly, it is overexposed. Again this is *not* the light meter's fault since it thinks the world is always gray, and when metering Ivan and his surroundings, all quite dark, the meter reacted as if to say, "Hey, I am not sure why you are not reflecting 18 percent of the light, but no worries, I will make you 'gray.'" In effect, the light meter is suggesting a reading that ends up overexposing Ivan. The solution is a simple one in this case: take a meter reading from his very neutral blue-graylike shirt, which is about as close to 18 percent reflectance as you will get. When I did that and shot at this exposure, notice the difference. Ivan looks like the Ivan I met and the Ivan he knows as well!

Both images: Nikon D800E, Nikkor 24–120mm at 85mm, ISO 200, (top) *f*/11 for 1/40 sec., (bottom) *f*/11 for 1/100 sec.

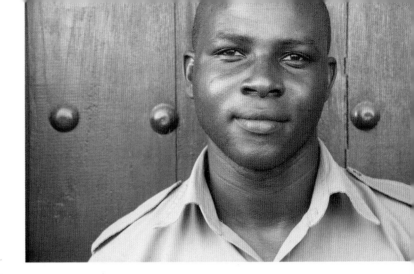

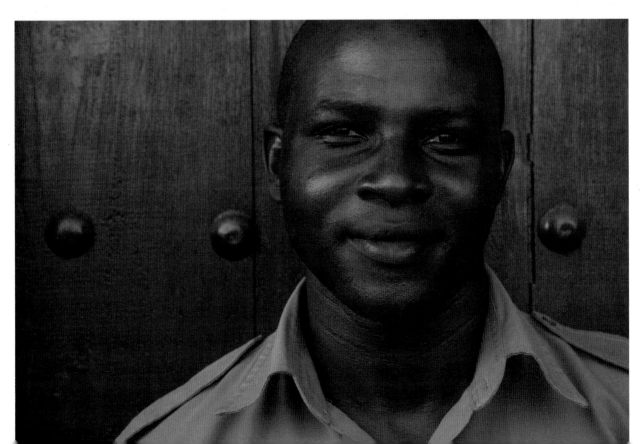

MR. GREEN JEANS (THE SKY BROTHERS' COUSIN)

Mr. Green Jeans is the cousin of the Sky Brothers. He comes in handy when you are exposing compositions that have a lot of green in them (you take the meter reading off the green area in your composition). Mr. Green Jeans prefers to be exposed at −2/3. In other words, whether you bring the exposure to a close by choosing either the aperture or the shutter speed last, you determine the exposure reading to be "correct" when you see a −2/3 stop indication (which means you adjust the exposure to be −2/3 stop from what the meter tells you it should be). If there's one thing I've learned about Mr. Green Jeans, it's that he's as reliable as the Sky Brothers, but you must always remember to meter him at −2/3.

This is a classic example both of what the light meter wants to do when confronted with white (in this case the white water of a waterfall) and of the need for Mr. Green Jeans. The first image is the result of leaving the meter to its own way of thinking: gray water. Not only is the water underexposed, so is the surrounding green tree.

So I swung the camera and lens to Mr. Green Jeans (the area shown in the second image) and readjusted the aperture until f/18 indicated a –2/3 underexposure and

then recomposed the scene with the waterfall. Of course, when I swung the camera back to the waterfall, my light meter indicated that a different exposure was required, but I ignored it. I was right and the meter was wrong.

Both images: Nikon D800E, Nikkor 70–300mm at 210mm, ISO 100, (left) f/32 for 1/4 sec., (right) f/18 for 1/4 sec.

NIGHT AND LOW-LIGHT PHOTOGRAPHY

There seems to be an unwritten rule that it's not really possible to get any good pictures before the sun comes up or after it goes down. After all, if there's no light, why bother? However, nothing could be farther from the truth.

Low-light photography and night photography pose special challenges, though, not the least of which is the need to use a tripod (assuming, of course, that you want to record exacting sharpness). But it's my feeling that the greatest hindrance to shooting at night or in the low light of predawn lies in the area of self-discipline: "It's time for dinner" (pack a sandwich); "I want to go to a movie" (rent it when it comes out on DVD); "I'm not a morning person" (don't go to bed the night before); "I'm all alone and don't feel safe" (join a camera club and go out with a fellow photographer); "I don't have a tripod" (buy one). If it's your goal to record compelling imagery—and it should be—night photography and low-light photography are two

areas where compelling imagery abounds. The rewards of night and low-light photography far outweigh the sacrifices.

Once you pick a subject, the only question that remains is how to expose for it. With the sophistication of today's cameras and their highly sensitive light meters, getting a correct exposure is easy even in the dimmest light. Yet many photographers get confused: "Where should I take my meter reading? How long should my exposure be? Should I use any filters?" In my years of taking meter readings, I've found there's nothing better— or more consistent—than taking meter readings off the sky. This holds whether I'm shooting backlight, frontlight, sidelight, sunrise, or sunset.

If I want great storytelling depth of field, I set the lens (i.e., a wide-angle lens for storytelling) to f/16 or f/22, raise my camera to the sky above the scene, adjust the shutter speed for a correct exposure, recompose, and press the shutter release.

One of the most dramatic bridges in the southeastern United States has to be the suspension bridge in Charleston, South Carolina. I remember the first time I was setting up to shoot this bridge at sunset; there were perhaps as many as eight to ten other photographers nearby, and as the sun started to set, I heard two guys talk with elation about the great shots they had just gotten as they were leaving. I shook my head in disbelief. In another twenty to twenty-five minutes a much better shot would unfold if they were willing to wait.

In my first exposure (on the left), it was a simple aim and shoot since the focal length I was using, 60mm, does not increase the intensity of the sun's light the way a 200mm or 300mm lens would. Nikon's matrix metering handled this exposure just fine. As nice as the resulting exposure was, it was the second image that I consider the real prize.

About twenty minutes after the sunset shot was made, I placed my camera on tripod, set the aperture to f/11, and placed my one and only colored filter, a magenta-colored filter, the FLW to be exact, on the front of the lens. With the lens now pointed to the dusky blue sky above the bridge, I adjusted the shutter speed until 13 seconds indicated a correct exposure. I then recomposed the scene you see above, and with the camera's self-timer set, I pressed the shutter release. I use the self-timer with "long" exposures simply to avoid any contact with the camera during the exposure time. I don't want to risk any camera shake, since sharpness is paramount almost every time I record an exposure.

Note that your camera's default for the self-timer is usually a 10-second delay, but I would *strongly recommend* that you consider changing this to a *2-second* or *5-second* delay. Waiting 10 seconds between shots can often mean not getting the shot. (To be clear, you can also use a cable release, but even here there's the slight risk of camera shake, since you're still "tied" to the camera.)

Both images: Nikon D3X, Nikkor 24–85mm, ISO 100, (left) at 60mm, f/11 for 1/60 sec., (above) at 85mm, f/11 at 13 sec.

Without a tripod, a night shot like this just isn't going to happen, especially when you are going to be the one to run into the shot and hold a pose to bring some scale to the scene.

This is the brain clinic in Las Vegas, designed by the architect Frank Gehry. I was not leaving Las Vegas without photographing it, and fortunately for me and several of my students, we had the pleasure of meeting the security guard. She wanted to make sure we got a great shot, so she offered to turn on the colored lights inside the clinic while the sky was a dusky blue.

With my camera on tripod, I first set my aperture to the "who cares?" choice of $f/11$ (since everything was at the same focused distance: infinity). I then tilted the camera to Brother Dusky Blue Sky and adjusted the shutter speed until 4 seconds indicated a correct exposure. After that, it was simply a matter of recomposing the scene, and with the camera's self-timer engaged, I fired off the first frame you see here (top). As much as I liked it, I felt it needed a sense of scale. I would take a "selfie"! With the self-timer set to a 10-second delay (instead of the normal 2-second delay) I was able to run into the scene and hold my position on the side of the building, appearing as if I were about to begin climbing the building. Of the three images, I prefer the one with "that" guy in it (bottom).

All images: Nikon D800E, Nikkor 24–85mm at 24mm, $f/11$ for 4 sec., ISO 200

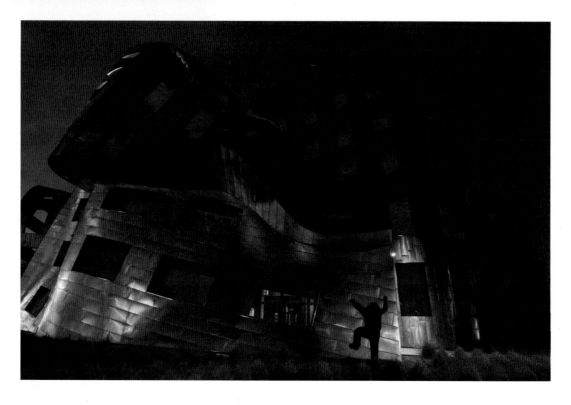

When I made this long exposure of the pier at Folly Beach in South Carolina, I was grateful that I had arrived as early in the morning as I had. The "streetlights" of the pier were still on, and those lights, small as they are, add some much needed contrast to an otherwise flat image. Making dusky blue exposures does not require the dusky blue that follows sunset, as is obvious here. There is no shortage of dusky blue light before sunrise—about forty-five minutes or so before sunrise to be exact. Yep, I am sure I just lost about four-fifths of you with that comment, but to those of you who are still with me, I'm going to assume you can set an alarm and need to know that you don't meter any differently! In this case I pointed the camera and lens to the dusky early morning blue sky above the pier, and with my aperture set to f/22, I adjusted the shutter speed until 13 seconds indicated a correct exposure. With the camera and lens on tripod, I recomposed the scene you see here with my 17–35mm lens at 17mm and tripped the shutter by engaging the camera's self-timer.

Nikon D800E, Nikkor 17–35mm at 17mm, f/22 for 13 sec., ISO 100

When shooting the Telus World of Science building and a portion of the distant Vancouver skyline, I used a filter I can't live without (besides the polarizer and my LEE 3-stop graduated): the FLW. It's a magenta-colored filter that is not to be confused with the FLD. The magenta color of the FLW is far denser and is far more effective on normally greenish city lights, giving them a much warmer cast. Additionally, this filter imparts its magenta hue to the sky, and that makes it perfect for nights when there isn't a strong dusky blue sky.

With my camera mounted on a tripod, I chose to shoot at f/11. I pointed the camera to the sky above and adjusted the shutter speed until 15 seconds indicated a correct exposure and then recomposed and recorded the exposure you see here.

Nikon D800E, Nikkor 24–85mm at 24mm, f/11 for 15 sec., ISO 200

The Punakha Dzong in Bhutan without question provides one of the finest opportunities to convey a sense of both tranquility and motion during a time exposure under the light of the full moon. This exposure, although it appears difficult, is quite easy to make. Directly overhead a full moon was illuminating much of the landscape in front of me, but I still needed to ensure that my use of the foreground foliage would be visible during this 30-second exposure. It was then that I used a flashlight that I carry with me in my camera bag, and over the course of the 30-second exposure I waved the flashlight repeatedly over the green branches.

Of the three 30-second exposures I made, this one turned out the best.

How did I determine that a 30-second exposure was the correct one? Again, with my aperture set to f/22, I merely pointed the camera and lens into the sky that you see straight ahead, above those hills, and adjusted my shutter speed until 30 seconds indicated a correct exposure.

Nikon D800E, Nikkor 17–35mm at 20mm, f/22 for 30 sec., ISO 200

While many photographers watch the large and looming moonrise, few photograph it because they aren't sure how to meter the scene. Surprisingly, a moonrise is easy to expose for. They are actually just frontlit scenes, the same frontlit scenes found in daylight, but in lower light. So what's the "secret" to getting a correct exposure?

Because depth of field was not a concern, I set the aperture on my 70-300mm lens to f/11 and called upon my friend, Brother Dusky Blue Sky. Metering the light in the sky around the moon, I adjusted my shutter speed until a 1/8 second indicated a correct exposure. With the camera on tripod, I then recomposed the scene and using the camera's two second delayed self timer, I fired the shutter release button.

With moon landscapes, it's best to shoot *the day before* the calendar says the moon will be full. Why? Because moons are often fullest early in the morning of the calendar day listed—meaning the time to shoot the fullest moon rise is the night before.

Top image: Nikon D800E, Nikkor 70-300mm at 280mm, *f*/11 at 1/8 sec., ISO 200

FLASHLIGHTS AND STARLIGHT

Some thirty years ago, I saw an advertisement for *The Lazy Man's Way to Riches*. I never bought the book, but from what I could determine, it was about buying real estate and how you end up making huge financial gains with other people's money. I do not know if the plan worked for the millions who bought the book, but certainly it was working for the man who wrote it.

I'm here to tell you that you too can make millions while sitting in a lounge chair out in the middle of a desert: millions of tiny exposures, that is!

I am referring to the millions of bright stars that come out at night and are best seen in the country, away from the artificial lights of the city. Read on to learn how to capture starlight.

It was during night in the Arizona desert that I shot this single 30-second exposure. My motivation to shoot a single 30-second exposure was provided by the sound of a lone motorcycle that I could hear coming down the highway. With my camera and tripod set up alongside the shoulder of the road, I waited to start the 30-second exposure until the motorcycle had just entered the frame from the right. This explains why there is no trailing taillight coming into the frame, although it starts once the motorcycle is well inside the frame. As you can see, I recorded not only the taillight but also the illuminated roadway in front of the motorcycle thanks to the headlight. I also captured the single points of light from many of the stars in the western sky on this otherwise very quiet night in the Arizona desert.

Nikon D800E, Nikkor 16–35mm at 22mm, *f*/5.6 for 30 sec., ISO 1600

On more than one occasion while in the country or desert, I have set up my tripod and camera and pointed it toward the North Star, attached my cable release, set the ISO to 1600 and the aperture to f/5.6, and proceeded to make a minimum of sixty 30-second exposures, one right after the other, all while seated in my lightweight lawn chair. Lately, I've started to bring along my Bluetooth Bose speaker and listen to music while recording these 30-second exposures of the millions of stars overhead; this is truly a lazy man's way to record the riches of the universe!

Upon completion of my night out, I return to the studio, and if not that same evening then certainly the next morning, I will load the images into Photoshop and call upon that program's ability to stack and process all the images into a single exposure. The stacking process is truly easy, and there are countless video tutorials on YouTube that explain just how to do it. Be assured that after a brief 5 to 7 minutes from start to finish, which includes loading your images into the computer, you will end up with the same sixty images all stacked together into a single exposure that looks much like the image you see here. Because the earth was rotating during that combined 30 minutes of exposure time, you will see the stars "arching" across the sky.

If you want even more arching, you can simply keep shooting additional 30-second exposures for upward of 3 to 4 hours if you wish. And all the while, you sit back in your lounge chair and listen to the night air or your music and try not to fall asleep.

Nikon D800E, Nikkor 16–35mm at 16mm, f/5.6 for 30 sec. (60 exposures total), ISO 1600

LIGHT PAINTING

If we think of the digital sensor as a blank canvas (a good habit to get into), it might be easier to appreciate the surprising results of light painting. We are able to paint these "canvases" using long exposure times that allow us to draw with artificial light sources such as flashlights and small LED light panels.

In the normal everyday world of image making, most of us associate exposure with shutter speeds that are often faster than the blink of an eye, yet when it comes to light painting, the exposure times are more often than not seconds and sometimes even minutes. Unlike an actual painter's canvas, where oils or acrylics are used, your materials will be flashlights, sparklers, and even your electronic flash and any number of assorted colored gels. Depending on the time of day you choose to begin your light painting, you will find yourself on occasion calling upon your 2- to 8-stop variable neutral-density filter.

Effective light painting as a general rule relies on exposure times of 8 seconds or longer, even minutes, yet there are exceptions to this rule. Your exposure time will be determined in part by the time of day, the aperture in use, the selection of your ISO, and, as was mentioned a moment ago, the addition of any filters, including an ND filter.

One of my neighbors, Aya (which means "colors" in Japanese), agreed to assist me with a simple light painting trick. Before turning off most of the lights in my studio, I asked Aya to lie down on the edge of my bed and fan her hair out across the black sheets. I then set up my camera and tripod, and while framing up the tight close-up of her face that you see here, I also focused on her eyes and then turned off autofocus. With the aperture set to f/16 and the ISO at 100, I knew from experience that I would be able to "paint" for about 2 seconds maximum before I ran the risk of an overexposure from the small flashlight. With the shutter speed set to 2 seconds and with my cable release attached to the camera, I was ready. I turned off the lights and tripped the release, and for the next 2 seconds I began painting her with an ordinary flashlight in a diagonal up-and-down fashion, making certain to light only those areas around the eyes that I wished to record during the exposure. As you can see in the resulting image, only the cheek and part of Aya's lips are lit, and the "spillover" light was able to illuminate those areas near her cheek and lips, including some of her hair. This very controlled "spot light" technique is one of the unique characteristics of painting with a narrow-beam flashlight.

Nikon D800E, Nikkor 24–120mm at 120mm, f/16 for 2 sec., ISO 100, tripod

Whether you are visiting the beach, the desert, the mountains, the city, or your own backyard, the opportunity to paint presents itself every day around dawn or shortly after sunset. It does not matter what time of year it is or if it's cloudy, clear, raining, or snowing. All that matters is that you use no less than an 8-second exposure time.

It was at a workshop in New Zealand that a willing student posed for all of us against the remnants of an impressive sunset that had taken place 15 minutes earlier. With his arms outstretched and a willingness to hold still as well as he could, I quickly made an outline of his body with two flashlights, one covered in a blue gel and the other in a red gel. Then, with a third flashlight covered in a yellow gel, I made a swirling motion with my hand as I walked out of the frame during the final 2 seconds of this 15-second exposure.

Much of light painting is trial and error. Sometimes success comes easily, but at other times it seems to elude you no matter how hard you try. But one thing is certain: it is an area of exposure that is well worth exploring and one where there are still many new discoveries to be made.

Nikon D300S, Nikkor 17–55mm at 17mm, f/22 for 15 sec., ISO 200, tripod

THE IMPORTANCE OF THE TRIPOD

When should you use a tripod? When I want exacting sharpness and/or when I'm shooting long exposures and want to convey motion in a scene, I always call upon my tripod.

The following features are a must on any tripod. First, the *tripod head*: This is the most important, because it supports the bulk of the weight of the camera and lens. When you look at the many different styles of tripod heads, make it a point to mount your heaviest combination of camera and lens on each head as a test. Once you secure the camera and lens, check to see if it tends to flop or sag a bit. If it does, you need a much sturdier head. Next, see if the tripod head offers, by a simple turn of the handle, the ability to shift from a horizontal to a vertical format. Also check whether you can lock the tripod head at angles in between horizontal and vertical. Finally, does the tripod head offer a quick release? Some tripods require you to mount the camera and lens directly onto the head with a threaded screw. A quick release, in contrast, is a metal or plastic plate that you attach to the camera body; you then secure the camera and plate to the head via a simple locking mechanism. When you want to remove the camera and lens, you simply flick the locking mechanism and lift the camera and lens off the tripod.

Second, the *base stability*: Before buying any tripod, you should spread out its legs as wide as possible. The wider the base, the greater the stability. Each leg of the tripod is composed of three individual lengths of aluminum, metal, or graphite. You can lengthen or shorten the legs and then tighten them by a simple twist of hard plastic knobs, metal clamps, or a threaded metal sleeve.

The *height of a tripod at full extension* is another important consideration: Obviously, if you are 6 feet 2 inches, you don't want a tripod with a maximum height of only 5 feet 2 inches—unless you won't be bothered by stooping over the tripod all the time. All tripods have a center column designed to provide additional height; this can vary from 6 inches to several feet. Some center columns extend via a cranking mechanism, whereas others require you to pull them up manually. Keep in mind that you should raise the center column only when it's absolutely necessary, because the higher the center column is raised, the greater the risk of wobble—which defeats the purpose of using a tripod.

Finally, when you are shooting any subject with your tripod, make it a point to use either the camera's self-timer or a cable release to trip the shutter.

Does the scene before you offer any motion-filled opportunities? Cityscapes often provide wonderful ways to show the flow of traffic. (Keep in mind that the headlights and taillights of cars will be rendered as streaks/lines of red and white, and so when you set up your composition, you must ask yourself if these lines will keep the viewer in the scene or take the viewer out of the scene.)

When a cityscape does offer a motion-filled opportunity, it is time to give your attention to the right shutter speed; at a minimum, a 4-second exposure will render the flow of traffic as streaked colored lines. With my aperture set to f/16, I aimed toward the dusky blue sky to

the left of the Eiffel Tower and adjusted the shutter speed until 8 seconds indicated a correct exposure.

From atop the pedestrian plaza at Place de la Concorde, the views of the Eiffel Tower are some of the best! With my 70–300mm lens and camera on tripod, I zoom out to 300mm and fill the frame with the lower portion of the Eiffel Tower and all that traffic. As I kept an eye on the streetlights, I determined to trip the shutter release via the self-timer when the traffic flow was at its most dense.

Nikon D800E, Nikkor 70–300mm at 300mm, f/16 for 8 sec., ISO 200, tripod

SPECIAL
TECHNIQUES

POLARIZING FILTERS

Among the many filters on the market today, a polarizing filter is the one that every photographer should have. Its primary purpose is to reduce glare from reflective surfaces such as glass, metal, and water. On sunny days, a polarizer is most effective when you're shooting at a 90-degree angle to the sun. For this reason, sidelighting (when the sun is hitting your left or right shoulder) is a popular lighting situation when you are using a polarizing filter. Maximum polarization can be achieved only when you're at a 90-degree angle to the sun; if the sun is at your back or right in front of you, the polarizer will do you no good at all.

Working in bright sunlight at midday isn't a favorite activity for many experienced shooters since the light is so harsh, but if you need to make images at this time of day, a polarizer will help somewhat. This is because the sun is directly overhead—at a 90-degree angle to you whether you're facing north, south, east, or west.

If you're working in morning or late-afternoon light, you'll want to use a polarizing filter every time you shoot facing to the north or south. In this situation, you're at a 90-degree angle to the sun, and as you rotate the polarizing filter on your lens, you'll clearly see the transformation: blue sky and puffy white clouds will "pop" with much deeper color and contrast.

Why is this? Light waves move around in all sorts of directions—up, down, sideways, and all angles in between. The greatest glare comes from vertical light waves, and the glare is most intense when the sun is at a 90-degree angle to you. A polarizing filter is designed to remove this vertical glare and block out vertical light, allowing only the more pleasing and saturated colors created by horizontal light to be recorded.

Note that if you shift your location so that you're at a 30- or 45-degree angle to the sun, the polarizing effect of the filter will be seen on only one-half or one-third of the composition, and so one-half or one-third of the blue sky will be much more saturated in color than the rest of it. Perhaps you've already seen this effect in some of your landscapes. Now you know why.

Although there's vertical light around when you're working with frontlit or backlit subjects, there's no need to use the polarizing filter at those times, since the sun is no longer at a 90-degree angle to you.

Is the use of polarizing filters limited to sunny days? Definitely not! In fact, on cloudy or rainy days there's just as much vertical light and glare as on sunny days. All this vertical light casts dull reflective glare on wet streets, wet metal and glass surfaces (such as cars and windows), wet foliage, and the surfaces of bodies of water (such as streams and rivers). The polarizing filter gets rid of all this dull gray glare.

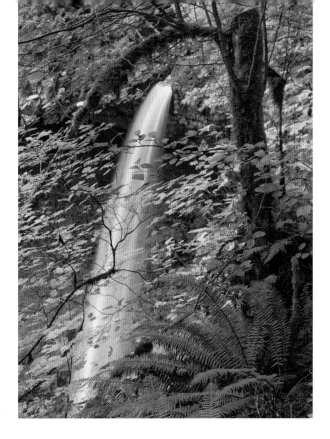

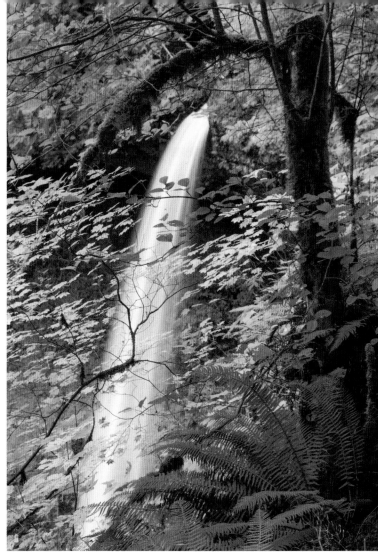

You will see two different exposure settings below because a polarizing filter cuts the light down by 2 stops. That accounts for the 2-stop difference in shutter speeds between these two photos.

Both photos: Nikon D800E, Nikkor 24–85mm at 24mm, ISO 100, (left) *f*/22 for 1/4 sec. without polarizer, (right) *f*/22 for 1 sec.

I don't know how often you have a chance to shoot a rainbow, but if you want to add some real intensity to your next rainbow image, put on a polarizer. As you turn the outer ring of the filter, you will clearly see the intensity of the rainbow colors increase dramatically. Obviously, you want the most intense colors, so once you see that, stop turning and start shooting.

Most rainbows are shot with a wide-angle lens since a rainbow covers a wide area across the landscape or cityscape. Also, more often than not, rainbow compositions do not offer the opportunity to use immediate foreground interest, and so you usually will end up calling upon the "who cares?" apertures from *f*/8 to *f*/11. Finally, a rainbow that fills the sky like this is 100 percent dependent on rain and frontlight. After a rain shower, if you now find yourself being blinded by the sun as it pops through the clouds, turn around! Chances are really good that you will see a rainbow.

Nikon D3X, Nikkor 35–70mm at 35mm, *f*/11 for 1/160 sec., ISO 100

GRADUATED NEUTRAL-DENSITY FILTERS

Neutral-Density filters reduce light transmission throughout the scene. Unlike a neutral-density filter, a graduated neutral-density filter contains an area of density that merges with an area of no density. In effect, it is like a pair of sunglasses with lenses that are tinted only one-third, leaving the other two-thirds clear. Rather than reducing the light transmission throughout the scene, as an ND filter does, a graduated ND filter reduces light only in certain areas of the scene.

Suppose you find yourself in the country just after sunset and want to use your wide-angle lens to get a composition that includes not only the sunset but several small farmhouses and a large barn nearby and of course the surrounding wheat fields. Assuming this is a "who cares?" composition, you'd choose the right aperture first, in this case *f*/11. Then you'd point your camera at the sky to find the shutter speed that is required to make the sky a correct exposure; let's assume it reads 1/30 sec. Now point the camera down so that no sky is included and take a meter reading of the landscape below: the farmhouse, barn, and wheat field; let's say 1/4 sec. is indicated as a correct exposure. That's a 3-stop difference in exposure. If you went with *f*/11 for 1/30 sec., you'd record a wonderful color-filled sky, but the farmhouse, barn, and wheat fields would record as a dark, underexposed mass. If you set your exposure for the landscape below, the sky would be way overexposed and all its wonderful color would disappear.

The quickest way, and the way that requires the least amount of work, is to use a 3-stop LEE graduated neutral-density filter. The design of this filter, along with the filter holder, allows you to slide the filter up or down or even turn the outer ring of the filter holder so that you can place the filter at an angle. This in turn allows for perfect placement of the filter in most of your scenes.

In the situation described above, I would not hesitate to use my 3-stop graduated ND filter positioned so that only the much brighter sky was covered by the graduated ND filter. I do not want the filter covering anything other than the bright sky. Once the filter is in place, aligned so that the ND section stops right at the horizon line, the correct exposure of the sky is reduced by 3 stops, and I would now shoot the entire scene at *f*/11 for 1/4 sec.

Although graduated ND filters come in 1- to 3-stop variations, I've never understood why one needs a 1 or 2 stop. But for sure, the 3 stop will get a lot of use. In addition, they come in hard-edge and soft-edge types, meaning that the clear section of the filter meets the ND section with either an abrupt change or a gradual transition. My personal preference is the soft edge.

ALIGNING THE FILTER

If you have a camera with a depth-of-field preview button, use it as you position the graduated ND filter. As you slide the filter up or down, you can see exactly what portions of the composition will be covered by the density of the filter. Using the preview button will guarantee perfect alignment every time.

The tricky part of this scene was the almost 4-stop difference between the rocks and water below and the buildings and sky above. With my camera and lens on a tripod, I chose an aperture of f/16 and set my exposure for the rocks and water below. As you can see on the left, this resulted in a correct exposure of the foreground rocks and water, but at the expense of the skyline and the blue/magenta dusky sky. Before shooting the next exposure on the right, I placed my 3-stop ND filter on the lens, and voilà, problem solved! My exposure time for both of these images was the same: f/16 for 4 seconds.

If you don't have a Graduated ND filter (or you forgot to bring yours), you can always do this effect in Lightroom or Photoshop during the RAW processing phase by using the built-in Graduated ND filter. But first, make your exposure in the same manner as if you had the filter; exposing for the scene below the horizon line.

When you bring the file in for processing, you simply click on the Graduated ND filter feature, and after setting an exposure adjustment, you pull down the arrows until the over-exposed, brighter part of your scene, above the horizon line, is more in line with the overall correct exposure. In effect, it can render the over-exposed sky and cityscape as a correct exposure.

Both images: Nikon D800E, Nikkor 24–120mm at 24mm, f/16 for 4 sec., ISO 200

MULTIPLE EXPOSURES

If taking a single exposure of a scene or subject doesn't quite do it for you, how about taking two exposures? Or why not seven or nine exposures of the same subject, stacking all the exposures one on the other and within seconds collapsing them all into a single image? You can do all this *in camera* with most Nikon cameras, a few of the Pentax models, and of late a few of the Canon models. Get out your manual if you have trouble finding this feature, because once you do, you can explore the many creative possibilities it affords.

I like to inject a bit of implied movement into my multiple exposures. To do this you simply point your camera at the subject, choose the appropriate aperture (*f*/16 or *f*/22 for storytelling, *f*/4 or *f*/5.6 for isolation, or *f*/8 or *f*/11 for "who cares?"), and, if you are in

Aperture Priority mode, fire away three, five, seven, or nine times, all the while moving the camera ever so slightly with each exposure. If you choose to shoot in manual exposure mode, adjust the shutter speed until a correct exposure is indicated (as if you were shooting a single exposure) and then fire away, again moving the camera slightly with each of your three, five, seven, or nine exposures. The camera's "auto-gain" feature will take all your combined exposures and blend them into a single, correct exposure.

Almost any subject can benefit from the multiple exposure technique—even city scenes. Overcast days, sunny days, frontlit scenes, and even some backlit scenes lend themselves to multiple exposures as well, but most of all, look for scenes that are colorful and filled with pattern.

With my camera and 200mm lens mounted on tripod, I chose to focus on this lone tree; in the background, another tree was full of magenta-colored blooms. With my "who cares?" aperture set to *f*/11 for maximum depth of field, I simply adjusted the shutter speed until 1/160 sec. indicated a correct exposure and pressed the shutter release, which resulted in the exposure you see here (left). It's a nice shot, for sure, but I thought it also might be one of those subjects that look even better as a multiple exposure, because it was an image made up of *colors* and *textures*. Plus, on this particular day, with a cloudy sky above, it was a classic

opportunity to shoot multiple exposures as far as I was concerned since contrast was low! Again, with that same exposure reading, I set the multiple exposure feature on my Nikon D800E to nine shots, and as they fired, I moved the camera ever so slightly up, down, and from side to side while pressing off all nine shots. Within seconds of the firing of all the shots, my Nikon D800E "processed" them as a single correct exposure (right).

All images: Nikon D800E, Nikkor 70–300mm at 200mm, *f*/11 for 1/160 sec., ISO 100

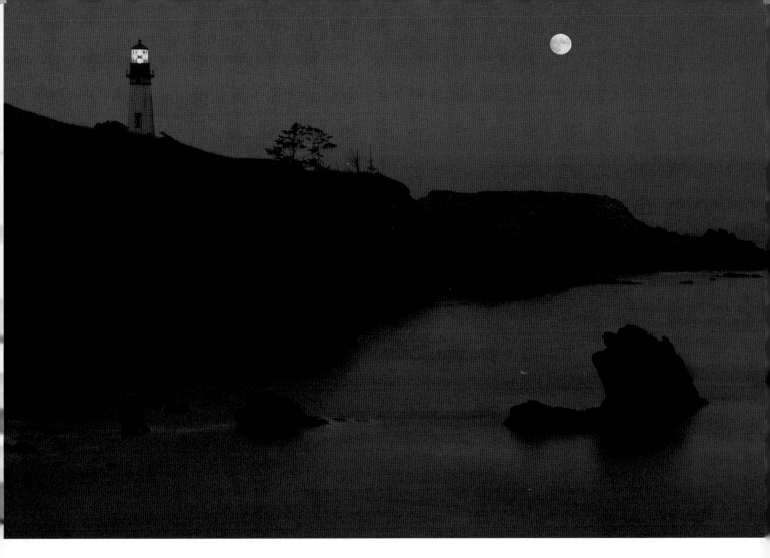

In anticipation of your question: *yes*, you can always shoot just two separate exposures, and oh my, do I ever have a good idea for those times when you want to try your hand at shooting just two! Shooting only two exposures opens up several welcome possibilities: you can combine out-of-focus subjects with in-focus subjects or shoot that full moon in the eastern sky and then shoot that nearby landscape or cityscape, and voilà, it now has a full moon in it!

First, go to your menu and find the multiple exposure feature. Choose 2, and just as I did here, you can now shoot the full moon up there in the eastern sky and compose the moon so that it is in the upper right-hand portion of the frame. Now turn around to the west and compose the Yaquina Head Light along the central Oregon coast, and within seconds the camera blends the two exposures together, as you can see here!

In shooting a full moon against the dark sky, your correct exposure is f/11 at 1/125 sec. with ISO 200 or f/11 at 1/60 sec. with ISO 100. You must shoot either of these exposures with the camera in manual mode or your

camera's light meter will think the scene with the moon and *all* that dark sky needs to be shot at a really long exposure, and of course that is not the case. You want only the bright full moon!

After you shoot the moon, you will set a completely different exposure for whatever scene you are going to shoot next; for me that was the lighthouse. With my aperture set to f/16, I pointed the camera up at the dusky blue sky to the right of the lighthouse and adjusted my shutter speed until 15 seconds indicated a correct exposure, and I then fired away. Again, as you can see, the moon and the lighthouse became one right then and there!

Are we having fun or what? If ever there were two techniques that allow me to stay true to my motto (Get as much as possible, if not all, done in camera), these would be it.

Moon: Nikon D300S, Nikkor 70–300mm at 135mm, f/11 for 1/125 sec., ISO 200. Lighthouse: Nikon D300S, Nikkor 70–300mm at 80mm, f/16 for 15 sec., ISO 200

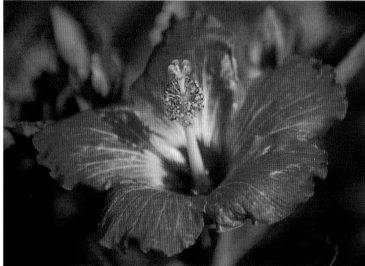

Take your camera with you the next time you head down to the local garden center. In addition to buying some flowers, you will want to shoot some double exposures while you are there. With your multiple exposure number set to 2, take an out-of-focus picture of a large group of flowers and then take an in-focus picture of a single flower, and voilà, let the romance begin!

The first image I shot (top, left) was with my Nikkor 70–300mm, and I deliberately shot at a wide open aperture, *f*/5.6, and with the flowers out of focus (another example of times when you must have autofocus turned off). After making this out-of-focus exposure, I found a single bloom (top, right) and used an aperture of *f*/22 to get a lot of depth of field from the tip of the stamen to the throat of the flower.

After these two images were shot, the camera automatically blended them together (bottom).

All images: Nikon D800E, Nikkor 70–300mm, ISO 100, (top, left) *f*/5.6 for 1/1000 sec., (top, right) *f*/22 for 1/60 sec.

There really is no limit to subject matter when it comes to shooting double exposures or multiple exposures. If I had a higher page count for this book, I am sure I could fill up twelve to sixteen pages with ideas, but within the limited page count I must include the suggestion to shoot another double exposure idea that also has unlimited potential: combining a portrait with a pattern or texture. I am sure that with just a few minutes of thought you will be out the door to try your hand at the multitude of textures you can double-expose with any number of portraits, for example, a portrait of your child with the SpongeBob pattern found on his or her pajamas; a portrait of your husband, "the Skipper," with a patternly shot of the many boats in the marina; a portrait of a young boy with a portrait of his grandpa, and so on. Just let your imagination run free!

Something as simple as combining the moss-covered bark of an oak tree with a young woman's portrait creates a haunting ghostlike image. There is no limit to the textures one can use when creating double exposure portraits.

All images: Nikon D800E, Nikkor 24–120mm at 100mm, *f*/11 for 1/160 sec., ISO 100

ELECTRONIC FLASH

THE PHOTOGRAPHIC TRIANGLE AND FLASH

We had a thorough discussion earlier in this book of the photographic triangle as it applies to *natural-light photography*. These three factors—*f*-stop, shutter speed, and ISO—must all work as a team, and between the aperture and the shutter speed, one of them will always be given the role of the leader. The kind of picture you wish to take (depth-of-field concerns = aperture choice, motion-filled opportunities = shutter speed) will determine which of these two parts of the triangle will lead the charge. If the aperture will take the lead role because of depth-of-field concerns, your shutter speed will control the exposure—underexposure, overexposure, or a perfect exposure—depending on the duration of the time that the shutter is allowed to stay open. If the shutter speed will be leading the charge because of motion-filled opportunities, your aperture will control the exposure—underexposure, overexposure, or a perfect exposure—depending on the size of the opening of the lens.

When you choose to *mix* flash photography exposures with natural-light photography exposures, the photographic triangle remains alive and well, but a really simple understanding of how the leadership roles have changed slightly is necessary.

The sun is a constant "floodlight" that rains down on the earth, giving all of us the time to move around and really see what is going on in our world. In sharp contrast is that very quick, as in 1/10,000 of a second quick, burst of light that is expelled from an electronic flash. How the heck can any of us expect to see, really see, in that incredibly short amount of time not only what the flash lit up but also how well it lit it up? We can't and nor should we, but with today's amazing technological advances, we really can expect a "perfect flash exposure" each and every time, whether we choose to use the flash in TTL mode (through the lens, discussed below) or in manual exposure mode. After all is said and done, isn't a perfect exposure what we're all trying to shoot?

Unlike a naturally frontlit scene in which everything is just about evenly illuminated by the *huge* ball of burning gases otherwise known as the sun, the minuscule output of light from your flash, comparatively speaking, can only light up subjects that are usually within a short range, such as 2 to 50 feet, of the camera. And unlike natural-light exposures whose correct exposure can be determined by a combination of large or small lens openings and slow or fast shutter speeds, a correct flash exposure is solely and 100% dependent on choosing the *correct aperture*.

TTL stands for "through the lens" metering, and for the purposes of this book, there is no reason at all to go deeply into TTL since that would not make you a better photographer. You would be a bit more informed, but knowing more about TTL will not make you more creative. There is only important thing to know about TTL and the creative process: your choice in aperture will dictate the parameters of the flash-to-subject distance when you are shooting in TTL mode.

As we are about to discover, flash photography follows the same principles as manual-exposure photography in natural light. The only difference is the addition of supplemental light from a portable "miniature sun." With that in mind, these are the only three rules you need to remember about shooting with electronic flash.

At my Key West Workshop, one of my students owned a "lighted boat" business; both paddle boards and kayaks were outfitted with colorful and waterproof LED lights on their undersides. The combination of the sunset sky and the lighted boats could make for a compelling image. But just how should we go about doing this?

I began with the camera in full manual mode, and since I needed some front-to-back depth of field, I called upon f/11. I used the 24-120mm lens at 24mm, and in the absence of an immediate foreground, an aperture of f/11 was totally sufficient to render sharpness from the subjects and their boats all the way to the distant sky.

Now all that remained was to adjust the shutter speed until 1 second indicated a correct exposure so I had the correct exposure for the ambient light. Without the use of the flash, the people in this shot would be rendered quite dark, so the solution was to bring out the flash. With my Nikon SB-900 in full manual flash mode, I dialed in the aperture of f/11 on the back of my flash and discovered that a flash-to-subject distance of 17 feet was being indicated for an aperture choice of f/11. After asking the subjects to row in a bit closer to me, I fired off several frames, one of which you see here.

Nikon D800E, Nikkor 24-120mm at 24mm, f/11 for 1 sec., ISO 200, flash

THE THREE FACTORS FOR CORRECT FLASH PHOTOGRAPHY EXPOSURE

There are three factors that go into creating a dynamic flash exposure: (1) choosing the right aperture, (2) making certain your subject is at the right flash-to-subject distance, and (3) with the aid of the shutter speed, deciding whether to include the ambient light that is often present in the scene as a correct exposure, slight underexposure, or instead to "kill" the ambient light entirely by shooting at a shutter speed that in conjunction with your aperture creates at least a 4-stop underexposure. Let's explore each of these factors in much greater depth so that we can realize their individual impacts on the overall exposure.

Factor 1: A correct flash exposure is determined by selecting the right aperture. And what is the right aperture? That depends on how much depth of field the composition before you needs. Are you shooting a storytelling composition? If so, you will need a lot of depth of field, so choose $f/22$ or $f/16$. Are you shooting a singular-theme/isolation composition? If so, you will want very little depth of field, so choose $f/4$ or $f/5.6$. Are you shooting a "who cares?" composition? If so, you will want to take advantage of the "critical aperture" and choose $f/8$ or $f/11$.

Factor 2: Once you have determined which aperture makes the most sense, if you are shooting with the flash in TTL mode, you will see on the back of your flash a *flash range* indicated in either feet or meters. For example, when choosing $f/11$ you might see a range of 3 to 18 feet, and when choosing $f/5.6$ you might see a range from 6 feet to 39 feet (the bigger the f-stop opening, the longer the reach of the flash range). If you are able to shoot in manual flash mode and depending on the brand of flash (e.g., Nikon SB-900 or SB-910 or Canon 600), you will not see a range of flash distances but only a *single* distance indicated in feet or meters, such as 12 feet or 4 meters.

If you are in TTL mode a $f/11$, that 3- to 18-foot distance is telling you that *if* your subject is within a 3- to 18-foot distance of your flash, a perfect flash exposure will be the result. If you are in manual flash mode and *if* your subject is within a half foot or so of 12 feet from the flash, you also will experience a perfect flash exposure.

To be sure, TTL flash is a technological marvel simply because it does reduce, considerably, any worries you may have about a correct flash exposure. When you are in the TTL mode, just below your flash head, an infrared beam is sent out that hits the intended subject and determines its distance *before* the flash fires. On the basis of that distance and assuming that your subject is within the 3- to 18-foot distance given above, the flash will self-adjust its power and send out less power when the subject is closer, say, 3 to 5 feet, or add more power when the subject is farther, say, 15 to 18 feet. If your subject is closer than 3 feet or much farther away than 18 feet, the flash exposure will be overexposed or underexposed, but again, as long as the subject is within that flash range of 3 to 18 feet, you should get a correct flash exposure.

Considering the technological marvel of TTL flash, why would anyone even consider using the flash in manual mode? I cannot speak for others, but my reasoning in using my flash in manual mode is that I find it more reliable, plus I am what one might call "old school." Let me explain briefly what I mean by more reliable and also explain why it's a more logical choice for *my* kind of flash photography.

I do not shoot weddings or events. In just about *every* flash exposure I have ever made, I have had close to 100 percent control over the subject that I wanted to light up with my flash, whether that subject was a foreground of wildflowers, a model, or a product/still life. Unlike a wedding reception

or an awards ceremony, where there is constant movement of the subjects you are trying to photograph, my subjects can be moved by me or asked to move at my direction. Once *I* have determined what depth-of-field issues I am facing, I choose the aperture accordingly and then can decide where the subject needs to be standing, jumping, posing, sitting, lying, climbing, riding, or, in the case of a still life, placed. Let's say I choose to shoot at *f*/11 in manual flash mode; in that case a distance of 12 feet is indicated, which simply means I need my subject to be roughly 12 feet from the flash.

Again, there is *nothing* to prevent you from choosing TTL to shoot the same subjects that I choose to shoot in manual flash mode, but I will add—for the last time, I promise—that if we shot flash exposures of the same subject side by side one hundred times, I would be spot on one hundred times and you probably would be spot on around ninety seven times. There is not enough space in this book to explain all the whys, but suffice it to say that TTL flash reacts to white and black subjects in much the same way your camera's built-in light meter reacts: instead of recording white or black, you record gray flash exposures. In contrast, since I am in manual flash mode, I record white or black. Experienced wedding and event photographers know how to overcome these issues and when to employ the autoexposure overrides that their flashes offer, but again, I do not have space in this book to cover it all. (If you're interested, you might consider buying my book *Understanding Electronic Flash*.)

But hey, ninety seven out of one hundred correct flash exposures is still impressive, so let's move on to the *drama* that can result from using your flash, a drama that has *everything* to do with combining the correct flash exposure with the ambient exposure (natural light) that surrounds the subject you wish to flash.

Until now, I have limited our discussion on flash to the role of the aperture and how the aperture dictates not only the resulting depth of field but also just how far the flash is able to travel. What

It was not just the wildflower explosion that brought my car to a halt as I toured the area of Glacier National Park, but the impending storm that would soon unleash torrential rain and hail stones. This was going to be a great opportunity to use the story-telling aperture of *f*/22. When combined with a deliberate under-exposure of the existing light, and the use of my flash to illuminate the foreground flowers, a dramatic landscape was in the making.

With my camera and 12-24mm lens mounted low to the ground on my tripod, I pre-set the focus on my lens to 1 meter. I then adjusted the shutter speed when a 1/30 sec. indicated a correct exposure. Since I wanted to under-expose the landscape, I chose to keep adjusting my shutter until a 1/125 sec. indicated that I was now two stops under-exposed. Had I shot that exposure, we would see a dark two-stop under-exposure from front to back, but in fact we see that the foreground flowers are brightly illuminated. How did I do that? I dialed in *f*/22 on the back of my flash and with the zoom head of my flash set to 18mm, my distance scale on the flash indicated a correct flash exposure if my flash-to-subject distance was 4.4 feet. Holding the flash with my left hand, I fired off the frame you see here with a correct flash exposure for the foreground flowers against the more ominous under-exposed landscape.

Nikon D800E, Nikkor 12-24mm, *f*/22 for 1/125 sec., ISO 200, flash

A dramatic sky presented itself on a typical overcast day in Holland. With my camera in manual exposure mode, I asked one of my students, Dennis, to pose against the backdrop of the many tree-lined roads that the Holland countryside is noted for. In the absence of flash, my two stop under-exposure of ƒ/11 at a 1/160 second resulted in a silhouetted Dennis and trees against a dark and foreboding sky. The second time I brought out the flash, and with the flash in my left hand and in TTL Mode and with Nikon's Commander Mode engaged to fire it, I took that same exposure and Dennis was lit up against the dark and contrasting background. With the flash in TTL Mode a distance range is always visible on the back of the flash. In this case TTL was indicating that as long as my subject was within 3 to 14 feet, I would record a correct exposure, and as is clear, Dennis is correctly exposed by the flash.

Both images: Nikon D3X, Nikkor 24–85mm at 50mm, ƒ/11 for 1/160 sec., ISO 200, (top) no flash, (bottom) flash

role, if any, does the shutter speed play in a correct flash exposure? It plays a huge role and is in fact responsible for all the potential drama!

Factor 3: In combination with the aperture you have deliberately chosen for reasons of depth of field and *always* with the camera in manual exposure mode, the shutter speed can now be set so that the surrounding ambient light is correctly exposed, slightly underexposed, or severely underexposed.

Let's assume you wish to use an aperture of ƒ/11 to shoot a portrait from a low viewpoint against a dusky blue sky about 10 minutes after sunset. In this situation, depth of field is *not* an issue, so you wisely choose ƒ/11, and now you simply adjust the shutter speed while pointing the camera into the sky until you notice that at 1/60 sec., you are 2 stops underexposed. Now press the shutter release and voilà, you are looking at a correct flash exposure against the welcome contrast of a 2-stop underexposed dusky blue sky. Yep! It is that easy! It also bears repeating because you always want to have full control over how much or how little ambient light is included in your flash exposure so that you will *never* use the camera in any exposure mode except manual mode. (If you tried to shoot this scene with the camera in Aperture or Shutter Priority mode, you would end up with a sky that is perhaps a bit overexposed and a portrait that is surely overexposed because of the combination of a correct flash exposure and a correct ambient exposure!)

If you are not convinced that shooting in manual exposure mode is a smart thing to do when you are shooting only in ambient light, you will soon be supremely convinced that it is the only mode to shoot in when using your flash. Unless you're shooting in a completely dark room, there's always ambient light present, and it's your creative input that decides how much or how little of it contributes to the overall flash exposure. Without further ado, while these very basic principles of flash are fresh in your mind, let's head out into the field and put these ideas into action.

More often than not, shooters associate the use of flash with shooting portraits. This one idea I am about to share with you is by no means the only way to shoot a flashed portrait, but it does remain one the simplest and most effective ways to capture a flashed portrait.

Asking one of my students, Phillip, to take a seat on a small stairway, I first took a simple composition and metered solely for the available light. At the "who cares" aperture of *f*/8, and with the camera in manual exposure mode, I adjusted the shutter speed until a 1/60 second indicated a correct exposure. It is a far from flattering portrait (right) and it has much to do with the flat light of open shade and the somewhat blue, somber light. But fixing this is easy! Bring out the flash and add an amber gel to create a warm light.

With the flash in my left hand, I lit Phillip from the side, creating a sense of low-angled sidelight. Additionally I wanted to kill the ambient light here, so a two stop under-exposure was needed so I stopped the lens down to *f*/11 (-1 stop) and decreased the shutter speed to a 1/250 sec. (another -2 stops) for a total of three stops under-exposure. Finally, I used another student's black sweatshirt as a backdrop and this accounts for the "disappearance" of the white wall. Hand-holding the flash in TTL Mode to the side of Phillp's face, I captured this image. The low-angled and warm side-lighting from the flash makes for a far more pleasing portrait (top).

Top image: Nikon D800E, Nikkor 24–120mm at 120mm, *f*/11 at 1/250 sec., ISO 100, flash

THE DANGERS OF BECOMING A FLASHAHOLIC

It may come as a surprise to some that I am about to play the role of a spoiler. Up to this point in the book I have made it clear that the understanding of and use of electronic flash have improved my life as a photographer in all areas of my interest: nature, industry, people, travel, and of course the studio. Thus, what I am about to say may sound quite profound, but here goes.

Much of the world in which we live could easily be photographed without putting in the time and sometimes the hassle of using flash *and* shot not only faster but with the resulting photographic image looking much better! "What?" you ask. "Have you all of the sudden become antiflash?" Not on your life, but I would be irresponsible if I brought this book to a close without addressing the deservedly hot topic of using no flash in lieu of the very fine grain that is quickly becoming the norm when one shoots with ridiculously high ISOs in available light.

Of course I do not believe those who say flash is no longer necessary because of these fine-grain high-speed ISOs. In fact, it is my belief that those who give such advice are doing so from a position of ignorance and, rather than truly investing the time to learn about the endless stream of creativity that the knowledge of electronic flash can unleash, are hiding that ignorance behind fine-grain high ISOs.

Again, to be clear, I am not suggesting that the use of electronic flash is the be-all and end-all; if anything, I *am* suggesting a word of caution about its use. Do not overthink the use of flash. It is easy to get caught up in the enthusiasm of learning something new, and before you know it, it takes over your life so much that you have actually gone out and bought five Nikon SB-900 strobes because you want to light up your kid's basketball games at his or her junior high school. Damned if you don't have a Nikon D700, and knowing that, I would *never* suggest that you not try to light the games; instead, I am suggesting a much more logical solution: available light!

With your ISO set to 6400 and your white balance on automatic at least initially, you would find yourself shooting "unencumbered" at *f*/4 at 1/250 sec. Not surprisingly, you would come away at the end of the game with not only great shots but shots that were far from being "massively grainy" as a result of the low noise factor for which the D700 is noted.

I am writing this book in 2015, and perhaps you find yourself reading this page in 2016. Trust me, in this brief interval, the technology in the low-noise high-ISO arena has only gotten better. Both Canon and Nikon produce a plethora of cameras that offer low noise with high ISOs. The others, such as Olympus, Pentax, Leica, Sony, and Panasonic, have followed suit, and Nikon recently announced that it broke through the 100,000+ ISO barrier!

Taking advantage of low-noise high ISOs is certainly not limited to the gymnasium. Eventually we will see everyone waking up to the realization that the many forthcoming birthday parties for all of the Jacobs and Emmas of the world will be shot indoors *without the flash* along with the many holiday celebrations and numerous office parties that take place indoors. In both of these situations, simply go to those high ISOs, set your lens at or near wide open, and set your white balance to either incandescent or fluorescent and you are good to go!

Then there is action photography, and I am not talking sports here. The fact is that photographers have been able to shoot sports with 100- to 400-ISO film for years with no trouble stopping the action. Just look at issues of *Sports Illustrated* dating back to the mid-1970s and it's obvious that these ISOs are more than enough. The action I am talking about is much faster, such as a water balloon bursting on the sidewalk, a hammer smashing a light bulb, or the proverbial bullet piercing an apple. Of course, along with these low-noise high ISOs comes the need for speed, but trust me on this, we *will* one day see shutter speeds approaching 1/30,000 sec. in a DSLR,

My son Justin needed to pay a visit to his storage facility, and having been there once before, and regretting I did not have my camera with me, I was quick to accept his invitation to join him. I had one specific photograph in mind, the whimsical portrait of him that you see here. This is just another of many more examples where you might be seduced into thinking that a shot like this needs a flash, since it is indoors.

With high ISOs, and their very low noise, found on many of today's digital cameras, one can easily record evenly lit exposures in many indoor shooting situations, without any flash.

Nikon D800E, Nikkor 17-35mm at 20mm, f/22 for 1/40 sec., ISO 3200

and with that will come an entirely fresh migration of images that everyone will stand up and take notice of, all done without the benefit of high-speed strobes or flashes.

There are many other situations that I have not described in which the normal train of thought is to call upon a flash. The assumption that flash is always necessary when one is shooting indoors is firmly rooted in a mentality that goes back well over seventy-five years and continues today, yet I am merely pointing out that it's time to consider embracing modern technology. In doing so, you may find that the hardest pictures we are called upon to take (family gatherings indoors) are now some of the most rewarding, simply because we did not resort to using the flash but embraced the technology of low-noise and high ISOs.

In addition, there are still a host of subjects and scenes you will come across for which the use of flash not only is impractical but could also spoil the moment or cost you the shot as you fumble around looking for it in your camera bag. In addition, the light that is currently falling on your subject may not necessarily be flattering, but again, is the flash going to overpower the light that is there, turning an otherwise potentially nice image into a "snapshot"? Sometimes the dappled light you see falling on the subject needs be seen. At other times it is best eliminated with a simple diffuser. My point in sharing this with you is to put your mind at ease so that you feel free to use your high ISOs in situations in which the use of flash just isn't practical.

Now that you are breathing a sigh of relief about *not* having to worry about trying to get great flash shots of your two-year-old's birthday party, let's move into those areas where the use of flash really does make all the difference. I firmly believe that the understanding and creative use of flash is critical to your becoming a truly great photographer!

THE LIMITATIONS OF YOUR TEENIE-WEENIE POP-UP FLASH

Your camera's built-in flash, also called a pop-up flash, has one huge limitation: it can't be moved off the camera; it also has a limited power range and angle of view. Does that mean that it is totally useless? No, but as you are about to learn, you have to work within those limitations. One of them is lack of power, because these types of flashes are best suited for subjects that are ten to twelve feet from the camera. The position of the flash is also limiting because it sits right there on top of your camera, pointing straight out at the same subject you see through the lens. There is no rotation or bounce flash ability, and if you are using a wide-angle lens that is zoomed wide, the flash hits the lens and casts a shadow in the bottom of the picture. This shadow seems to go away when you zoom out to 50mm or

more. It's like sitting in the driver's seat of your car, and your camera's viewfinder is like viewing through the windshield and your built-in flash is like having headlights on the roof. In addition to these lights casting a shadow across the hood of the car and onto the street and that straight-on, very unflattering direction of the light, the flash is responsible for that "deer in the headlights" look we have all seen in images taken with a built-in flash.

Until you can afford to buy a portable electronic flash, I would limit your use of the pop-up flash to close-ups of some nature subjects and small interiors that you have determined, for whatever reason, lend themselves to using a flash instead of a higher ISO and/or tripod.

About forty-five minutes before sunrise I was outside picking dew-laden dandelions that had gone to seed, holding them up in front of my tripod-mounted camera and 105mm macro lens. After having shot several of them against the orange sky, which resulted in silhouetted shapes of dew-laden seed heads, I turned to my built-in flash as I wanted to extract some detail of the seed heads while still maintaining the ambient exposure of the colorful sky.

First, with the camera in Manual Exposure Mode, I determined this is a "who cares?" exposure so I chose f/11, took a meter reading of the dawn sky, and adjusted my shutter speed until a 1/100 sec. indicated a correct exposure. Secondly, I engaged my pop-up flash, which was in TTL Mode, and I set the exposure over-ride for the flash at -2. Third, with my camera and 105mm lens on tripod, and with my left hand holding the seed head in front of the lens, I focused the lens with my right hand and fired away! As you can see, I have "two" perfect exposures; the f/11 flash exposure is perfect in terms of subject distance, and so is the f/11 at a 1/100 second using the available light exposure of the dawn sky.

Nikon D810, Nikkor 105mm macro lens, f/11 for 1/100 sec., ISO 100, tripod, flash

I met Earl in Clarksdale, Mississippi, while conducting a workshop. He owned a restaurant, and I met him outside on the street while he was cooking ribs in a 55-gallon drum that was cut down the sides and then hinged so that it was not a whole lot different from one of those $800 barbecues you get at Home Depot but at one-twentieth the cost. I would say the food tasted even better, but this is not a cookbook, so we'll leave that debate for another day. I enjoyed his many stories, and when the sunset began to put on a show, I stopped our conversation and asked him to pose against the beautiful magenta sky to the west.

First, I determined that I did not have any strong depth-of-field needs, so a "who cares?" aperture choice it was at f/11. Second, at f/11 and with the camera in manual mode, I took a meter reading of the sunset sky and adjusted the shutter speed until 1/15 sec. indicated a correct exposure.

Third, there was no way I could handhold that available light exposure of f/11 at 1/15 sec., so I put the camera and my 24–85mm lens on tripod. Fourth, I zoomed out to 50mm and filled the frame with Earl's face, engaged the pop-up flash, and, with the flash in TTL mode, fired one shot and discovered that the flash exposure was a bit "hot," or overexposed. Therefore, I powered the flash down to –1 stop and fired again, and that resulted in a correct exposure, as you can see here. (I also shot Earl's portrait with my Nikon SB-900 portable electronic flash, and that also turned out really well, but for the purposes of this story, I wanted to share with you this version, which I shot with my camera's pop-up flash.)

Nikon D800E, Nikor 24–85mm at 50mm, f/11 for 1/15 sec., ISO 200, flash

POWERING DOWN THE FLASH

Now I want to call your attention to the subject of powering down the flash.

In both of the examples I just shared with you, I found myself needing to set the flash to either a –2 or a –1 exposure. This function for setting your flash exposure to a minus exposure can be found in your camera's menu and often will be readily apparent *only* after you have engaged the built-in flash.

When you call upon the flash exposure compensation button (–), you are doing nothing more than taking a bit of power away from the flash. This feature is *not* limited to your built-in flash either; it is found on most portable electronic flashes as well. In effect, this powering down function is no different from a dimmer switch in your house. When that switch in your dining room is at full brightness, you know how easy it is to turn it down, and of course the light in the room gets "dimmer."

When it comes to a flash exposure, we want perfect flash, and if your flash exposure is too hot (overexposed), you either move the flash farther away from the subject or move the subject farther away from the flash *or* call upon the dimmer switch, which means simply powering the flash down. Usually a –1 will do the trick, but sometimes you might have to resort to a –2, as I did with the dandelion. This was the case solely because the distance from the dandelion to the flash was "closer than the norm," and so I had to dim the light. Now that it was dimmed, the flash fired with much less intensity, and as the picture shows, it proved to be a correct decision. That brings me to another important point about flash that needs to be understood.

Lying underneath a hammock, I prepared to photograph a model I have shot often, Diana Sahara. The light, however, was truly flat on this cloudy day, and any light from overhead was being blocked by Diana. This was time to call upon the portable electronic flash. I wanted to replicate the warmth and color of the low-angled light of a late-afternoon summer day, so I also placed an amber gel on the flash.

There was no way that at full flash power I could expect to make this a correct exposure, since the flash was indicating a correct flash exposure at an 11 foot distance and Diana was only 18 inches from the camera and lens. The solution was an easy one; I simply dialed down the power of the flash, and as you can see in the illustration, the distance of a correct flash to subject exposure is considerably shortened when you power down the flash. With *f*/11 set on my lens and on the back of the flash, I began to dial down the power until I saw that 1/128 power would give a correct flash exposure at my flash-to-subject distance of 18 inches. Because I wanted to replicate a low angled sun, I also chose to hold the flash about 20 inches to my left, creating low-angled side light.

Nikon D800E, Nikkor 24–85mm at 35mm, *f*/11 for 1/200 sec., ISO 200, flash

FLASH AS A FILL LIGHT

On a strictly professional level, the use of fill flash is probably called upon most often when one is shooting portraits, posed or candid. Newspaper, wedding, and fashion photographers are all too familiar with the use of fill flash. Newspaper photographers do not get to choose what time of day accidents and/or catastrophes happen. Often the light is too harsh, so out comes the flash, and it is used to "fill in" areas of extreme contrast or to add a "catchlight."

Fashion and wedding photographers are often out shooting when the sun is almost if not directly overhead and contrast is at an all-time high. Raccoon eyes, the noticeable shadow under the eyes, is highly noticeable, and again, the flash is called on to fill in this area.

Fill flash enables the photographer to illuminate areas in a scene that would otherwise be lost because of high contrast (the extreme range of light) when the camera cannot expose properly for both the light areas and the dark ones. It can brighten deep areas of darkness in a scene to balance out the exposure, improving the overall composition.

Earlier in this book I mentioned briefly the range, from shadows to highlights, that our eyes can see and what digital cameras can record, with the eyes somewhere around 16 stops and the digital cameras around 7 stops. This difference between highlights and shadows is referred to as dynamic range. On very bright days, the dynamic range is far wider and too extensive for any current camera to capture in one frame.

While exploring the many small villages that surround the area around Angkor Wat near Siem Reap, Cambodia, I came upon this elderly woman tending to her rice fields. It was in the middle of the afternoon, but the sky overhead was filled with clouds. This was one of those golden opportunities to make a flash exposure with welcome contrast.

I first determined that I wanted a great deal of depth of field and front-to-back sharpness, so I opted for f/22, and then, with the camera pointed to the heavy overcast sky, I adjusted the shutter speed until I saw that at 1/160 sec. a 2-stop ambient exposure was indicated.

I also noticed on the back of my flash, when it was set to f/22, that a flash-to-subject distance of 7 feet was indicated. With the camera on tripod and my Nikon SB-900 in my left hand, raised up a bit high and coming in from the left side, *and* with the Commander mode function that allows me to fire my flash wirelessly, I simply tripped the shutter release, and the contrast of the well-lit subject against the deliberately underexposed sky was evident. Clearly, without benefit of the flash, the subject is rendered as a dark silhouetted shape against the dark underexposed sky.

Both images: Nikon D300S, Nikkor 24–85mm at 53mm, f/22 for 1/160 sec., ISO 200, tripod, (top) no flash; (bottom) flash

Conversely, a short dynamic range might involve a foggy morning along the ocean where you are photographing a lighthouse and fishing boats in the harbor under relatively even illumination and the digital camera can capture the entire dynamic range of the scene.

When you are photographing in very bright situations with a high dynamic range, your camera's light meter will always favor the highlights in the scene, often to the detriment of the shadows. When you expose for a scene of great contrast (high dynamic range), the picture often works better when it is exposed closer to what's deemed the best exposure for the highlights rather than what's best for the shadows. This results in perfect highlights at the expense of shadows but is more visually pleasing than good shadow detail and blown-out highlights. How does one manage to capture detail in both the highlights and the shadows? The answer is to use flash to fill in those dark shadows, thus lowering the dynamic range. This reason alone makes fill flash one of the most commonly used features of flash.

On a bright day the sun is the key light. Thus, it is not surprising that a subject who is wearing a hat may have a shadow cast across the face and that with no hat and outside when the sun is high overhead, raccoon eyes are the norm. Backlit subjects can benefit from flash fill by outputting flash into the shadow side or front side of the subject. And wildlife photographers are known to use flash fill simply to add a catchlight to an animal's eyes.

Atop the Valensole Plain near the town of Valensole in Provence, France, I set up my camera and tripod right in front of some lavender flowers. After several hours of thunderstorms, the sun popped through a small opening in an otherwise ominous sky. With my wide-angle lens in place and an aperture of f/22, I first made a –2 stop exposure for the ominous sky that resulted in a silhouetted exposure of the flowers: f/22 at 1/200 sec. Although dark, the sky was still much brighter than the flowers below. I then dialed f/22 into my flash, and the distance scale indicted a

flash-to-subject distance of 4.4 feet. All that was left to do was raise the flash in my left hand about 4^1/$_2$ feet from the flowers at a 45-degree angle, and as you can see, I was able to record a correct exposure of the foreground lavender flowers against that dark and foreboding sky.

Both images: Nikon D800E, Nikkor 17–35mm at 17mm, f/22 at 1/200 sec., ISO 100, tripod, (left) no flash, (right) flash

One of the most common compositional choices that every photographer is presented with involves the idea of "isolating" a subject from an otherwise busy and sometimes even chaotic scene. Successful isolation or singular-theme compositions owe their impact in large part to being the center of attention, since there is nothing to detract from the scene or distract the eye/brain as it views the resulting image. Effective isolation relies in part on a photographer's ability to combine the proper lens choice and the proper aperture (most often a telephoto lens and a large lens opening such as f/4 or f/5.6), along with a background that can be rendered into out-of-focus tones or shapes.

If these out-of-focus tones or shapes are at a distance of at least 5 to 6 feet from the focused subject, they can be rendered into complete darkness when the main subject is flashed. This extreme shift in contrast from light to dark also can be used to isolate the focused subject. The biggest key to making this happen with a shot like this is to "kill" the ambient light.

In the absence of flash, this yellow orchid looks okay in terms of its contrast with the complementary out-of-focus greens, but is there a way to make that background go black? Yes, and if you have a friend along with you plus a black cloth, he or she could simply drape the cloth in the background at a distance of about 3 or 4 feet behind the flower, and when you shot, the background would be black. However, more often than not, the simplest solution is to call upon your flash.

With my camera and 105mm Micro Nikkor lens on tripod, I was able to set an ambient exposure of f/16 at 1/30 sec. and recorded a pleasing image of this yellow orchid, but when I called upon my Nikon SB-900 flash and set it for f/22, I noticed a flash-to-subject distance of 7 feet, and so I set the flash to 1/4 power, and the flash-to-subject distance drops to $3^1/_2$ feet, which is perfect! So, with the flash in my left hand and the camera in Commander mode for remote firing, I adjusted the shutter speed until a 4-stop underexposure was indicated (1/250 sec.). Holding the flash at a slight angle to the flower, I pressed the shutter release and recorded a perfect flash exposure and also a perfect severe underexposure of the background. Clearly, the contrast between the flower and the black background is much greater than it is when seen against the out-of-focus tones of green.

Both images: Nikon D800E, Micro Nikkor 105mm, f/16 for 1/30 sec., ISO 100, tripod, (left) no flash, (right) f/22 for 1/250 sec., flash

ABOVE: Emily, seen here at the base of the Manhattan Bridge in New York City, is a photography student of mine, and so are her parents. They are the poster family for what I have I have always said: "Families that photograph together stay together!"

Emily also models for an agency in Los Angeles, and it was during one of our New York workshops that she and I had a chance to take a few quick shots before the workshop began. In this situation the use of the flash was paramount!

Note in the first example, as Emily turns her head toward me and with *only* my exposure set for the bright ambient frontlight, how dark her face is. This is the case because my ambient exposure, $f/11$ for 1/200 sec., ISO 100, is set only for bright early morning frontlight, and of course as you can clearly see, when she brings her face around, it is in the shade, not the sun. What's the solution? Flash, of course, and in this instance I'll leave the flash on TTL mode and also hold it off camera in my left hand, triggering it with Nikon's Commander mode. Now, as Emily comes around again, I fire, and voilà, the flash fires, too, and fills her face nicely with its warm light. I say "warm light" because this time I am also using an amber-colored gel over the flash. The light amber color warms up the light that is emitted by the flash.

This warmer light is closer in color temperature to the warm ambient light that is frontlighting Emily during this early-morning hour. We'll say more about using colored gels in a few more pages.

Both images: Nikon D800E, Nikkor 24–85mm at 35mm, $f/11$ for 1/200 sec., ISO 100, (left) no flash, (right) flash

OPPOSITE PAGE: Olga, a student from Denmark, had the idea to jump against the backdrop of the Eiffel Tower while wearing her yellow raincoat and white "princess" dress. As we had made these plans several weeks in advance, I was thankful on the day of the shoot to find a sky with heavy overcast, which will always generate an image of great contrast *if* you set a 2-stop underexposure for the sky. Let me explain.

Step 1 is to set your camera in manual exposure mode since we will need a great depth of field here. We'll go for $f/16$, and with an ISO of 100, I adjust the shutter speed until 1/160 sec. indicates a –2-stop underexposure. With the Nikon SB-900 flash set to manual flash mode, I dial in the aperture of $f/16$ and discover that a flash-to-subject distance of 11 feet is being indicated, which means, simply enough, that Olga needs to be jumping at a distance of about 11 feet from the flash. On the count of three from my low viewpoint while shooting upward, and with my flash on a small stand and attached to a Pocket Wizard Plus III, Olga jumps, and the flash exposes her correctly against the welcome contrast of a 2-stop underexposed sky. (Yes, you could have shot this flash composition with your flash in the TTL mode with either the aid of coiled cord or the use of dedicated radio triggers that are designed to work off camera with TTL flash: Pocket Wizard TT1 and TT5.)

Nikon D800E, Nikkor 24–85mm at 24mm, $f/16$ for 1/160 sec., ISO 100, flash

WIRELESS FLASH

As you no doubt have surmised by now, the use of your flash *off camera* is the way to go. Most effective flash exposures by serious amateurs and professionals are done with the flash off camera. The shortest route to shooting with the flash off camera is literally to use a short dedicated coiled cord; one end mounts to the camera's hot shoe, and the other to the flash. These cords allow one to fire the flash off camera from about a 6-foot distance from behind the camera, in front of the camera, or to the left or right side of the camera. However, most serious flash shooters use their flashes off camera by taking advantage of the wireless world in which we find ourselves living. Imagine the possibilities if you had several flashes and could place them anywhere in your scene, such as behind your subject or inside

a camp tent; simulate the light of a campfire or a studio portrait; and light a home interior or the inside of a machine that a mechanic is repairing. The ability to use multiple flash units all triggered wirelessly expands your creative options almost beyond imagination. Wireless flash offers unlimited potential for creative effects, so let's take a look at how it works.

Flash units that are not connected to the camera by a dedicated sync cord need to be triggered wirelessly to flash at the appropriate time. Today there are many devices available for triggering an off-camera flash, including sync "extension" cords (non-TTL), optical slaves that "see" the other flashes fire and trigger the one they are attached to, radio remotes, and designated devices. I am going to skip

OPPOSITE PAGE: Okay, let's break this down. We find ourselves in an area of open shade on the back deck of this young woman's house. We are quick to compose this frame-filling portrait of our young model, and the camera's meter indicates an ambient exposure for her face of f/8 at 1/125 sec. I fire the shutter, and here is that correct exposure. Pleasing? Sure, but are we done? Nope!

Behind our model and quite close, about 4 feet, I have my flash and Pocket Wizard attached to a light stand. I am in manual flash exposure mode. With the flash at full power, the distance indicator on the back of my flash is telling me that at f/8 my flash-to-subject distance needs to be 18 feet, but as I just mentioned, the flash is a mere 4 feet behind the model's head. I do not want to stop the lens down any further because I do not want to render more of the background in greater detail. Thus, the only option I have is to power the flash down, but *not* until a 4-foot flash-to-subject distance is indicated but instead

until an 8-foot flash-to-subject distance is indicated. Why an 8-foot distance? Because this will surely cause a 2-stop overexposure and I *want* a 2-stop exposure to create the illusion that a very bright light source is behind her head, aka the "sun," and 2 stops is usually all one needs to create this effect.

With the aperture set to f/8, I zero in on her face with my 70–300mm lens and simply adjust the shutter speed until 1/125 sec. is indicating a correct exposure. Sure enough, I then trip the shutter release, and this time the flash fires behind the model's head, and in that instant I record a correct exposure of the natural light that is reflecting off the front of her face while at the same time recording a 2-stop overexposure around the edges of her hair, which was illuminated by the flash behind her head.

Both images: Nikon D800E, Nikkor 70–300mm at 210mm, f/8 for 1/125 sec., (top) flash, (bottom) no flash

the older technology in favor of the newer devices such as infrared triggers and radio remotes. Today's newer flash units come with wireless flash ability built in, including Canon's 430EX, 550EX, 580EX II, and 600 and Nikon's SB-600/-700/-800/-900 and -910. These systems have the ability to trigger as many flash units as you have, provided that they are compatible with the system. The advantages of dedicated wireless are no wires between camera and flash, the ability to place the flash a great distance from the camera, and TTL features that can adjust each flash unit's output levels right from the camera. You need one master flash or triggering device and some flash units acting as slaves. With Canon dedicated units you place the master flash unit in the hot shoe and slide the switch to master, and the flash will trigger all the other units in your lighting setup that are set to slave. Nikon works similarly by placing a master unit in the hot shoe to trigger the slaves, but with the newer camera models with a pop-up flash (I knew it was good for something), it can be set to Commander mode by popping up the on-camera flash and setting a menu item to Commander, allowing it to trigger all the slave flashes. To recognize the master or Commander mode's signal, each slave unit is assigned an ID that allows its power output to be adjusted right from the camera. Imagine being able to adjust your key flash and fill flash no matter where they are and all from the camera. Also, if you have a flash in the hot shoe or are using the pop-up as the master unit, both can be set to act only as the trigger for the other units in your setup without outputting any flash light.

If you would rather not designate an expensive SB-900 or 580EXII as the master triggering unit sitting in your hot shoe and your Nikon does not come with the Commander mode feature, you can use the manufacturer's dedicated infrared triggering devices. The IR trigger for Canon is the ST-E2, and Nikon's is the SU-4, but remember that you do not need these infrared triggers if you always have one of the flashes on camera acting as master or in Commander mode. However, when you have invested in these costly flashes, wouldn't you rather have both flashes available to light your subject from any angle? This makes the infrared trigger a lower-cost option than using a flash to trigger the slave units.

There are some drawbacks (as always) to IR triggers, and one is that when used outside in bright sun, the IR trigger is not always reliable as the sun interferes with the IR signal. Also, the receiver and transmitter must be in each other's line of sight for the IR signal to be seen by the slave, thus eliminating the possibility of hiding a flash behind a building or another object so that it is not seen. Indoors this is not a problem as the signal bounces off all the walls, but outdoors it becomes a challenge. And that isn't all. IR triggers also are limited in the distance range within which the trigger and slave flash can be, so before you invest heavily in these devices, be sure to do your research. Many pros using wireless portable flash systems prefer the wireless radio remotes to infrared devices because the radio signal does not require a line-of-sight approach.

There are many manufacturers of radio remote devices for wireless triggering that are designed for both studio strobes and portable flash. There are the Pocket Wizards, Quantum Radio Slave, RadioPopper, MicroSync, and many more, including foreign-made models that are available on eBay. Make sure to research the devices thoroughly. A test of various radio remotes on Robgalbraith.com found that some of the popular triggering devices could not sync fast enough to be used in high-speed sync situations, and the shutters sometimes closed before the flash burst was complete. This is the same problem you can have when using normal flash at anything other than the normal sync speed on older camera models.

Peter Kastner is a musician who lives in LA and has played with a host of jazz musicians in addition to doing a great deal of music for radio and television commercials. After coming upon an alleyway just off of Venice Beach on this early morning, I remarked that the red wall and the gargoyle figure would make a perfect backdrop to shoot a portrait of Peter. While he was retrieving his bass guitar from his nearby car, I asked Ray, another friend, to stand in so I could shoot some test shots (left).

In this scene I am using two lights. The "rear" strobe is off camera left and pointed to the wall at the gargoyle in the background. The front light is off camera right and pointed at Ray. Both strobes have diffusers placed over them and also light amber gels placed inside. Since I wanted the wall and gargoyle to remain somewhat "soft," allowing Peter to be the subject in sharp focus, I chose to use an aperture of f/5.6. I then dialed up f/5.6 on the foreground flash and with my front flash being only about three feet from Ray, I was quickly dialing down the power

until 1/32 power indicated a correct flash exposure at f/5.6 from 4 feet. I then went to the flash at the back wall and determined my flash to subject distance to be about 5 feet (I wanted to light the gargoyle and a portion of the wall around it), and after dialing down the power of the strobe, I found that a 1/16 power would allow me to shoot that wall and gargoyle at f/5.6 from a distance of 5 feet. With my camera and lens now set at f/5.6, I took a meter reading of the overall ambient light in the scene and an ambient exposure of f/5.6 at 1/15 sec. was indicated. Since I wanted to impart a bit of mood to the scene, I chose to set my ambient exposure about 1-1/3 stops under-exposed, f/5.6 for 1/40 sec., and as you can see in the exposure of Peter (right), that part of the red wall that is not lit by the flash imparts a somewhat moody feel to the overall exposure.

Both images: Nikon D300S, Nikkor 24-85mm at 85mm, f/5.6 for 1/40 sec., ISO 200, flash

COLORED GELS

You have already seen several examples in this book where I turned the normally white light of the flash (5200 K) into light that was much warmer, akin to the warm, golden low-angled sunlight of early morning or late afternoon. In those situations I was able to make the light much warmer with the use of an amber-colored gel that was placed directly in front of the flash head. The purpose behind using gels in working with electronic flash are the same principles that apply to using colored filters in shooting available light: you wish to add color to or subtract color from the natural-light scene in front of you or from the light that you are about add from the flash.

The amber gel you have seen me use is actually intended for indoor use where incandescent/tungsten light abounds and with your white balance set to Incandescent/Tungsten. With the gel in place in front of your flash, the color temperature of the light being emitted by the flash is now the same temperature as that of the incandescent/tungsten lights, and as you fire away, everyone and everything in the room is of the same color: a somewhat cool white. Similarly, when you place the light green gel that comes with the Nikon SB-900 over the flash head and change the white balance to fluorescent, you can expect to get nice "white" pictures inside offices, where fluorescent lighting is often found. This use of the green gel converts the flash to the color temperature of fluorescent lights, and when you then combine this with a Fluorescent white balance setting, you eliminate the normal sickly green cast that sometimes is seen in office party photographs. The use of colored gels, at least initially, is fun, and they do have their place, but as I have learned, using gels falls into the category of less is more. Yes, I often use the amber gel, but I seldom use any others, and that's not because there is a shortage of colored gels—heck, you can find gel packs that offer more than 250 colors! Can you imagine having 250 colored filters for your lenses? Neither can I, which raises the question of why you would need 250 colored gels for a flash. You don't, and that is why I would like to dispense some timely advice that might save you some money in both the long run and the short run.

Assuming you want a few gels, the good news is that they are easy to acquire. My good friends at Adorama sell the Rogue Gel Kit, and I don't go anywhere without it. Its wallet size makes it easy to toss in your bag. Also, on the side of each gel you will find written the exact number of stops of light that each gel reduces the flash output, something that is really important when you are using these gels in TTL mode.

Since you will know before firing your flash how many stops of light the gels are reducing flash output, you will simply move in that much closer than the distance being indicated by the flash, whether you are in TTL mode or manual flash mode. For example, when you are using the Nikon SB-900 in manual flash mode with ISO 200 and an aperture of $f/8$, the flash states that a flash-to-subject distance of 22 feet is required for a correct exposure. The flash also gives me that information on the assumption that I am *not* using any gels, yet in this case I am using a red gel, with which, according to the Red Rogue gel I am using, a 3-1/2 stop of light loss can be expected! (It says "3-1/2 stops of light loss" on the side of the gel.)

A *full stop* of flash exposure is a 25 percent increment, and so I need to bring my flash in closer to compensate for this 3-1/2 stop in flash output: 22 feet to roughly 16 feet (1 stop), to 11 feet (2 stops), to about 6 feet (3 stops), and finally to $4^{1}/_{2}$ feet (1/2 stop) for a total of 3-1/2 stops. Not surprisingly, when you are shooting with red, blue, or any of the darker-colored gels, the flash-to-subject

distance often is quite close. Of course if you find yourself being too close to the subject when using your gels and for composition reasons you need to move back a bit, you simply increase your ISO a stop or two, and that often will do the trick. For example, when I use a red gel on a subject and my ISO is not 200 but 800, my flash-to-subject distance with the red gel is now 9 feet instead of 4^{1}/$_{2}$ feet (bumping my ISO from 200 to 800 allowed me to pick up 2 stops).

(For those of you whose flash capacity is limited to the pop-up flash built into your camera, you can easily wrap a gel in front of that itsy-bitsy, teeny-weeny, yet surprisingly powerful flash with a small rubber band. Just make sure the rubber band is wrapped around the gel and below the flash head itself so that it does not cover any part of the flash head.)

The use of two flashes and the combination of a red gel and a blue gel is certainly not limited to patriotic themes. A simple fire hydrant "glows" in the dark, almost as if it is radioactive, when flashed with two strobes and gels.

Step 1: I determined that I wanted a reasonable depth of field, so I chose f/16. Step 2: With the aperture set to f/16, I adjusted the shutter speed until 1/125 sec. indicated a –2 stop underexposure for the sky. Step 3: I placed one flash to the left of the fire hydrant and the other to the right, both

at about a 3-foot distance. Each flash was set to manual flash mode and attached to its own Pocket Wizard Plus III. Atop my camera, in the hot shoe, was another Pocket Wizard Plus III that served as the "messenger" to fire the two flashes. As you can clearly see, the resulting exposure did in fact turn an ordinary fire hydrant into something far more ominous!

Both images: Nikon D800E, Nikkor 24–85mm at 35mm, f/16 for 1/125 sec., ISO 200, two Nikon SB-900 flashes

It was during one of my Washington, D.C., workshops that I got the idea to light up the Lincoln Memorial columns in red and blue. I could not have done this shot without the aid of *two* flashes, one with a red gel and one with a blue gel, and with each attached to a Pocket Wizard Plus III.

First, this image requires some front-to-back depth of field, so f/16 was chosen. I also know from experience that when I use my colored gels a lot of light gets lost, so I chose to use an ISO of 640.

At ISO 640, the ambient exposure for Abe, who was sitting in the much brighter light beyond the two columns, was f/16 at 1/40 sec. So without benefit of flash, I took a shot, and not surprisingly, the columns were really dark but Abe looked great.

After putting a blue gel on one flash and a red gel on the other, and with each flash in manual mode and at a distance of about 3 feet from its respective column, I fired away at f/16 for 1/40 sec., and voilà, I got my red, white, and blue Lincoln Memorial composition!

You could have made this shot in TTL mode, but you still would have required some kind of cordless attachment such as the Pocket Wizard TT1 or TT5. In addition, you would have to figure in the loss of light, since your flash in TTL mode does not have a clue that you are using the gels.

Top image: Nikon D800E, Nikkor 17–35mm at 20mm, f/16 for 1/40 sec., ISO 640, flash

REAR CURTAIN SYNC

When any flash is set to its default setting, the flash fires at the *beginning* of the exposure. It is assumed by the camera manufacturer that your flash is used for all intents and purposes as the *main* light source in your photo, and any other lights that might be on, or any other daylight that might be in the overall scene, will take a backseat (in terms of their exposure) to the flash exposure. I hope that by now you have figured out that using the flash as a supplemental light source also has great value.

However, when the camera's flash is set to fire in *rear curtain sync* mode (called *second curtain sync* on some cameras, including Canon), the flash won't fire until the *end* of the exposure. The exposure times I'm referring to here last anywhere from 1/250 sec. to minutes, depending on what you're shooting.

Do you have any idea what kinds of fun and what creative exposures you can achieve when the flash is in rear curtain sync mode? Probably not so, it's about time you get enlightened, pun intended!

Rear curtain sync with your flash is a simple idea to understand, and it goes like this: When you use your flash and set it to its default setting, the flash fires at the beginning of the exposure. When the camera's flash is set to fire in rear curtain sync mode, the flash *will not* fire until the end of the exposure.

As long as your camera has a "rear curtain sync" or "second curtain sync" setting, you can always make a fun and unexpected portrait as I have done on many of my workshops with my students. I recently purchased the Sony RX100 and it does have a rear curtain sync as an option when using the built-in flash.

While conducting one of my summer workshops in Chicago, my students were shooting around the Buckingham Fountain at dusk and it was there that I shot a number of flash portraits, including the one you see here. Again, it's really easy to do! Step one is to set your camera to manual exposure and to set an ambient exposure for the bright city lights, i.e. *f*/8 at 1 sec. with ISO 400. Make sure your subject is in a dark area of the overall composition, (lower portions of the frame with your city lights in the middle and above) and once you have composed them, press the shutter release and turn the camera in a circular motion and at the end of the exposure, your flash fires and voila, you have a high-energy portrait like this!

Sony RX100, 28–105mm at 35mm, *f*/8 for 1 sec., ISO 400, flash

MAKING A SOFTBOX

For years I enjoyed shooting a two-light setup with my two White Lightning Ultra 1200 studio strobes, placing each in a softbox—one on the floor, pointed up, and the other on a light stand, pointed down. Between the two softboxes would be a 4- by 4-foot sheet of $^1/_8$-inch white Plexiglas on which I'd place numerous subjects, including flowers and fruit and vegetable slices. But as much as I enjoyed this setup, it did take up a large corner of a room, and it was expensive.

One day I stumbled upon the obvious. I lined the inside of a medium-size cardboard box with white poster board, replicating a softbox. I put one portable electronic flash inside the box, pointing it up. On top of the box, I placed a sheet of $^1/_8$-inch white Plexiglas, and I mounted another portable flash on a light stand overhead about 2 feet above my subject. By doing this, I was able to create a scaled-down version of my old larger setup with studio strobes and softboxes. Some kind of wireless device is the key here to get both of the strobes to fire simultaneously. To deal with the obstruction of the flash in the box, I've found a radio remote, such as a Pocket Wizard, to be most successful.

To start, set both flashes to the same output—full power. Also make sure that both flash distance scales indicate the same f-stop; f/11 is a good place to begin. Keep in mind that the flash in the cardboard box will be illuminating the subject through the $^1/_8$-inch Plexiglas, so don't place a diffuser or any other light-filtering device on the strobe. The Plexiglas becomes the diffuser. However, do place a diffuser on the other flash so that its light output is also diffused. Next, call on a normal sync speed of 1/125 sec., 1/200 sec., or 1/250 sec; the choice is yours. Then place a flower or another small subject on the $^1/_8$-inch Plexiglas and shoot down on the setup.

Check your exposure. Your goal is to have a subject floating in white space while being well exposed from both front and back. Many subjects will appear to glow. This is due to the strong backlight of the strobe firing from inside the box. You may end up decreasing the power of one strobe to make it mesh more with the light output of the other. It's easier to make any changes to the strobe outside the box (the one on the light stand).

For this flower image of rain, I purposely held off watering these Gerber daisies so that their stems became soft and pliable, like rope, and this allowed me to spell the word "rain." After stripping off some petals from several other daisies, I was able to add some rain to the overall composition. The flowers appear to float, and the combination of backlight and frontlight creates an image of pure white contrast.

Nikon D800E, Nikkor 24–85mm at 85mm, f/11 for 1/250 sec., ISO 100

Chloe got a nice guitar for her birthday when she was 11 years old. Ten years later it still sits there in her room, untouched for the most part, on that nice guitar stand we also bought. Shortly after she got her guitar I wanted to get some shots of her playing it out on the small terrace of the apartment in Lyon, France, where we were living at the time. I chose to do this at dusk, against the backdrop of Old Lyon. This proved to be a really easy exposure, and it would have been for you, too, I am sure. With my tripod-mounted camera set for ISO 200 and my 17–55mm lens set to *f*/16, I took a meter reading from the dusky blue sky in the background and adjusted my shutter speed until 8 seconds indicated a correct exposure.

Just before I pressed the shutter release, I lit a sparkler, and during the first 7 seconds of my 8-second exposure I simply made an outline of Chloe, using the sparkler in much the same fashion as a magic wand (it really was like a magic wand, as you can see), and since my TTL flash was set for rear curtain sync, it did *not* fire until the very end of the expsoure. It was also at the end of the exposure that I asked Chloe to make a screaming rocker expression.

The reason you do *not* see any evidence of me in this photo is that the magic wand and I *never* stayed in the same place long enough during the first 7 seconds of this 8-second exposure *and* I of course was *not* in the shot at all during that last second of exposure when the flash fired. Also, it should be noted that since the ambient exposure was for the much brighter sky, even if I had stayed still the entire time, both Chloe and I would have been a silhouette against the much brighter sky without benefit of the flash exposure. Again, rear curtain sync exposure allows any lighted and moving subject/object to "streak" along the initial exposure, leaving a "trail" if you will, and only at the end of the exposure does the flash fire the necessary light to correctly expose the subject(s) you want to light up with the flash.

Nikon D300S, Nikkor 17–55mm, *f*/16 for 8 sec., ISO 200, tripod

INDEX